T0166334

Who Says?

Permissions

"Between Teller and Listener: The Reciprocity of Storytelling" printed by permission of Rafe Martin.

"The Continuing Circle: Native American Storytelling Past and Present" printed by permission of Joseph Bruchac.

"The Icebergs of Folktale: Misconception, Misuse, Abuse" printed by permission of Barre Toelken.

"Innervision and Innertext: Oral and Interpretive Modes of Storytelling Performance" printed by permission of Joseph Sobol. An earlier version of this paper appeared in *Oral Tradition* 7:1 (March 1992), 66-86.

"Jewish Models: Adapting Folktales for Telling Aloud" printed by permission of Peninnah Schram.

"Old Stories/Life Stories: Memory and Dissolution in Contemporary Bushman Folklore" printed by permission of Mathias Guenther.

"Old Stories/New Listeners" printed by permission of Kay Stone.

"Playing with the Wall" printed by permission of Bill Harley.

"Two Traditions" printed by permission of Melissa A. Heckler.

"Who Says? The Storyteller as Narrator" printed by permission of Carol L. Birch.

Who Says?

ESSAYS ON PIVOTAL ISSUES IN CONTEMPORARY STORYTELLING

Edited by

Carol L. Birch & Melissa A. Heckler

August House, Inc.
ATLANTA

© 1996 by Carol L. Birch and Melissa A. Heckler.
All rights reserved. This book, or parts thereof,
may not be reproduced, or publicly presented,
in any form without permission.
Published 1996 by August House, Inc.,
www.augusthouse.com

Printed in the United States of America

10 9 8 7 6 5 4 3 2 PB

LIBRARY OF CONGRESS CATALOGING-IN-PUBLICATION DATA
Who says? : essays on pivotal issues in contemporary storytelling /
edited by Carol L. Birch and Melissa A. Heckler
p. cm.
Includes bibliographical references.
ISBN 13: 978-0-87483-454-3 (paperback)
1. Storytelling. 2. Folklore—History and criticism.
3. Oral tradition—History and criticism. I. Birch, Carol (Carol L.)
II. Heckler, Melissa A., 1950– .
GR72.3.W56 1996
808.5'43—dc20 96-14860

Executive editor: Liz Parkhurst
Project editor: Joyce Hancock
Editorial assistants: Georganne Rodriguez, Sandy Lacer, Sue T. Agnelli
Cover design: Harvill Ross Studios Ltd.

The paper used in this publication meets the minimum requirements
of the American National Standards for Information Sciences—
permanence of Paper for Printed Library Materials, ANSI.48-1984

AUGUST HOUSE, INC. PUBLISHERS ATLANTA

*To all who have struggled across the divides of time,
culture, and space to bear witness in stories.*

Acknowledgments

*T*his book would not be possible without Judy O'Malley, who skillfully guided us through the shape-shifting world of publishing. We also gratefully acknowledge Joyce Hancock's contribution, which shaped the book into its present form. We thank our contributors, who accepted the challenge of writing with unwavering attention to form and meaning. Our greatest thanks go to Liz Parkhurst from August House, who so willingly shared our vision.

Thanks to all participants over the years in workshops where we've held up our models for discussion, debate, and refinement—particularly the eager and voluble supporters at the 1994 National Storytelling Conference in Fort Worth, Texas.

Finally, we thank Carol's husband, Richard Drewelus, and Melissa's children, Annabelle and Paul. They believed in our doing this book from the beginning and cheerfully accommodated our schedule, allowing us to work with (almost) no complaint.

Contents

Introduction

*F*ive years into her storytelling career, Carol grew tired of hearing people say, critically and knowingly, under their breath: "Well, *that's* not storytelling!" She wondered, "Who says?"

Over the next twenty years this phrase echoed and reechoed, as actors, mimes, performance artists, dancers, writers, poets, comedians, folk musicians, ministers, inspirational speakers, librarians, and educators made their way onto the platforms of storytelling. Each person spoke from the aesthetic vision in which he or she was trained. All too often, "That's not storytelling" was used to dismiss another storyteller's style. The limitations of critique-as-argument made it easier for storytellers to say what storytelling wasn't, rather than what it was. The tendency was to make others "wrong" in order to feel right about a preferred approach.

One of the most pivotal issues in storytelling today is how to respect different models in developing a critical language for approaching and assessing contemporary story occasions with widely diverse audiences, tellers, and types of material. Rather than the variety of perspectives polarizing discussions and obscuring the multifaceted nature of truth, this book seeks to broaden a dialogue across philosophical, professional, academic, regional, and cultural divides. These essays—by storytellers, folklorists, anthropologists, and theorists in the fields of literature, communication, education, and the performing arts—are challenging, thought-provoking, and robust.

Contemporary storytelling has its roots in the oral and literary traditions. We asked contributors to consider what constitutes aesthetics in these traditions. This initial question gave birth, like Nasrudin's borrowed pots, to many other questions. Are we only discussing modern storytelling? Ancient storytelling? Self-conscious? Spontaneous? Interpersonal? Small group? Mass communication? Urban, suburban, or rural? Recreational? Didactic? Religious? How culturally relative are the aesthetics of storytelling? And conversely, are there any historically and culturally based aesthetics which could be considered universal? Do the same aesthetic values apply to stories told from literary traditions as to those told from oral traditions? Finally, does an aesthetic of storytelling imply an ethical code of storytelling? If so, what and how?

Discussions in workshops revealed a wild variety of denotative and connotative associations with the word *aesthetics*. The following definition best encompassed the range of issues contributors were asked to consider:

> The branch of philosophy dealing with such notions as the beautiful, the ugly, the sublime, the comic, etc., as applicable to the fine arts, with a view to establishing the meaning and validity of critical judgments concerning works of art, and the principles underlying or justifying such judgments. (From *The Random House Dictionary*, 2nd edition, unabridged, 1987)

Certainly what is considered beautiful varies tremendously, not only from person to person, but from culture to culture, and even historically within the "same" culture. Thus, we might expect to find that the aesthetics of storytelling is relative. Aesthetics in storytelling seems to be affected by the audience, the occasion, the place, the time, and of course, the stories themselves, including their origins. Surely many storytellers have experienced telling one story to an audience, and upon hearing the reaction of individual audience members, feeling that they told a different story to every person. Some may find a story beautiful, while others find it horrid. Here, perhaps, lies one of the great sources of storytelling's potency through all of

human history to the present time: it is adaptable. It has been, and still can be, used in almost any human situation, as an aid to memory, as a way to comfort, cajole, teach, entertain, empower, and inspire. Even as the sense of what is beautiful mutates, so does what is considered a successful or effective story.

In evolutionary terms, we humans have been propelled forward by an astonishing plasticity of mind. Through the extension of our minds, we operate tools we have devised with our amazing hands. The evolution of the opposable thumb on the human hand allowed us to grasp, to wield, to manipulate devices both delicately and powerfully. Perhaps stories are a mental opposable thumb, allowing humans to grasp something in their minds—to turn it around, to view it from many angles, to reshape it, and to hurl it even into the farthest reaches of the unconscious.

Anthropologist Robin Ridington proposes that stories are a spirit net, much like the first hunting nets in which humans carried their meat away from the kill. The group could have a home base, rather than always having to follow the hunters to the kill. Similarly, Ridington implies, we use stories to carry from people to people, generation to generation, our essential experiences. From the precise moment of an experience (the kill) we can carry it with us, eventually sending it down through time by way of our children.

Paleoneurologists have their own story to tell about the evolution of the human mind and the capacity for language. Harry J. Jerison posits that it was the very capacity to make pictures in our brain that compensated for our comparatively weak senses of smell, sight, touch, hearing, and taste. We were not instinctually wired with the acute sensitivities of other animals when it came to many of these senses. So how did we find our way around in the world? And how did we do it safely? Jerison suggests it was our ability to first form, then retain pictures in our minds. He further suggests that these skills, combined later with the capacity to vocalize, may account for the enormous jump in brain size in the last spurt of our evolution. "We need language more to tell stories than to direct actions. In the telling we create mental images in our listeners that might normally be produced only by the memory of events as recorded and inte-

grated by the sensory and perceptual systems of the brain." The first virtual reality.

So, what is storytelling in its broadest sense? An opposable thumb? A spirit net? A map or a blueprint? Anthropologist/folklorist Megan Biesele proposes that storytelling is the engine, the expressive heart of human communication systems in all cultures. Perhaps, ultimately, what makes a storytelling occasion aesthetically pleasing is the complete attention and respect that the storyteller pays to the story, the audience, the place, and the occasion. When a storyteller has all of these airborne simultaneously, something takes place, something that is at the heart of human communication, something so successful it has propelled us forward on this planet as the animal who tells, listens, and loves stories. Whatever our focus, storytelling is an enormously potent and plastic phenomenon. At the sites of both our labors and pleasures, storytellers have held audiences so enthralled that space and time, physical realities and inescapable existential dilemmas, have been all but forgotten.

Three stories illustrate storytelling's power and adaptability as it helps people transcend the immediate limitations of time and place.

In a dark elevator trapped between floors of a huge New York City skyscraper, after the World Trade Center bombing in 1993, a kindergarten teacher comforted her small charges by telling them stories, reciting prayers (ritual stories), and singing songs (stories with rhythm and pitch) for nearly eight hours to manage their fears and hers.

"We won't kill him; he's our storyteller," said young Khmer Rouge soldiers who were instructed to slay all the prisoners they were guarding. The man they would not kill had spent his time in captivity teaching his tormentors the nursery rhymes and simple tales of their culture they had not heard during years of indoctrination.

In 1992, in a portion of the Kalahari, a member of the Ju/'hoansi sat amid a dozen or so villagers, regaling them with a hunting tale whose antiquity is beyond measure—while a group on the other side of the village enjoyed the story of a recent hunt.

Teachers, preachers, hunters, gatherers, shepherds, farmers, warriors, pacifists, nuclear physicists, boat captains, presidents, kings, queens, grandparents, shamans, dictators, thugs—all have a story to tell. What makes a story work, then? What compels an audience, even of one, to attend to our words and believe us? Or disbelieve us? Often a child can be heard asking, "Is that true?" As we grow, we learn there are many kinds of truth, disguised and bare, fancy and plain. Sometimes, the arrangement of facts in time has nothing to do with what actually happened and yet the story is true. As a rabbi was reported to have said: If it wasn't true before the story was told, it is now! Or as a third grader said to another, commenting on the veracity of a story and the storyteller who had just told a literary tale, "She knows that story, 'cause she was there." Each story carries within it seeds that can grow within a listener. If the story works, then somehow, it is true, and perhaps even beautiful.

And what about ethics? Can we consider the aesthetics of story-telling without considering the ethics of storytelling? Historically, thievery has been the prerogative of dominant cultures. But in our complicated world, just emerging from the long shadow of coloni-alism, people are struggling with subtle and egregious forms of appropriation. If a storyteller finds a story in a collection of an indigenous people with whom he or she has no connection or knowledge, how can the storyteller treat this material responsibly? Is it to be used—as its presence in a collection suggests—as a product to be consumed? Or as the consciousness of what has been done to indigenous peoples seeps into our awareness, do we need to debate a new ethic among ourselves? What are the views, the models, that might suggest new ways of looking at the complex communication systems of other cultures? What might these new ways of looking suggest about using stories of other cultures? Some of these views suggest that stories are processes, both profane and sacred, and cannot be treated as only products. And, perhaps, therein lie many of our modern difficulties.

If the plasticity of storytelling has been one of its strengths, setting out to establish a rigid set of guidelines and rules would be antithetical to the very way storytelling brought us forward in

evolution. The question "Who says?" acted as an irritant, like the proverbial grain of sand in an oyster, and an impetus for Carol Birch. For Melissa Heckler, who was concerned with child development and cross-cultural child rearing practices, the question was, "How do you know what you know?" We began a six year dialogue. The questions each of us had sometimes intersected and sometimes paralleled one another. The spirited discussions led to more questions, not necessarily answers. We were led to a kind of experimentation in our work and a new level of critical awareness. We wanted to do the best work in our teaching and our telling. We realized that the kind of microsurgery on stories with which the professional storytelling world is replete does not necessarily produce excellence. Microsurgery, by the nature of its minute focus, doesn't encourage people to question the assumptions, large and small, in which their tellings are rooted.

In wanting to encourage platform storytellers to do the best work possible, we thought the best *we* could do was assemble many different models and points of view. We wrote letters to many people we knew, and a good many we didn't know. We cajoled a few more, pleaded with some. Our editorial process was a laborious one. We read each paper out loud–stopping to discuss, often at some length, the points raised–and restated to each other what we thought each author was trying to say. We carefully collected our thoughts, and sat down at the computer to compose letters that reflected our appreciation, understanding, confusion and suggestions. In letters to all our authors, we described our editorial process and cautioned them that if "we sound challenging, we mean to be."

But this is just a beginning. We hope that in identifying different models for discussing storytelling that we have provided all practitioners—and beneficiaries—of the art with an expanded vocabulary for articulating their own thoughts and beliefs.

In the views assembled here we trust new options can be found for increasing an individual storyteller's, as well as our profession's, creative tensile strength. To develop a language for this art is to be involved in a process of synthesizing many models into an emergent aesthetics and ethics of storytelling. ❦

Two Traditions

Melissa A. Heckler

THE FIRSTGREAT DIVIDE in contemporary storytelling is the conflicting value systems between oral and print cultures. In this first essay, Melissa Heckler traces some of the historical developments of this divide and some of the implications for modern storytelling. Her experience with the Ju/'hoansi of Namibia highlight the contrast between the two value systems and put it in a contemporary context. This is not just a conflict fought in the past but goes on hourly as indigenous cultures struggle to retain their potent, beautiful, and supple oral cultures.

Contemporary storytellers inherit their art from two traditions, the oral and the literary. Our job, our work, and our passion are rendered complicated, challenging, and confusing by this dual heritage, for the oral and the literary traditions do not have the same value systems. Some of the questions plaguing our growing profession today are the result of a confusion that comes from value systems that are not only different, but often clash with each other. If we clarify the differences between the two value systems, and determine the fundamental purposes at the heart of each tradition, we can move toward a reevaluation of contemporary storytelling.

THE JU/'HOANSI LANGUAGE is one of the Khoisan languages, which includes clicks that are treated as consonants. (Ju/'hoan is the singular form, Ju/'hoansi the plural.) The clicks are pronounced as follows:

/ *dental:* pull tongue from behind upper front teeth, as in Tsk! Tsk!

= *alveolar:* with the entire tongue flat against the roof of the mouth, remove just the tip of the tongue.

! *alveolar–palatal:* with the tip of the tongue straight up to the middle of the roof of the mouth, pull the tongue quickly away, like a cork coming out of a bottle.

// *lateral:* pull the tongue away from the cheeks as though urging a horse on.

My thanks to the late Patrick Dickens, avid horiculturalist and brilliant linguist, who devised a new orthography for Ju/'hoansi, and patiently gave me click lessons, including the above descriptions.

With fuller consciousness of what we are doing, we can begin to create and articulate a new set of values and new role models for the practice of our art. It is not only how we practice our art that is affected by this confusion, but the very definition of our roles as storytellers in a media- and entertainment-saturated age.

Literacy and the traditions it spawned honor accurate word for word repetition. The history of the development of literacy itself has much to do with the development of the values that come along with its uses. As humanity moved from hunting and gathering to animal husbandry and farming, writing developed as a way of recording the storage and subsequent distribution of goods. In *The Origins of Writing* (edited by Wayne Senner, University of Nebraska Press, 1989), scholars discuss findings indicating that writing and numeracy evolved simultaneously as a way of recording the kind and quantity of stored goods. Thus accuracy, the exact alphabetic and numerical repetition of what was stored, was a critical element in the evolution of storage systems; inaccuracy would skewer the distribution. Further, as hierarchies developed through the storage and distribution of goods, practices such as taxes and tithing evolved. Accuracy in record keeping was of growing concern as economic practices became more complicated. Initially, records were literally written, if not in stone, then in clay, making mistakes hard to change. The combination of this difficult technology and an increasingly complex economic system made alphabetic accuracy a matter of paramount importance.

One way, then, that this value system impacted the literary tradition was in the very idea of ownership. Writing and numeracy evolved partially as ways of keeping track of who owned what. Keightley suggests in *The Origins of Writing* that the only system of writing to develop concurrently with an aesthetic value in addition to simple record keeping was the Chinese alphabet—probably, he suggests, because it was based on visual images rather than sounds. To date only the Chinese and Japanese alphabets are still based on images rather than units of sound. While this aesthetic component led to the parallel development of literary art forms and record keeping, it also led to the most difficult alphabets in the world. Such

complicated alphabets created an elite class of scholars and artists who could master the complexities. Once an alphabet based on sound rather than image was developed, literacy became available to many more people because of its relative simplicity. An alphabet based on sound has far fewer symbols. As literacy increased beyond a select few, the democratic spirit often found in indigenous, preliterate cultures began to reawaken. Individually authored poetry, stories, and drama began to flourish in Western cultures. Storytellers, who are practitioners of an oral art form, need to remember that literary authorship seems to have borrowed from its very beginnings ideas of ownership and alphabetic accuracy in repetition. The writer of a story owned the story and controlled its word choices and word order.

In literary traditions there are two main story possibilities. One is the creation of a story entirely out of an imaginative or actual author. The other is the written "record" or adaptation of a traditional myth, folktale, fairy tale, or legend. As storytellers, how should we treat each of these creations? In contemporary storytelling, we frequently face a dilemma when we wish to tell an individually authored story. Some authors do not want their stories told without permission. Others want to be paid. Still other authors do not want their words changed in any way, holding the idea of individual ownership paramount. These attitudes have created a debate between authors and storytellers, and because many storytellers are authors, between storytellers and storytellers.

Several factors complicate the situation. Stories created out of the author's imagination (or life experience) are fundamentally different from stories collected from folk traditions and written down by a person who is a combination of author and editor. One can well imagine why authors who work so hard to find just the right words might want to retain artistic control over their work. Yet, any work that stays only written is unlikely to be preserved beyond the physical life of the book. Picture books, for instance, on the average, stay in print fewer than two years.

A *New York Times* article (10 October 1989), demonstrating the limitations of print, chronicles the attempt of the Washington State

Centennial Commission to bury a time capsule to be dug up in several generations. The Commission researched the most reliable means of storing a record of the capsule's burial site. They concluded that computers were too quickly outdated. Books were deemed equally unreliable when the Commission found that in a similar endeavor, copies of a book that had been put in the Library of Congress were all lost. The Washington State Centennial chose the means which seemed to show the most promise, the oral tradition. A group of ten-year-olds were told where the capsule was buried. In twenty-five years they will choose another group of ten-year-olds, and so on through time.

Several things happen in turning a book or an idea over to the oral tradition. Longevity is ensured. Story, in its most portable form, the spoken word, is carried to diverse and sometimes remote places in the country or city. Librarians do not pay the author of stories they read aloud. However, were we, as storytellers, to limit ourselves to reading aloud, we would not only lose the purposes of our profession, we would limit what we could tell/read to the books we could physically carry in a single day. Storytellers know that while they plan certain stories for specific occasions, those stories sometimes turn out to be inappropriate for the targeted audience, place, or time. The plasticity of the oral tradition allows the storyteller to be completely present to the physical and emotional needs of the moment, to respond spontaneously to the fears and delights of any audience in any time or place. Storytellers are not bound or hampered by the weight of a book, the order of words in the book, or the size and preset imagery of its pictures.

Author Natalie Babbitt was asked at a workshop at the Storytelling Center Inc., in New York City, if she objected to people telling her stories. Initially, she seemed surprised by the question. "No," she said, "I'd be honored for you to tell my stories." The audience, composed of storytellers confused by her generosity, pressed further with details of the debate raging in the storytelling world. She thought aloud with us. She said, essentially, if you don't tell my stories, then they will simply lie in the books, unread. "Whenever you tell my story there is always the possibility that someone will go

back to the book. But even if they don't, my story has been told." She laughed and added lightly, "Probably I should pay you to tell my stories."

The audience then asked, "What about changes storytellers might make in one of your stories?" She replied, "I know that telling stories is different from reading stories. You have to change certain things in any story to reach an audience. But I trust if you have been drawn to tell the story in the first place, you will not change the important essence of it. I trust you, as storytellers."

One storyteller/author suggested that the storyteller adopt the model of the playwright who gets a small royalty each time a play is performed. But, Natalie Babbitt's lighthearted suggestion that perhaps the writer should pay the teller points to a deeper issue for authors: when written stories are told, the stories themselves are being given new, and perhaps longer, life. Perhaps, like Beauty in the well-known folktale, storytellers are life-bringers to the literary tradition. They literally blow the breath of life into a story frozen into words on a page.

In addition to individually authored stories, many authors collect and rewrite stories from the folk traditions of many cultures. Often the authors are people outside the culture from which they are collecting. Some authors want to be paid by storytellers who use material from these collections, which raises many ethical questions. When you take stories from another culture, what is your responsibility to that culture? Aren't the people themselves the owners of their stories, not the collector/recorder, or any subsequent teller who obtained the stories from the collector? Yet, in this culture, we seem to value individual authorship above community authorship, particularly if that community authorship is oral and the individual authorship literary. Whether the form is a folk song or a folk tale taken from a culture, most often the collector receives the monetary benefit, not to mention the credit, rather than the original creators.

Some collectors claim the story as their own because they have made changes in the text. But if we take a story refined through a culture's oral tradition and adapt it to fit modern ears and sensibilities, doesn't the story still belong to the people who created it? We

may have borrowed it, or, if we have taken it without permission, stolen it, but adapting it does not make it ours. A value, like ownership/authorship, held by the literary tradition does not give an inherent right to plunder a culture's written or unwritten oral tradition.

Ownership is not only an issue in storytelling, which I learned first hand when I first went to Namibia to live and work with the Ju/'hoansi. *The Gods Must Be Crazy* was a film recently made by a South African film maker, supposedly about the idyllic life of the Ju/'hoansi. The film misrepresented the people's past struggles as well as their present ones. The publicity surrounding the Ju/'hoansi and the film maker was full of falsehoods about the actors and their reaction to the film making process and the payment they received (or didn't receive). The film brought unwelcome publicity and interpersonal conflict to the traditionally close-knit group. Publicity articles in newspapers, meanwhile, dwelt on the economic benefits this film brought to the Ju/'hoansi. The articles, as well as the film makers, failed to note that economic viability for the Ju/'hoansi relies directly on the harmony of community relations, which the film makers severely disrupted for a time.

After the sequel *(The Gods Must Be Crazy II)*, the Nyae Nyae Farmers' Cooperative, a representative group of Ju/'hoansi from twenty-four villages, voted against admitting another film crew into their area. I happened to be working with them just after this vote, when a new film representative showed up. Denied permission on the radio phone to enter the Nyae Nyae region, she rented a car and drove up anyway. She lay in wait for Tsamkxao, then the head of the Farmers' Cooperative, in a little town just outside of Ju/'hoan land. She begged entrance, pleaded to make just one film. When Tsamkxao refused, she reminded him of a donation she had made earlier. She then threatened to demand that it be returned to her. "You owe me this," she insisted. Tsamkxao grew silent. The Farmers' Cooperative did not have the money to reimburse her, and Tsamkxao was honor bound to uphold his people's vote on the matter. Tsamkxao, usually quite direct and articulate, did not verbally respond. I sat beside him in the truck as he drove off. Normally a careful driver, Tsamkxao

took the dusty bush roads as though he were on a race track. I felt he was angry at mistaking a contribution for the bribe it turned out to be. That film was never made.

Whether film maker or story collector, one must bring some sense of reciprocity, of honor and integrity on any work borrowed from another culture. In a litigious age when people try to spell out the details of this reciprocity in exacting legal terms, they forget one of the simplest and most universal relationships offering a clear model of behavior—friendship. Friendship is characterized by respect, affection, and mutuality. When any one of these three qualities is missing, the very foundation of the relationship's parity is reduced. We would not take the story of a friend, tell or sell it as our own, so we should not take stories from other cultures as our own. Of course we tell the stories of our friends all the time, but we do not tell them as our own. The plasticity of the oral tradition affords a teller many changes, but one would never represent a friend's wisdom, garnered through her life experiences, as your own.

Historically, there are few positive role models for what artists, anthropologists, archaelogists, economists, historians, or other students of a culture owe and give back to the culture studied. Perhaps, because our ideas of scholarship are also derived from the literary tradition and its values, we do not see some of those values for what they are: a cultural colonialism of the spirit.

This spiritual colonialism may underlie the ease with which people from European-derived cultures take from other cultures and give nothing in return, yet expect payment for individual authorship based on their work with that culture. Dr. Asa Hilliard III, an educator, proposes that education should be informed by the values, traditions, and respect of indigenous cultures found in anthropological literature. Perhaps the world of storytelling would benefit equally from exposure to indigenous cultures and from exposure to the values of oral traditions.

The oral tradition was never primarily concerned with word-for-word alphabetic and object literacy, or individual ownership. Words, images, metaphors of a told story are subject to many changes over time. While every indigenous oral tradition is different,

still a principal concern of most seems to be the use of the oral tradition as a flexible means of communication, which creates in each telling a dialogue between perceived concerns of the past, present, and future. This capacity to conserve important elements of the past while incorporating the reality of the present and dreams of the future is part of the strength of oral traditions.

In recent years anthropologists introduced to their own field the idea that communications systems within living indigenous cultures, though invisible, are extremely complex and perhaps more able to deal with life's ambiguities and human ambivalence than communication systems of the modern world. Anthropologists once considered myth and story-making less important than more easily mapped and recorded rituals and kinship ties. Anthropologists like Megan Biesele, Robin Ridington, and Mathias Guenther have used ethnographic material to support their hypotheses that myths and stories are the heart, the matrix, the engine of cultures and their communication systems. The muscular strength of these story systems lie in their use of metaphor and image. Metaphors condense meaning. Just as scientific notation condenses a mathematical equation, metaphors similarly condense literal and symbolic meanings into a potent and efficient package. Of course, metaphors play an important role in the literary tradition, too. In the oral tradition, however, metaphors are more flexibly stored as they are not connected to a value system that is slow to admit change.

Consider a story told in Namibia by /Kunta Boo, a Ju/'hoan storyteller. He was telling a story about the branding of all the different animals from a central fire. In the late afternoon of this particular day, we gathered to hear stories. Our small group sat in the sparse shade of a hut. On one side of us a small fire burned for tea and coffee.

While /Kunta was the central teller, he passed, or rather cheerfully tossed the story around, effortlessly including his wife, N!ai, and sometimes to his friend /Ashe. When Horse tried to take Eland's shiny black shoes, N!ai teasingly took the story from him—and my shoes from me—and pretended to be Horse. She stood up in my shoes and turned her foot this way and that, admiring the fit and the

color. Another time /Kunta didn't remember what happened next in the story so he and / Ashe discussed the story between them until the next animal finally came to them. When he told of Lion's marking, he said Lion's eyes glowed like flashlights.

After an hour and a half of telling /Kunta said, "I'm going to have to shorten this today. We're not even up to the birds!" Then, a little later in the story, / Ashe interrupted him to say that he remembered an incident differently. "Oh, I'm going there," replied /Kunta cheerfully, "I'm just going around by a different road."

The next day at the morning fire, I asked /Kunta what the lion's eyes had been like *before* they were like flashlights. /Kunta's eyes twinkled mischievously: "Embers," he said. /Kunta's humorous nod to the presence of his flashlight-dependent Western listeners, brought us into the story playfully, as had N!ai's shoe-snatching episode.

Later, Megan Biesele, anthropologist/folklorist, told me she had heard this story many times in her twenty years of collecting Ju/'hoan stories, and had never heard many details /Kunta told that day. In fact, she never heard the story told exactly the same way twice.

Any story which is collected from an oral tradition has to combine and/or condense in order to create one version out of many. Sometimes story collectors have been wise in their renditions, sometimes not. The literary tradition has some severe limitations, such as the need to select one version out of all the variants. As storytellers, we need to be aware we are telling *a* version, not *the* version.

An awareness of the limitations of a single version can point us in the direction of good, thorough research when we are telling stories from a culture other than our own. Gioia Timpanelli, a storyteller, scholar, author, and poet, put it succinctly when she said, "What a story is about is not in the story, but in the people who first told the story." Whenever possible, storytellers need to be responsible and check a version against other collected versions; they need to read literature by people in the culture and talk to people from the culture. Just as there are many versions of a story, there are many answers to the dilemma of adapting stories from other cultures.

Every culture has its own values and traditions which deserve respect when preparing a story for platform storytelling.

Several role models come to mind from tellers who tell outside their own tradition. In the late 1970s, Diane Wolkstein, author, scholar, and storyteller, began researching the Sumerian epic *Inanna*. The Sumerian culture, of course, is extinct. The goal of her meticulous research, including word by word, line by line translation with the late Sumerian scholar Samuel Noah Kramer, was to tell a story rooted in its traditions, yet accessible to modern listeners. For several years she took sections of the text and read or told them to small audiences. She listened carefully to what confused people, what moved them, awed them and seemed clear to them. She then reworked the text, each time checking back with Kramer to make sure that the text's integrity had not been violated. She has given the world the gift of an ancient story that resonates beautifully with the present and authentically with the past.

Rebecca Chamberlain is another role model. Rebecca, a storyteller from the Northwest Coast of Washington, has been apprenticed to Vi Hilbert, a Salish Elder. Rebecca learned both the language and the stories of the Salish people. After many years of study and practice, she was given permission to tell these stories. Her acquired knowledge of the Salish community values, combined with her knowledge of the language, grounded her story translations in the principles, dreams, confusions, and conflicts of their original tellers.

An essential aspect in Rebecca's relationship to these stories is that she grew up on the same land that gave birth to the Salish stories. In some basic way, especially with the folklore of an indigenous people, the stories are both a home and a map of the landscape and the way humans have learned to live in relationship to that land. The land can teach and speak to a person today as it did hundreds and thousands of years ago. A person like Rebecca, shaped by the same land of the stories, is able to bring an additional strength and sensitivity to her telling.

The final model offered here is from my own research and work. In 1981 I began researching the stories of the /Xam Bushmen of

South Africa. My first exposure to the Bushman stories was through the writings of Laurence van der Post. His descriptions, like "this little man," seemed condescending and patronizing. The phrase "stone age hunter" deprived the Bushmen of their contemporaneity. "Primitive spirit" belied their psychological complexity. His voice overwhelmed their stories, robbing these tales of their true voices by attempting to use them as illustrations of some primitive, less-evolved antecedent to Christianity.

The source material to which I then turned was *Specimens of Bushman Folklore*, by Wilhellm Bleek and Lucy Lloyd (London: George Allen, 1911) and *Mantis and His Friends*, also by Bleek and Lloyd (Cape Town: Maskew Miller, 1923). These could have given me enough work for lifetime. Still, they did not answer some frustrating questions. How did the Bushmen tell these stories? When did they tell them? Who was their audience? What did the stories mean to them? What was the landscape of the stories? What was the weight and balance of humor and seriousness? What treasures were hidden in the metaphors?

Finally, one day in Vermont I found Marjorie Shostak's book, Nisa: The Life and Words of a !Kung Woman. Two things happened. First, I found an address of a foundation where I could donate part of the small amount I earned telling Bushman stories to a group of existing Bushmen, the Ju/'hoansi of Namibia. Secondly, I was given the names of two people to contact who worked with the Ju/'hoansi, Claire Ritchie, a documentary film maker and Megan Biesele, an anthropologist/folklorist. I began a long correspondence with Megan Biesele. Eight years later, I joined her in Namibia, where I used my educational skills to help develop in-village schools in the Nyae Nyae region. And I finally had the opportunity to be a student of Bushman storytelling.

It was quickly apparent to my twentieth century perspective what had been left out of a nineteenth century Victorian collection. Sex and scatological references were either deleted by the collectors, or by the storytellers themselves, who were sensitive to their collector's sex and/or morals. Mathias Guenther gave this example in a paper presented at the first Bleek/Lloyd Conference, in September

of 1991. He pointed to one phrase footnoted as "meaning not known at this time." In the story it turned out that /Kaggen, the trickster, was calling out a familiar phrase "our name is Penis! The man has done it." Given that Lucy Lloyd collected this version, Guenther concluded that the male storyteller simply refrained from giving a translation out of polite deference to Lucy Lloyd.

As I lived, worked, and played with the Ju/'hoansi over an extended period of time, the Bleek stories told by the /Xam Bushmen of South Africa became resonant with day-to-day experiences. Written texts could not provide sense memories on which I could draw. In 1991, I was fortunate to travel in South Africa with Janette Deacon, an archaeologist. She painstakingly pieced together evidence from the written texts with the actual landscape and found the original homes of the /Xam storytellers, //Kabbo, /Han=ass'o, and Dia!kwain.

The desert which the /Xam storytellers came from was remarkably different from the desert of the Ju/'hoansi. The northwestern Kalahari of the Ju/'hoansi seems a paradisical oasis compared to the harsh, dry, and—from a distance—almost colorless terrain of the /Xam storytellers. Closing in on the distances, however, one sees a sparse beauty in delicate flowers blooming at the base of massive black dolerite boulders. On the shiny black surfaces of these boulders, animals were etched long ago by /Xam artists. Elands, elephants, springbok pose alone, gather in seemingly numberless herds over the rock faces, or perform dances of magical transformation and power with the /Xam shamans who, in all probability, were the creators of these etchings.

"My place," //Kabbo told the Bleeks, "is the Bitterpits." From the boulder-strewn brinkkops near the Bitterpits, where //Kabbo sent his children when he "felt the sprinkbok sensation" (i.e., that he sensed that the sprinkbok were coming), one can see a huge round plate of land stretching in all directions to meet the horizon edge of the the bowl of sky. Before white people came, the land breathed mile upon mile of springbok. Today fences divide the land that for the /Xam were marked by boulders, waterholes, saltpans and brinkkops. The springbok no longer dance there. Still the improbable

bursts of color freely volunteer themselves everywhere—in tufts of grasses the color of pale yellow fire, in aloe plants bursting into deep orange-red flame flowers. This is the land from which the /Xam storytellers were taken as prisoners, south to Capetown. There, far from their homes, they labored in the Breakwater Prison, quarrying out rock for white colonists. Deacon writes that one /Xam prisoner was asked why he stole the sheep when he surely knew what his fate would be. Since the prisoner's hunting grounds and water holes had been stolen from him and his people by the colonists, the question of a "stolen" sheep was a moot point. The /Xam prisoner's answer was, "It's a fight with death, either way."

Their land stolen, their women, children, and old people starving, their own physical limits taxed by the back-breaking labor of rock quarrying, it is surprising that these prisoners had any energy—or heart—left to tell their stories to even as sympathetic an audience as Wilhelm Bleek, Lucy Lloyd, and—many years later—Wilhelm's daughter, Dorothea Bleek. A description of the land, which helped give birth to these stories, cannot be found in the written texts. Neither Wilhelm Bleek or Lucy Lloyd visited their storytellers' homes. Dorothea Bleek visited many years later, but her book, *Mantis and His Friends*, has no portrait of the land. None of the collectors ever saw or heard a story told in a cultural or physical setting natural to the stories.

For my development as a storyteller, I needed to flesh out the stories by embarking on a journey to a people who live similarly to the /Xam, and back to the land itself, the birthplace of the /Xam and their stories. This model worked for me and for the stories I was attempting to tell.

I could not tell these stories without giving something back to the people from whom the stories came. What the Ju/'hoansi wanted from me was my help in creating schools. This exchange acknowledged our willingness to engage in a meaningful relationship with one another. A relationship involves responsibility and a healthy respect for the other as equal. This sense of responsibility, in addition to the affection, respect, and knowledge of Ju/'hoan and /Xam traditions guides me in the choices I make in telling, shaping, and

changing any story I tell. / Kunta gave me permission to tell Ju/'hoan stories. He did so with a generosity characteristic of his people, who in their traditional gift-giving practices seem to acknowledge that one way to keep something is to give it away.

In each of these examples, the storyteller becomes a bridge, a conduit. Diane Wolkstein is not Sumerian, nor Rebecca Chamberlain a member of the Salish Nation. I am not a Ju/'hoan. We cannot speak as if we were members of the culture. The narrators of the stories we tell must remain ourselves, members of a contemporary American culture who have chosen to be visitors, and even friends, to another culture. What we can speak of is our understanding of the culture, of our relationship to that culture. We can not presume to speak as experts of the culture, only experts of our relationship to that culture. In doing so, we may build bridges from one culture to another that may allow us and our audience that imaginative experience of looking at the world from a different perspective.

These three models—Diane, Rebecca, and myself—are starting points offered for more discussion among ourselves. To find solutions to the problems in professional storytelling, perhaps we need to examine and share information about as many cultures as possible. Studying stories and storytelling traditions involves us in a process that can inform what we do and help shape how we do it.

All three of us are working within literary and oral traditions. Both traditions inform our role as storytellers. Yet, an outraged folklorist criticized an article of my storytelling experiences with the Ju/'hoansi by writing, "She's taken a point from the story and applied it to herself!" Exactly. I had. The job of the storyteller is fundamentally different from the job of folklorist, scholar, or researcher who may try to keep a clinical or academic detachment from her or his work. It is precisely the storyteller's work to explore a story and make a personal relationship with it. This isn't entirely an intellectual quest, but also a quest for an emotionally meaningful relationship with a story so we can tell it with conviction. A folktale, of any culture, in some essential way, must happen to us as much as any personal story we tell.

In the literary tradition, authors may write about any subject they choose, freely drawing upon the riches of the world's cultures. The success or failure of their work is dependent on the internal consistency of the work. Does it feel like the author is telling the metaphorical truth about the people, places, and times of the story or not? Failure to convince readers does not result in the author being labeled fraudulent, but simply a writer who needs to rework her fictions into more convincing work.

However, this is not simply a confusion about what we do with texts, but a confusion about the storyteller's role in modern culture. From whom have we learned our art and what are we doing with what we have learned? Few of us are fortunate enough to have been taught our roles by indigenous storytellers. Some of us have found role models in other cultures, but compared to indigenous storytellers exposed from infancy, rather late in life.

The literary tradition has spawned artists, poets, dramatists, novelists, and short story writers. They create the works we tell if we draw our material from literary tales. Questions about permission and ownership have already been raised. To clarify issues about the role of the modern platform storyteller, we need to ask questions about the purposes of storytelling.

Literary tradition was originally hinged to historical record keeping, and only later to spiritual record keeping. Oral traditions originated and maintained themselves as spiritual and technological record keeping systems. Storytellers in preliterate societies, such as the Ju/'hoansi, until recently, performed a variety of spiritual tasks as well as reminding people of important landmarks, hunting techniques, animal behavior and all varieties of human behavior—and misbehavior. Education of the young and entertainment were and are a part, but by no means all, of a traditional storyteller's function.

Today education and entertainment are the two primary needs platform storytellers are called upon to fill. We tell stories at schools, libraries, and daycare centers. Too often, it seems, as one storyteller put it, "It's between the clown, the pony, and me!" via the birthday party circuit. There are other circuits, too—the December holiday circuit, storytelling festivals, or theaters. These are valid, often ful-

filling roles. Yet, many storytellers feel there is more to storytelling than this.

The additional roles open to storytellers in preliterate societies range from maintaining the psychological health and well-being of individuals and the community, to being historians, philosophers, and spiritual guides. Storytellers in these communities give voice to people's illnesses, fears, hatreds, concerns, misapprehensions, loves, joys, beliefs, confusions, and nightmares. In the mirror of the story community members can see and evaluate their own behavior and its possible consequences.

The experience of a modern storyteller after a performance gives an example of the difference in the role of storyteller in the modern tradition and the storyteller in an indigenous tradition. Certainly one important function of a storyteller is his or her role in reconfirming both the individual and the community at the same time. Individuality is seen within its matrix of community. Stories tell us we are all different, unique, and yet bound together in similar needs for love, support, and recognition, which we receive only in proportion to our relatedness to others in the human community.

When /Kunta Boo finished telling a story, people would continue to talk around the fire, perhaps offer another story, or go their separate ways ... sometimes only a distance of twenty feet. One memorable day, /Kunta told stories all afternoon, led an all night healing dance, and after a couple hours of sleep, stepped into the freezing morning air and said cheerfully, "Oh, I'm dead." However, when he saw that his good friend Megan had beat him to making the morning fire, he chased her back to bed saying he wanted to be the one to make his friends their morning coffee. /Kunta's modern counterpart in our culture, after reconfirming the community of humanity, often retires to the nearest hotel room, a stranger to those in the next room, with as storyteller Gerald Fierst put it, "only the stale smell of the previous occupant's cigarettes for company." Forget making coffee for anyone.

Being responsible to individuals in large audiences is another challenge for the contemporary storyteller. Many stories we choose to tell may touch deep places in audience members. People often feel

the desire to respond to the teller on a more intimate level. That is not a possibility with fifty to a thousand virtual strangers. And it is certainly not possible in the way it would be for /Kunta, who has lived with fifty family and extended family members day in and day out his entire life. Even to those people not directly known to him, he is likely to feel some sense of kinship, and hence community. Perhaps he is related by name, or through a distant relative. If not, then the deep sense of relatedness to Ju/'hoan land and culture is always available to him to forge a personal relationship. He is, literally, a stranger nowhere in nearly fifty villages of Nyae Nyae. "Ju n/e'e," the Ju/'hoansi say, "we are one."

Do we raise, then, expectations we cannot fulfill? While we, the tellers, go off to our solitary hotel rooms, do we leave members of our audience unfulfilled because they cannot relate to us more personally? In opening minds, hearts, and souls through story, perhaps we then open people to deeper relatedness amongst themselves. Still, the storyteller leaves the audience, often going home alone and unrelated. While this situation should not keep us from traveling with our stories in the tradition of ancient bards, it does point to some of the pitfalls of the modern storyteller. We come as strangers, and in the larger sense, strangers we remain.

Storytellers' perceptions of other storytellers is another source of discomfort within the modern storytelling world. Those who tell myths and sacred stories from the world's traditions sometimes do not accept those who tell homespun stories from their own families and lives. And, in direct contradiction, those who choose to tell outside their traditions are told to go home and tell stories from their own culture. One older woman said rather plaintively to me when she heard I told Bushman stories, "Doesn't anyone tell from their own culture anymore?" Yes and no. Most of us in the United States, storyteller or not, come from one or more ethnic backgrounds. And not all of us feel related to the cultures or the stories of our ethnic heritage. Our profession might benefit in many ways if we could collectively and individually develop tolerance and support for the choices other storytellers make in their selection of material. There are all kinds of stories, and all kinds of places and times to tell stories.

In the end, we most effectively tell stories to which we feel related, whether they come from our biological heritage or from spiritual relatives. Even if we are not Irish or Scottish we may wish to tell Selkie stories. Even if we are not of African descent we may wish to tell Anansi stories. Or Bushman stories.

A similar paradox exists with advice given to aspiring writers. "Write what you know best," says one author. Yet another author says, "I find that my best writing comes from what I don't know about." Perhaps one thing we can learn from the oral tradition is a tolerance for seemingly contradictory points of view. There is no one right answer on the way to approach writing or storytelling. Author or storyteller, one has to keep trying different ways. The development of a unique personal voice in either profession usually comes from long years of practice—of imitating others, contradicting others, and exercising the freedom from negative judgment to make plenty of mistakes. It is important for storytellers to give and receive support, whatever the source of our material. The true criterion is, perhaps, whether the relationship we make with the material gives the stories we tell that unmistakable ring of truth.

In this world, there is a need for all kinds of stories: from great myths to homespun tales told as the fire dies down to a small crackle in our hut, our cabin, our apartment, our long house, our castle, our hovel, our split level modern. Our stories are our home. In the end it is the thing that cannot be taken from us. Perhaps what inspired //Kabbo, his son-in-law =Han/hass'o, and Dia!kwain to tell their stories in the strange land where they had been taken as prisoners was the need to recreate for themselves that sense of home. Survivors forced to flee their homes in times of disaster with only the clothes on their backs keep their stories, their invisible baggage inside them. In the terrible institutions hierarchies have created—slavery, reservations, concentration camps, apartheid—people fought and died to hold their stories.

There are many issues, then, to contemplate and discuss from our two traditions. Historically, the oral and literary traditions have had a conflicting set of purposes and values. In resolving the conflicts, we need to ask many questions. Among them: how do we

honor the traditions and cultures from which we take our material? What, if any, are the benefits to authors or cultures when a storyteller uses his material, written or oral? Should we pay authors to tell their stories? Should we pay cultures from which we have taken material?

While monetary payment is one way to honor an author or a tradition, is it the only way? In some fundamental way, we honor each story, each author, each culture, in the retelling of the story. As oral traditions remind us over and over, people or cultures are not dead until their story is no longer told. And of course, we honor by citing sources of our material. Finally, very few of us in this evolving role of storyteller are paid enough money to live on, which makes issues of financial reimbursement even more complex—and brings us back to the confusing modern role of storyteller.

Other professions derived from the arts and the psychological and spiritual needs of people are now paying professions, some of them high paying, indeed. Like the priests, mental health workers, painters, novelists, and poets who came before us, storytellers are now in transition to a professional status. How we set acceptable standards is a challenge that will help us define our roles anew.

As we articulate values, purposes, and standards, perhaps it is fitting to look back and remember the magnificence, the generosity, the true spirit of oral traditions: they preserve and expand our humanity. Long before the printed word existed, stories flexibly preserved for us the many ways people lived in the constant challenge of changing landscapes and changing mindscapes. Every story contains a blueprint for at least one way human beings have figured out how to live in a particular ecological or psychological niche. From these blueprints we, like the /Xam, can fashion messages to send into a future *we* will never know. Our stories will tell the world we, too, have been here and that we spoke.

The Icebergs of Folktale
Misconception, Misuse, Abuse
Barre Toelken

ONE OF THE REASONS *for writing this book was to challenge easy answers, assumptions, and cultural biases bandied about as people talk about stories and storytelling. Barre Toelken avoids these pitfalls as he maps out new ways through cross-cultural territories. This paper embodies the struggle of a scholarly mind to bring parity to his relationship with the people whose folklore he studies. His paper is the very best of thoughtful academic writing with the human heart engaged. It is enlightening to witness his willingness to pursue relationships which have caused him to question the very tenets of his own Euro-centric academic scholarship. He acknowledges powers beyond the linear processes of the mind in this essay. In sharing his willingness to be taught over a thirty-five year career as a folklorist, he gives a unique perspective.*

Over the years we have heard scholars and storytellers alike claim: "There really are five, ten … one thousand story patterns in the world." This paper alerts us to the numbing effect of believing that all stories can fit into a finite number of types, patterns, or motifs any culturally bound mind recognizes. It asks us to grapple with the ways we might be blind, deaf, and dumb, or as Toelken puts it, intellectually rough with material that comes from fundamentally different cultures. His paper under-

scores what we hope people will take away as one of the most vital points of the book: there are no answers that fit across the board in stories or storytelling; there may only be models with which to think.

We would further suggest that this inability to acknowledge radically different visions of the world enabled the forces of dominant cultures to make the two following assertions about the stories of "other" people. "That doesn't make sense," is one, relegating the story to the primitive, quaint, exotic, or childish. "I've heard that story before," is the second remark. It often means a seemingly recognizable piece of the story has been inserted into a pattern with which the listener is familiar. Either remark can obliterate, obscure, or desecrate whatever intrinsic cultural meaning there was. The impulses of fear, denial, and ignorance are the greatest divides between human beings; they keep us from standing in another's shoes. These same impulses have all too often lead to the genocide, subjugation, or dismissal of a people and their folklore.

*M*isconceptions about folktales, including what they are and how they operate, abound in our contentedly literate society; the result is that audiences often miss the richness and complexity of much that they hear and read, and storytellers often unwittingly tell the wrong story to the wrong people (sometimes with the wistful hope of "reviving" an "almost lost" "tradition" of storytelling that might never have been there). Even the official newsletter of the National Storytelling Association (NSA), *Yarnspinner*, recently ran a lead article about tall tales "told" about certain American heroes— which might easily lead the unsuspecting reader to assume that these heroes are (or have been) indeed the subjects of stories passed along in oral tradition.[1] Listed among the heroes, however, are mostly characters whose stories were never shaped by the cultural processes of oral tradition, but were developed originally with the pens and typewriters of talented professional writers and later taken up by a couple of generations of professional storytellers and authors of children's books.[2]

Paul Bunyan comes chiefly from the writings of W.B. Laughhead, James McGillivray, and especially James Stevens, whose avowed mission in life was to champion the image of the independent (i.e. non-unionized) worker. The few Bunyan stories collected from loggers themselves are not only rare as chicken lips, but are—as one might expect—more spicy than anything we will ever see in the fifth grade curriculum. Joe Magarac, authored by Owen Francis, first appeared not in the break-time narratives of Hungarian steelworkers, but in the pages of *Scribner's*. Pecos Bill similarly was born not in the cow camps but in *Century* magazine, in articles written by Edward O'Reilly. Febold Feboldson was dreamed up and published by lawyer Paul Beath. Even the nation's favorite "noble toiler," Johnny Appleseed, carries an image polished mostly by the popular press, not by oral tradition. In his case, there *are* many stories in oral circulation: they testify to his odd dress, his proclivity for yelling frontier sermons at people who didn't want any, his strange notions that you could plant apple trees with seeds (apple trees which actually bear apples are usually grown from grafts), and his antisocial way of casting weed seeds into the fields of those he disliked (as well as his own seed into their daughters). The stories really *told* about noble Johnny are not very likely to show up in schoolbooks, obviously. Casey Jones and John Henry do indeed come to us from oral traditions in song and story, but in both cases the "adult" dimensions of their active lives have been effectively removed by the antiseptic choices of writers whose audiences are not those for whom and among whom the stories developed.

And this is really the crux of the matter and the central issue of this essay: folktales, that is, narratives which come to us primarily through the oral traditions of those who actually tell them to each other in familiar, everyday circumstances, are stories whose meanings grow out of and reflect the values of the group in which they are told. Folktales are not "better" or "older" or "more genuine" than other stories; their primary characteristic is simply that they are formed and polished by those who tell them among themselves over time. Ghost stories told by teenagers at sleepover parties, jokes told by loggers in their favorite bar, legends of strange-but-true occur-

rences reported by a friend of a friend,[3] accounts of absent-minded professors by students and of mind-absent students by professors— these are a few of the traditional forms of narrative constantly being "performed" by people to others in their own familiar group. When such a story is taken out of the group and "retold" on a stage or to the rest of us who may not be members of that group, most of the richness of meaning—and even the reason for telling the story to begin with—usually falls away.

The stories about Paul Bunyan, Johnny Appleseed, and all that literary crew are not, on the other hand, poor stories in and of themselves, for any good story has its own meaning and momentum, no matter what its origins are. The difference is that most of these stories are not normally *told* in the traditional sense of being passed along orally from one narrator to another; rather, they are usually read, or read to someone, or memorized and "retold" for an audience of coincidental listeners who may show up in a class, a library, or an auditorium. It's therefore not fair to say that these stories somehow embody the ongoing oral traditions of American culture, or that they give *voice* to what is "respected, admired, and valued" in our society.[4] They obviously do reflect the idealized buying and talking tastes of the American public, or else we would not purchase these stories for our schools or read them to our children. So while they are indeed important, they are important for their ideas, not for their ability to convey naturally the values which close friends have been sharing with each other for years in their own conversations.

Undoubtedly, we would all benefit from knowing more about which stories are folktales, and about what their significance might be for us—especially since there is no indication that storytelling is dying out or fading before the supposed erosive forces of literacy and public education. Of course, television might be a real danger, because it inhibits people talking to each other altogether, but I hear no fewer jokes and legends going around than I did twenty years ago, and shuttle-disaster jokes—admittedly not narrative, but nonetheless lively interactive oral sets of dialogue—spread across the country within minutes of our shared viewing of the shocking Challenger explosion, probably *because* of television. But, supposing

one is interested in hearing more about folktales, whom can we ask? And what are the questions? Let's start with a few of the most common misperceptions about folktales, then discuss a small assortment of tales as they might be addressed by a folklorist (someone whose job it is to take seriously the expressive aspects of everyday life), and see if we can at least get some perspective on why it even matters to pay closer attention to the folktale.

One very widespread notion about folktales is that one complete version of a story—especially if it comes from an "authentic" collection of traditional materials—can stand as representative of the tale's meaning. Enough has been written about the ways in which the Grimms and collectors like Perrault rewrote, cleaned up, and reconstructed the stories they collected that I need not go into the matter here. But suppose we are interested in a story reliably collected with tape recorder and dutifully transcribed word for word without modification by even the most dedicated of folklorists or anthropologists; why is one text not enough to tell us what the *meaning* of the story is? After all, a single text, if complete, is certainly meaningful enough to have its own narrative coherence and thus to engage the interests of an audience, so what's the problem? There is no problem, as long as one remembers that a single version of a story—say, a version of Tale Type 510, "Cinderella and Cap o' Rushes"—is *only one* possible articulation of an ongoing cluster of possibilities. When it gets printed, it becomes a kind of fossil, because it no longer is susceptible to change, while the versions still in oral circulation change all the time, usually with each telling.

Thus, it is not surprising to find out that in England alone, there are numerous ways of telling the 510 story, each with its own logic, each with a different title (when titles are used), each contributing to an overall meaning but with no version being "the one and only" or "original" text.[5] Indeed, the reason we use a number like 510 to refer to this story is precisely that the titles are seldom alike, although the storylines may have strong family resemblances; Katharine M. Briggs lists sixteen English versions of this story, with titles ranging from "Ashpitel," "The Broken Pitcher," and "The Little Cinder Girl," to "Mossycoat," "The Red Calf," and "Finger Lock."[6] If we want to

get a sense of what this story has meant over the years to those who have continued to tell it, we would want to get access to all the printed "fossils" we could find, plus all the versions we could still locate circulating orally among living storytellers. By noting which traits and motifs have been prominent and which ones have dropped out, by noticing which motifs seem to be favored in certain regions or at certain times in history, we might come up with a feeling for what various communities at various times have done with the story. Then we might *start* to know what the story might have meant to those who have told it, noticing even then that the tellers have apparently not always had the same thing in mind when telling the story. Clearly *the* meaning is hard to pin down, then, especially when we learn that Tale Type 510 is found just about worldwide (see Aarne-Thompson, 175-79 for basic details); some versions focus on the stepsisters, some on the mother, some on the slipper, some on the father who wants to marry his daughter.

"The Animals in Night Quarters," Type 130, is known to most Americans as "The Bremen City Musicians," since most of us have heard or read a translation of the German version presented as #27 in the Grimm collection, and this has led many to assume that the story is originally a German one. But in fact it has extremely wide currency, being found in Turkey, China, Japan, and Yugoslavia, as well as in most of Europe and the Americas. In all versions of this story, as well as in the closely related Type 210, the animals go traveling together, usually find a house, and then by conquering the inhabitants they take over the place and settle in. In one English version given by Katharine Briggs, the animals are all male (bull, rooster, gander, ram); they go forth from home to seek their fortune; they ask for lodging, then they help defend the house from robbers by using their unique characteristics.[7] In the version offered by the Grimms, outcast animals, no longer suitable to their farms, leave home to avoid being put to death; they go to the local big city to become musicians (i.e., to change their occupations); they scare robbers out of a house by singing in their unique ways (and later by attacking the robbers who try to sneak back in).

On one level, we see these as two very similar ways to tell the same story; on another level, looking at the cultural motifs, we see the English version dramatizing proper English virtues like males leaving home to seek their fortunes, the achievement of their success hinging in part on their readiness to cooperate, offer help, and defend "home and castle" (shades of Tolkien!). The German version, on the other hand, focuses on quite another set of considerations right out of north German history: during several waves of population shifts beginning (probably) with the plague years, farm laborers leaving the tough and precarious agricultural life moved into decimated Bremen and changed their occupations in order to survive. They naturally took up dwelling in houses previously inhabited. Because Bremen has been since ancient times a center of commerce (it was a Hanseatic city-state), it is no surprise to see the inhabitants (import/export businessmen?) depicted as robbers counting their money. In both these scenarios—neither of them a matter of utter certainty—essentially the same story line expresses and touches off cultural values that are quite distinctly linked to local history and custom. In none of the versions available to me, moreover, is there even a hint that the story is told simply to entertain children with the foolish antics of animals or to explain how animals came to be the way they are; in other words, while the story may well be entertaining to children (and others) when it is well told, it seems to last through time because of its ability to crystallize meaningful sets of cultural assumptions recognizable to *everyone* in the culture—though not so stated in any overt way. What's the meaning of the "Animals in Night Quarters," then? It all depends on who's telling it, and where, and to whom.

But so what about all this? Does it really matter after all that a story can have numerous meanings? Not at all, as long as we are ready and willing to deal with the delights of variety, ambiguity, suggestion, nuance, and culturally centered elements of meaning. All too often, however, a folktale is used by a professional storyteller, author, or therapist as if it were a single articulation of some network of meaning shared by all mankind. Joseph Campbell's "monomyth" theories come to mind as one example: a myth story is presented as

if the narrative dramatized a universal meaning, or else all stories of
a particular sort (like those about heroes) are presented as if they
were all fragments of a single puzzle. Joseph Campbell's *The Hero
with a Thousand Faces* (New York: Bollingen Foundation, 1949) is
probably his best known opus on the subject of universality in
mythic narrative. Based on early Jungian theories on the nature of
"archetypes," Campbell's works tried to demonstrate that many
recurrent themes and plots were part of the human psychological
inheritance and were therefore susceptible to cross-cultural interpre-
tation. The problem is, of course, that irrespective of the universality
of archetypal images, different cultures organize and interpret (and
thus understand) the symbols quite differently. Campbell could
construct a monomyth of the hero, therefore, only by citing those
stories which fit his proposed mold, and leaving out equally valid
stories which did not fit the pattern.

Recently, this monocular notion has been pushed to monoma-
niacal dimensions by Robert Bly, in his study of Grimm #136, *Iron
Jack* [Eisenhans],[8] the less-common title of a tale usually known as
"Goldener" (The Golden One) in German. In the Aarne-Thompson
index it appears as Type 314, *The Youth Transformed to a Horse*, one
of the most widespread of all stories in Northern, Eastern, and
Southern Europe.[9]

There are three subtypes of this story, each of which seems to
flourish in a particular region. Subtype 1, found mainly in the
European countries, tells of a youth who—having been promised to
a demon, wild man, or magician—is forced to put in a term of service
caring for animals. The demon-master interdicts entry into a room,
or touching an object, or coming in contact with a spring of water;
following standard folktale logic, the youth breaks the interdiction,
obtains the use of a magic horse, and sometimes gets himself totally
or partially gilded. The youth and his magical horse flee the magi-
cian. The young man then hides himself by working as gardener for
a king and is noticed by the princess; in disguise he fights for the
king but is eventually discovered and is forced, persuaded, or
allowed to marry the princess. In some cases, his liaison with the
princess is initially rejected by the king, who makes the couple live

in a pigsty. Eventually the horse is disenchanted (often by decapitation) and turns into a handsome prince. This story is found fragmentally in North and South America, but *only* in the motif of the friendly and helpful horse.

Subtype 3, found in Greece, Turkey, Caucasus, Uzbekistan, and Northeast India, describes the youth as product of miraculous conception (his mother has eaten a magical fruit); a magician tries to kill him, but instead he kills the magician, finds rooms full of corpses (by breaking the interdiction against entering), obtains a magical golden hair, then flees and hides as a gardener whose story develops along the lines of subtype 1.

Subtype 2, considered by scholars to consist of the oldest, most coherent versions, is found in Southern Siberia, Iran, the Arabian countries, the Mediterranean area (including Sicily), Hungary, and Poland. It tells of the young son of a local ruler. The boy befriends a horse because they were both conceived through the gift of a magical fruit and both are born on the same day. The mother (who is involved in a love affair) wants to kill the boy and the horse in order to obtain a magical medicine (or to keep them from exposing her affair). The horse warns the boy, who asks his mother if he might take one last ride; once he's on the horse, both fly away. The boy hides as a servant (often gardener) of a neighboring king and visits his horse daily. The princess sees his golden hair, he fights for the king in wars (in disguise), gets magical medicine for the king, saves the princess from a dragon, is eventually discovered (often by employment of golden apples), and the young couple marry. The horse is beheaded and changes into a prince or princess.

The German version of this complex story—the one on which Robert Bly bases his discussion of male psychological development—fits into subtype 1 (that is, it's not particularly typical of the issues developed by the full range of the story possibilities). It is also a version *not* found in England and the United States, which makes for a slim argument indeed if one wants to claim that the story nonetheless dramatizes a monumental, archetypal sequence of psychological passages "we men" universally go through.

But "Eisenhans" does dramatize a number of important themes which come up elsewhere in German literature and folklore: the boy manages to escape the delicate situation of a mother who is having a sexual affair (the Grimms cleaned up their published version a good deal); he is able to escape his father's elite domination and replace it with the powerful influences of the wild man (society vs. nature). Although he's "golden," his success is mainly due to the powers of *Iron* Jack, and indeed this realization makes us want to know more about what gold and iron mean in German folklore. Will it surprise anyone to learn that iron was considered a powerful antidote against witches, supernaturals, sorcery, and bad luck? That finding old iron, especially if it's rusty, is lucky, and that the iron itself can be used for its healing power? That iron underwater is a witch and devil repellent? And that gold is also a healing substance, prevents the evil eye, protects children from witches and magicians? That having golden hair is seen as lucky?

There is no doubt that this is a rich and meaningful story. There is similarly no doubt that different cultural areas have rearranged and focused and intensified different aspects of the story to suit their own, not universal, demands. Bly is not at fault for choosing a wonderful story, but he is in error, I believe, to promote the idea that a single, rather idiosyncratic version represents male development generally, or that a story not normally told in America can somehow be seen as a cameo of the deep-seated assumptions and feelings of Americans. Not that Americans couldn't or wouldn't respond to this story: but a better question might be "what stories *are* the members of any group [men or women or children] telling which are or have been so current that they give us a view of their deeply shared processes, concerns, anxieties, or values?" Questions such as this bring us around again to the central issue of culture-based meaning, for it relates to the common misconception that if we have a full text and a good translation—even though we have only one version— then we have *the* story.

Well, we certainly may have *a* story, and it may surely be a powerful one; but without knowledge of the cultural context from which it comes (and here I mean something deeper than "here is a

story from Europe"), we may easily misunderstand it, miss the point, or perhaps even enjoy it for reasons which have less to do with the story than with our own personal and cultural preconceptions.

In St. Louis a few years ago, I was presenting a workshop at the National Storytelling Conference and I used a Navajo story as an example of how meaning may *attach* to a text or be touched off by it, but not be explicitly *in* the story. The story, to retell it briefly, tells of four men, the first three of whom say they can't remember the dream they had last night. The fourth one says, "Last night I dreamed I was hatching four birds' eggs, but three of them weren't mine; only one was mine." Together with workshop participants, I discussed some possible meanings for this brief story, which—when told in Navajo—is considered extremely funny. Since the fourth man is referred to in Navajo by a word that suggests he's older than the others, one possibility brought up was that the man had four children to raise, only one of which he had sired himself. Interpreting the eggs figuratively in our terms, then, we could infer that the man's wife had had other romantic company and he had been left with the embarrassing results. But since Navajo women own their children and can have children by anyone they choose (since they are a matriarchal, matrilineal culture), this isn't the best possibility for meaning— although when I checked this interpretation with some Navajo friends, they replied that, well, yes, that might be *part* of the meaning.

Someone in the workshop suggested that since eggs are symbols of fruitfulness, potentiality, life, new developments as yet undisclosed, they might represent the dreams themselves; the older man has had to dream for all four, since the others didn't remember theirs. This one doesn't ring a bell for my Navajo friends at all, though I think it is a clever insight into the manifest details provided by the story text itself. What kinds of considerations come up in Navajos' minds when this story is told? I have spent about thirty years asking about this one, and here is a partial list:

Navajos usually don't talk about dreams, so the very articulation of the story puts it into a category not unlike our sexual jokes—not exactly taboo, but potentially uncomfortable because of the way the

topic ruptures daily convention. The first three "dreamers" are then acting normal when they say *hola*, "I don't know," because this would be the normal, acceptable way of avoiding mention of an uncomfortable subject. When the older man openly tells his dream, though, his description of it not only triggers laughter because he has mentioned that which is seldom discussed, but this reference to eggs makes possible a long list of inconsistencies in nature: a male doing what a female would normally do (hatching the young), an older person doing what a younger person would normally do (*having* young), a human doing what a bird should do, a heavy object sitting on a light, fragile object. Discrepancies in nature are "funny" to Navajos for the same reason that discrepancies in race, politics, sex, or religion are "funny" to typical Euro-Americans: the discrepancy itself dramatizes a set of concerns or anxieties about a sensitive subject. The most sensitive subject to Navajos is the maintenance or restoration of health—the ideal condition of which is expressed in terms of harmony, balance, reciprocity, integration; images of natural discrepancy and imbalance, especially when uttered in a joking narrative like this, in which the properties of normal conversation are interrupted, can suggest psychological disaster.

Then why would the Navajos tell a joke like this at all? In the Navajo way of telling this story, the verb for "hatching eggs," or "sitting on birds' eggs," makes it clear that the "sitter" was a bird, for one realizes with a split second of thought that the verb is not the one which would be used for a person. This in turn means that the old man has really dreamed he was a *bird* sitting on eggs, a perfectly normal image and thus not productive of anxiety. The Navajos laugh (I now think) because the story is loaded with potential anxieties which are resolved as soon as one realizes that the turn of the phrase is central. The dreamer thinks he was dreaming something dangerous, but we see that he doesn't understand his own dream yet, and we laugh at his dullness. Even having said all that, I do not imagine the people reading this essay are now doubled up with laughter at this demonstration of Navajo wit. Moreover, I do not suppose that even after thirty years of working with this short story I have reached a full sense of its meaning, since I have only this one version. Every

time I have tried to get a Navajo friend to tell it again, I've been told, "Oh, you already know that one!" As a folklorist, I have to allow for the great possibility that other versions of the same story would tell me something about its meaning and function that I cannot derive from one.

Just the same, as a folklorist interested in narratives, I often *must* cope with the fact that one text is all I have available. It is here where the cultural information surrounding the tale becomes extremely critical. For example, there is the magnificent story told by Charles Cultee to Franz Boas in 1890; at that time, Cultee was one of the last three people who spoke the Kathlamet Chinook language, and not long after the story was manually recorded, the living language was gone. Reworked into modern English by Dell Hymes, the "Sun Myth" of Charles Cultee stands as a stunning testimony to the richness of Northwest mythic narrative.[10] But what does it mean? It features an impatient chief who goes forth into the world to visit the sun; once in the sun's house, he is surrounded by all the riches the Northwest mind could imagine, yet he eventually gets homesick and returns to his people, destroying each of the five villages (and all their inhabitants) of which he was once chief. At the end of the story we see him totally alone, building a small house.

If we use Joseph Campbell's idea of the hero monomyth, we will be more than a little confused to find our apparent hero in this story leaving home and achieving everything—according to our expectations—then losing it all and destroying his own world and family instead of supplying their needs—at the end. In Chinook culture, however, the chief was not supposed to leave home on private errands, but rather remain in his village as the medium through whom goods were redistributed. Moreover, for the Chinooks—as for many Northwestern cultures—it was not the acquisition of goods but one's self-impoverishment in giving them away that brought high cultural esteem. Another hint about meaning lies in the Chinook custom of naming myths after the real central character: in this case, the Sun, the woman who does indeed supply goods to others and nurtures them, and who in this story is shown properly preparing her young granddaughter for a traditional entry into the social

structure. In the Sun's Myth, it is in fact the women who act—or try to act—according to cultural norms; it is an erratic, selfish male who threatens the world's stability. Thus, the story is not about a hero's valiant actions to gain the prize, but a dramatized account of personal and cultural disaster brought about by selfishness. The "meaning" of the story is close to an equation: the selfish pursuit of personal gain by someone who is supposed to be leader, by someone who ignores all good advice from people who know how to act properly, leads directly to cultural destruction and isolation. Clearly, this story is a tragedy brimming full of culture-based irony, and represents a distinctly different organization of human meaning than that assumed by the "universal school."

Many Native American stories end with the phrase, "and that's how the bear got a short tail," or "even today, the coyote's eyes are still yellow," or "because of that the rabbit got long ears," and so on. These stories, often labeled *etiological* tales because they apparently explain how something came about, are found abundantly in children's books, where they help to establish the concept that Native Americans are rather simple-minded observers of nature despite their long tenure on the land and their dependence on nature for survival. Now, it may well be that some young Native Americans have heard and understood only what the story says rather than what it means, just as many young Euro-American children think in their earlier years that the "Three Pigs" story is about pigs. As Native Americans grow up in their cultural surroundings, however, they begin to hear other comments, stories, songs, and rituals that provide the ethical and philosophical contexts for stories. They begin to realize that these alterations in animal appearance always follow upon some moral decision or unconsidered action on the part of the animal. These are always actions which make sense in terms of human values, not bear/coyote/rabbit behavior.

Mistakes in judgment can lead to big changes in the world, according to Native views in most tribes; we watch the stories to find a dramatization of those moral decisions which are most central to our continued existence. We watch the animal world to see daily physical reminders of the moral issues we face. For example, in a

Lummi story about five sisters who eat huckleberries in the woods instead of bringing them home to share with their families (most Native tribes proscribe the eating of gathered or hunted food until it is brought home and properly distributed), we are told they were turned into birds: "That's where the birds came from." The cultural point is not a feeble attempt to explain the origin of our winged relatives, but rather to say in effect, "Whenever you hear the birds' wings beating [as the girls had beaten the berry stems and leaves out of their baskets to make room for more] and see the birds flying past us bringing berries home to their young, you are reminded of your obligations to nature and to family."

N. Scott Momaday, in his classic book of Kiowa stories, *The Way to Rainy Mountain*, recounts the story of a brother who starts chasing his sisters with increasing aggressiveness and ferocity (we may safely presume that this was not considered ideal behavior) until he starts to grow hair, long teeth, and claws. The girls take refuge on a stump which rescues them by growing up into the sky, while the brother—now a bear—scores the trunk all around with his claws. Momaday comments, "From that moment, and so long as the legend lives, the Kiowas have kinsmen in the night sky."[11] His Kiowa kinfolk might add a few cultural "footnotes" here: the six sisters have become the stars of the Big Dipper, and—like all good relatives—they help the Kiowa in many ways, including as navigational aids on the Kiowa migration from the western mountains out onto the Great Plains by indicating the North Star, and in more recent times by helping to set the beginning and ending times for ritual events. The "fossilized" tree trunk, now called Devil's Tower, is still visible in northeastern Wyoming, so we could say that the Kiowas have retained a dramatic account of the geographical markers of their journey. As well, the Kiowas have kinsmen on earth among the bears, even though they no longer live in "bear country." Tales such as this function far more powerfully to situate a people in its cultural, spiritual, natural, and geographical contexts than they do to provide puffy "explanations" of where the Big Dipper came from.

I do not believe it takes an anthropologist to ferret out perspectives like these, for they are not hidden. There are numerous

books about Native American stories and storytelling, some of them very recent and written by outstanding critics and scholars, both Native and non-Native; and as I've suggested above, the unending stream of commentary and argument about themes and meanings and functions in Euro-American folklore stretches from the 1950s through the present without letup. There's so much of this contextual material available, in fact, that one begins to wonder how anyone could avoid it. Admittedly, there is not as much commentary available on Asian materials, unless one can read Japanese or Chinese (ever since the pioneering work of Yanagita Kunio in the 1920s, there has been a tremendous flow of interpretive works on Japanese folktale and legend, but very little of it is translated).[12] For this reason, however, there is a great possibility we may know a Japanese story through its translation in a children's book—for especially since World War II Japanese tales have been popular here—and feel we know it pretty well because of its common appearance, even though we may not have a whisper of a notion of how the story has been understood in Japan.

An excellent example of this is provided by the popular tale of Momotaro the Peach Boy. Because practically every older Japanese and Japanese American knows this story, it is easy to assume that its currency shows it to be a valid and ongoing dramatization of Japanese cultural values, and so it may be—for reasons not immediately apparent to the non-Japanese audience. During the years leading up to World War II, "Momotaro" was one of the dozen or so tales consciously utilized by Japanese educational authorities in school textbooks to develop a sense of pan-Japanese nationalism. Most Japanese folktales are quite regional, but the attempt in the late 1930s was to produce school children whose regional, linguistic, and dialectal differences had been leveled out. Tales were chosen especially for their capacity to represent all-Japanese virtues, Shinto mythology (much of it reconstructed by government experts), and assumptions about the purity of Japanese culture—assumptions which included the description of other cultures as comprised of "devils."

In the story of Momotaro, an elderly couple discover a peach floating down the river. When they open it, they find a young boy

inside. They nurture him and start to raise him, and when still quite young, he takes a lunch of millet dumplings and goes off into the world (eventually being joined by a dog, a monkey, and a pheasant) to attack the devils on Devils' Island. He conquers the devils, brings their treasures home to his "grandfather and grandmother," and they live together happily. This apparently child-like adventure, somewhat reminiscent of the Bremen City Musicians (in that the animals help Momotaro fight by using their particular animal talents), became the basis for a propaganda program since referred to as the "Momotaro-Paradigm."[13] In most of the films, articles, cartoons, and children's books of the war years, little Momotaro appears more often than any other character in the role of the patriotic hero. In his exploits, he comes to represent the ideals of Japanese heroism, courage, and dedication to country and family: although he's small, he succeeds in overcoming an apparently superior enemy made up of devils. He even appears in films like "Momotaro—Divine Troops of the Ocean," in which the enemy devils stammer, whine, and howl in English. Thus, Momotaro is so widely known by Japanese people of the previous generation principally because he was ubiquitous in their education and in "popular" media orchestrated by their government, not because his simple folktale had circulated so widely in oral tradition.[14]

Does this mean that no one should tell the tale anymore because of its racist or warlike implications? Probably not, but it does mean that if we tell it or print it in a "retelling" that sanitizes it to politically correct status, we will have also participated in the manipulation of its *meaning*, and on terms which do not grow out of the cultural values which nurtured the story itself. While we might view this kind of positive meddling as enlightened, because it "frees" the story of any politically ulterior motives (for us, at least), it is meddling nonetheless; in other cases, such manipulation can lead easily to downright expropriation of cultural materials and abuse of their meanings, and this is especially evident in the way Native American stories materials have been reused in the United States by both storytellers and academics.

A number of professional storytellers, because they cannot fairly represent other cultures' meanings or contexts in a strange environment, have ceased performing Native American stories; there are others who have never started doing it. Some, like Kay Stone, work strictly within the limitations set by their Native oral informants. Academics, because they fancy they *do* appreciate context and meaning, seem to have no hesitation to tell, retell, summarize, or assign American Indian stories to their audiences without any regard to tribal practice or belief.

A couple of years ago at the American Folklore Society Annual Meeting I gave a paper in which I detailed why I no longer felt I could discuss Navajo coyote stories in depth; a singer—a medicine man—told me that either I or a member of my family would pay for it with our lives. I was moved by how many colleagues agreed with my decision; I was offended by how many told me it was anti-intellectual to quit and that it was my duty to the folklore profession to go as deep into the field as I could and share the results; I was surprised by how many in both of these camps soon began inviting me to their campuses to talk about Navajo stories some more. I am a bit embarrassed to be writing about the subject today. And I know that within a month I will receive at least one telephone call saying, "We understand that you're an expert on the Navajos, and we wonder if you'd come and tell some Indian stories to our sixth-grade class when we do our one-week unit on folklore." I say all this to admit openly that any accusations I make here are to be understood as including me among the guilty. To be equally frank, "the guilty" also include many of my academic colleagues; strangely enough, while professional storytellers have generally been willing to understand the dilemma more fully, academics have resisted the subject because of its apparently romantic and non-objective implications. Because the issue is far from comfortably settled, and because many tellers—including academics—utilize Native American materials without regard for the inevitable complications, I would like to comment further on some of the practices which call into question our platitudes on the use of stories as catalysts for "intercultural understanding."

The following are my impressions of some of the most typical abuses we find when Native American stories are performed by non-Native storytellers (or even well-meaning Native storytellers) out of their cultural contexts, even when "recontexted" by the teller's commentary:

- The story is presented as a children's story, with the implication that it represents children's (or child-like) logic. This approach makes coyote stories into quaint animal tales; Coyote is a rascal who needs a good spanking. Such a presentation can trivialize a complex and evocative story because cultural context, which provides the matrix for moral response, is missing.

- The story is like a crystal pendant: in a hushed voice, the narrator reverently "shares" the secret wisdom of the ages. Coyote becomes a spiritual guru. In the background: the tinkling of glass chimes and the sipping of herbal tea.

- The story is a universal archetypal experience for all humanity (overlooking distinctive and significant differences in cultural worldview, gender, religious belief, humor, and entertainment!).

- The story becomes a histrionic exercise for an earnest performer: in fringed costume, beads, and feathers, the storyteller looms out over audiences of cowed children with flapping arms and eyes bugged out, yelling to imagined characters in the distance (if you told a story in this fashion inside a Navajo hogan, your audience would die of a heart attack).

- The story is an academic example, illustrating, as only the Natives themselves can (but in English translation, of course) important elements of structure, style, nuance, worldview, text, performance, language, metaphor, and so on (this is *my* usual method of abuse).

From a Navajo perspective, a story is an embodiment of reality, a creative act in the fullest sense, an evocation of the processes of life, a living drama. For the Navajo, *language creates reality*, not the reverse. A story therefore is not an *example* of anything, nor is it a chance for a performer to shine, nor does it very often *explain*

anything. Rather, in its articulation in cultural context it *is* or be-comes something. The problem for us is, of course, that we are not very well prepared to perceive what it *is*, so we have a tendency to interpret it in our own way, or at least to use our own intellectual resources in an attempt to fit the story into what we think is its cultural matrix. It's not a *stupid* effort, but it's rather like—not knowing about internal combustion—defining cars by the color of their paint and the direction of their movement. To carry the meta-phor further, from a Navajo viewpoint we are likely to be run over by our story.

The difficulty and delicacy of understanding even the most apparently simple Native narratives can be seen all too readily in the history of my own bungling attempts to work with Navajo stories. In the 1950s, I lived with a Navajo family; in the 1960s, I began taking a folkloristic look at the stories they told. In "The Pretty Languages of Yellowman," I tried to show how the stories embodied worldview in a very complex way that was not registered so much in manifest content as much as in performance styles and texture and inferable through audience responses.[15] By the 1970s, I saw I had to do a better job of translation, and produced, with the help of a Navajo friend, an updated phrase-by-phrase translation of the same story (about coyote making rain, killing prairie dogs, trying to cheat Skunk out of the meat, and finally not getting much for his efforts).[16] In the retranslation, I found I had been wrong in the earlier piece about some important matters of meaning and performance, and tried to correct them in a published essay. Then, in the 1980s I discovered, by way of an earnest warning from a medicine man, that my whole thirty-year flirtation with Navajo stories was getting dangerous; I gave a report of the matter at an American Folklore Society meeting, published an expanded version of it ("Life and Death in the Navajo Coyote Tales"[17]), and hoped that interested persons were following the increasing complexity of the matter and were thus adjusting their own uses of Navajo stories—at least the ones they may have gotten from me. But most of my academic colleagues are still having their students read the *first* article—without the later corrections and without the subsequent warnings about usage (this puts them in the

same ostrich-like position that they in turn often attribute to library storytellers who are believed to resist learning something about the living cultures they wish to represent in their stories). Recently, when folklorists Bruce Jackson and Sandy Ives asked me to write an essay about some striking fieldwork epiphany, I chose this one— partly because it had taken nearly thirty-five years before I had understood it (perhaps the world's slowest epiphany, I'll admit).[18]

In spite of the self-indulgence of this long litany, I wanted to bring it up here in hopes that the matter would at least come to the attention of people involved intimately with storytelling, for I think it is they who will best appreciate its human as well as its professional dimensions. A few years ago, Yellowman, my Navajo brother-in-law, and source of most of my Navajo stories, began having trouble with his legs. One needs to know not only that Navajo language and culture focus primarily on movement—on "going"— as the central aspect of reality, but that well into his seventies, Yellowman could still run after a deer all day until it was exhausted. He began to seek out the singers who could help him with his ailment, which he considered an attack by a *yenaaldloshi*—that is, a Navajo witch, but he had a heart attack coming out of the sweat lodge and died.

At about the same time, his family (including his brothers and their families) began to experience a run of misfortunes ranging from family animosities to car accidents, a drowning, a murder, a suicide, and a couple of rockfalls. In order to mitigate the imbalances caused by, and causing, these disasters, his family members have under- taken a series of healing rituals; in fact, I am also expected to be the patient in some Beautyway ceremonies, since I am the only family "member" who has all the stories now.

My earlier resolve to more or less pull back from active involve- ment in Navajo stories has turned out to be impossible: since I *have* these stories—on tape as well as in my mind—I am willy-nilly involved with powers which must be ritualized or else the family and I can be badly affected by mental and physical imbalance. I mention all this not in the dreamy expectation that every person interested in Navajo stories will follow the trail of cultural

perspective as far as I have been lucky to do, but rather to illustrate that dealing with Navajo stories is not just idyllic child's play. People who "simply" use Navajo stories, or the stories of *any* other culture, for entertainment and self-edification run the risk of dancing blithely through someone else's garden of delicacies.

Folklorists have proclaimed a special obligation to the collection and study of vernacular expression, to giving credence and lending nurturance to the voices of those who are seldom heard from in the elite histories. We have developed systems of study and analysis, insisted on contextual considerations, fostered codes of ethics. We have within our profession the tools for doing and understanding; but we seldom have considered the wisdom of *not* doing as a *way* of understanding. Yet I am certain that both professional and academic storytellers (is there finally a difference, I wonder?) will not abandon their interest in telling and analyzing Native stories.

So, realistically, I can only pass on the avuncular observation that telling Native stories for non-Natives out of context may be dangerous to our mental health: for we know there will always be a discrepancy between what the story *is*—as a living articulation—and what you and I think it *means* as an example of something-or-other. That very discrepancy, that lack of "fit" between reality and meaning, between inner and outer forms, as the Navajos might express it, is a real disjuncture. To the Navajo such misalignments produce the mental instabilities which in turn cause us to make poor decisions, use bad judgment, and endanger ourselves and our families by egotistical or competitive behavior.

If we actually seek to know something of Navajo and other Native worldviews, and if we actually wish to foster *respect* for the people whose stories we use, we must really begin to recognize the delicacy, perhaps the impossibility, of using outer shells of stories whose inner life does not belong to us. At the very least, we need to handle *any* Native stories like the delicate treasures they are, not like children's toys.

Should we then quit talking about them or ignore them? I don't see how we can. But we can adopt the very simple method used by Ethelou Yazzie in *Navajo History Part I:* when we get to sensitive

material, we can say, "If you want to know more about what this story means, ask your grandparents." Those with the right grandparents will know where to turn next, while the rest of us—perhaps with some selfish disappointment—can be content at least in knowing that there are still a few things we have not brought under our sterile control, and that the processes of tradition are still alive and well in the mouths and ears of those to whom they rightfully belong.

Admittedly, storytelling has changed vastly in function and meaning through the years. Stories which once dramatized the inescapable differences between cultures now can be used in a multicultural setting as timeless constellations of accumulated human wisdom available to us all—and potentially helpful to us all as we try to find our way through the confusing alternatives of life. Stories so common as to be thought mundane and trivial may now function as the last significant vestiges of cultural meaning for those groups who have been battered almost out of existence by the processes of invasion, colonialism, slavery, and universal education. Stories which were once told in the privacy of homes or only among the members of a particular gender or age group are now utilized by teachers, librarians, and therapists as generalized examples of the way human thought, experience, and emotion can be dramatized in narrative form. Is this to be regretted, and if so, can it be prevented? Certainly not; but the phenomena of stories and storytelling—precisely because they have remained significant—require us to pay attention to some important considerations. Moreover, since "intercultural understanding" is often the stated by-product of our retelling of other peoples' cultural goods, we need to be consistent and get serious about the cultural "rules" and conventions which give deeper meaning to these stories in their normal, traditional, home contexts.

To begin with, the intellectual roughness with which we willfully expropriate the culturally centered stories of others to our own uses—no matter how virtuous—must be replaced with a sense of human responsibility for the depth and richness of contextualized narratives. That is, the fullest possible appreciation of the story in its cultural setting should be more important to us than the practical

(and dare I say "selfish"?) concern for extending our "ethnic" repertoire. If there are tribal restrictions about storytelling, we need to find out about them and honor them, for if we are indeed dedicated to intercultural understanding, then *not* telling a story out of season is just as important as telling a story in season. Many Native American tribes believe, for example, that tales about Coyote, Raven, and Iktomi should be told only in winter, and yet the signs of winter's beginning and ending are different in each tribe. We thus have to find a way of getting beyond the text and into the culture if we want to avoid the arrogant misuse of narratives which are thought by many to be so powerful that they can affect the weather and have an impact on human sanity. This in turn means considerable research *and* conversation with Native people who know the traditions; the usual story collections for children—as well as the Cigar-Store Indians who tour professionally—are seldom adequate to this task. This also means that for the stories of peoples not native to America, our job becomes even more exhaustive and more complex, for the information we need will not be easy to find.

Related to these concerns is the recognition that most stories circulating in oral tradition have been told by generations of adults to generations of audiences made up of adults and children. I think we can take it as axiomatic, then, that these stories are not just for children, but that they represent a continual refinement of cultural values important to all ages and genders. Just as "Iron John" is not a bedtime story for little boys, so the Navajo coyote stories are not humorous children's fodder about how the coyote got yellow eyes. Acknowledging the depth and cultural complexity of traditional stories is an important step toward the larger vision that stories are far more than quaint entertainments for the "child in us all." Moreover, most traditional stories are not full of data or information; rather, they dramatize and make manifest and palpable cultural ideas which otherwise remain unarticulated. Rather than *telling* us something, they touch off our recognition of features and values which are assumed and self-evident in our cultures. Ignoring the cultural assumptions and focusing only on a text is simply not taking the story—or its cultural origins—seriously.

Obviously, then, one basic concern of any storyteller interested in retelling the stories of other cultures is the scarcity of reliable texts and translations that provide cultural settings and discussions of the possible ranges of meaning (note: this is not the equivalent to "Where do I find the 'right' answer?"). Fortunately, in recent years there have been many folklorists, anthropologists, and literary theorists who have taken up the question of cultural meanings; and there is a whole field of ethnic literature in which better texts and more thorough scrutiny of "cultural codes" have been central concerns.

There is no longer an excuse for not knowing about such matters. In the case of Native American materials (the area in which I work most regularly), I can recommend the following books, each of which provides notes, bibliographies, and references to still other reliable works: Nora Marks Dauenhauer and Richard Dauenhauer, *Haa Shuka, Our Ancestors: Tlingit Oral Narrative* (Seattle: U. Washington Press, 1987), and *Haa Tuwunaagu Yis, For Our Healing Spirit: Tlingit Oratory* (Seattle: U. Washington Press, 1990); Dell Hymes, *"In vain I tried to tell you": Essays in Native American Ethnopoetics* (Philadelphia: U. Pennsylvania Press, 1981); Melville Jacobs, *The Content and Style of an Oral Literature: Clackamas Chinook Myths and Tales* (Chicago: U. Chicago Press, 1959); Karl Kroeber, ed., *Traditional Literatures of the American Indian: Texts and Interpretations* (Lincoln: U. Nebraska Press, 1981); Jarold Ramsey, *Coyote was Going There: Indian Literature of the Oregon Country* (Seattle: U. Washington Press, 1977), and *Reading the Fire: Essays in the Traditional Indian Literatures of the Far West* (Lincoln: U. Nebraska Press, 1983); Brian Swann, ed., *Smoothing the Ground: Essays on Native American Oral Literature* (Berkeley: U. California Press, 1983); Brian Swann and Arnold Krupat, eds., *Recovering the Word: Essays on Native American Literature* (Berkeley: U. California Press, 1987).

In addition to these informative works, anyone interested in obtaining accurate translations of Native American stories should get—and use—Brian Swann's *Coming to Light: Contemporary Translations of the Native Literatures of North America* (New York: Random House, 1994). This collection, produced for the general

reader, brings together more than fifty Native stories translated by today's leading scholars (many of them Native people themselves). Unfortunately, these stories are not provided with extensive cultural notes and contextual detail, but they are excellent, clear translations, and are not designed as kiddie literature.

Finally, beyond these basic matters of respect—acknowledgement of cultural depth, use of reliable translations, and serious consideration of cultural contexts—there is another philosophical issue to deal with: why do we really want to tell others' traditional stories anyway? If indeed it is to demonstrate the narrative workings of the human mind and heart, if indeed it is to sponsor understanding and intercultural perspective, if indeed it is to provide dramatic experience in the richness of cultural treasures, then the tasks of research and reflection suggested in this essay will not be a high price to pay, nor will they be seen as pointless obligations to political correctness. And if we do in fact tell the traditional narratives of others for these reasons, we will certainly want to be sure that we know as much as we possibly can about meaning and worldview in the cultures from which these valued stories come.

But these are virtues easier to claim than to practice, because even the pious use of other people's cultural treasures can involve us—however unintentionally—in exploitation (I make a tidy honorarium for retelling slave stories from your great-grandma), entitlement ("let me share with you a story which *I* learned from *my* friends the Navajos, a story which you would never have had a chance to hear otherwise; take it from *me*, when the Navajos tell this story, they mean …"), cultural arrogance ("long ago, before the advent of science, primitive people believed the animals could speak"), blatant misrepresentation of cultural detail ("back when all the Native people worshiped the Great Spirit, a Navajo boy named Little Eagle left his father's family and …"). Beyond that, it constitutes scholarly or performative colonialism when a non-Navajo professor is touted as an expert on Navajo stories and people come to him instead of the Navajos for perspective, or a part-Mohawk storyteller sells tapes of "traditional, authentically told" stories from the Cherokee, Abenaki, Ojibwa, and Navajo, and is invited to appear as a traditional story-

teller at major festivals. You will recognize in some of these examples an acknowledgement of my own vulnerabilities in this field; the others you will already have heard or seen in one form or another in conversation or on the storytelling "stage." But these are built-in issues whenever we deal with *any* expressions from other cultures: languages, religions, worldviews, written literatures, music, arts, dances, behaviors. We cannot sidestep them and plead ignorance of their importance by simply reciting the platitudes of intercultural love, intergalactic archetypes and the power-of-a-story-to-heal-all-wounds-and-bridge-all-chasms.

But who has the right to monitor this bothersome mess of issues, problems, and behaviors? Who has the right to control what stories get told, to decide who gets to tell them, and to delineate how they are to reach performance? At the conclusion of this intolerably long outburst, am I going to propose a UNESCO Commission on the Proprieties for Expropriation of Cultural Treasures, or a plainclothes Folklore Police? Sorry, my suggestion is less dramatic and more basic: if we really want to show reverence and respect for traditional stories we must unavoidably have reverence and respect for the cultures from which they come. This means, in turn, that our rage to tell and retell must be balanced by—even overreached by—our responsibility to listen, study, and learn. Stories will not be silenced because people will not be silenced; but we can dedicate ourselves to the proposition that good stories deserve and demand the fullest, richest, most careful and informed articulation we can give them.

NOTES

1. Judith Rosenfeld, "Believe it or Not," *Yarnspinner* 17:2 (March 1993), 1-3.

2. For a standard, well-known discussion of these created heroes, see Richard M. Dorson, *American Folklore* (Chicago: University of Chicago Press, 1959), 199-243.

3. The many books of Jan H. Brunvand on the subject of the urban legend provide eloquent testimony to the vitality of contemporary "believable" narratives: *The Vanishing Hitchhiker: American Urban Legends and their Meanings* (1981), *The Choking Doberman and Other "New" Urban Legends*

(1984), *The Mexican Pet* (1986), all published by Norton and joined regularly by new arrivals based on Brunvand's ongoing research. Similar books have appeared in other languages as well, indicating that the dynamism in modern legendry is in no way limited to the United States. See Rolf Wilhelm Brednich, *Die Spinne in der Yucca-Palme: Sagenhafte Geschichten von Heute* (Munich: C.H. Beck Verlag, 1990), and *Die Maus im Jumbo Jet: Neue Sagenhafte Geschichten von Heute* (Munich: C.H. Beck Verlag, 1991).

4. Rosenfeld's claim in "Believe it or Not," cited above.

5. The basic reference work in the comparison and study of European folktales is Antti Aarne and Stith Thompson, eds., *The Types of the Folktale: A Classification and Bibliography*, Folklore Fellows Communications No. 184 (Helsinki: Finnish Academy of Sciences, 1964). Although it is now somewhat dated, it provides a basic gathering of folktale variants into family groups identified by numbering the most identifiable recurrent plot structures (since tales in oral tradition do not always have titles, and since the titles which do exist vary wildly).

6. Katharine M. Briggs, *A Dictionary of British Folk-Tales in the English Language, Part A (Folk Narratives)*, I (London: Routledge and Kegan Paul, 1970).

7. Briggs, I, 174.

8. Robert Bly, *Iron John* (New York: Vintage Books, 1990).

9. Tale Type 314 is discussed on pp. 108-10 in Aarne-Thompson, cited above. There is also a lengthy treatment of it in *Enzyklopädie des Märchens* (Berlin and New York: Walter de Gruyter, 1987), V, 1372-83.

10. The story text and Hymes's illuminating introductory essay appear in "Folklore's Nature and the Sun's Myth," *Journal of American Folklore*, 88:350 (October-December 1975), 345-69. It is an absolute classic of Northwest coast mythic narrative.

11. N. Scott Momaday, *The Way to Rainy Mountain* (Albuquerque: University of New Mexico Press, 1969); reprinted by Ballantine Books, 1970.

12. Nonetheless, a few good basic works on Asian folktales are available, including Wolfram Eberhard, *Folktales of China* (Chicago: University of Chicago Press, 1965), and Keigo Seki, *Folktales of Japan* (Chicago: University of Chicago Press, 1963).

13. The "Momotaro-Paradigm" and its historical context are fully discussed by John Dower in *War Without Mercy: Race and Power in the Pacific War* (New York: Pantheon Books, 1986), especially 252-59.

14. The Momotaro story in its various permutations is discussed in Klaus Antoni, "Momotaro (The Peach Boy) and the Spirit of Japan: Concerning the Function of a Fairy Tale in Japanese Nationalism of the Early Showa Age," *Asian Folklore Studies*, 50 (1991), 155-88. The same story, as

encountered by an American exchange teacher in Japan, is treated in Bruce S. Feiler, *Learning to Bow: Inside the Heart of Japan* (New York: Ticknor and Fields, 1991), 136-41.

15. "The 'Pretty Languages' of Yellowman: Genre, Mode, and Texture in Navajo Coyote Narratives," *Genre*, 2:3 (September 1969), 211-35.

16. "Poetic Retranslation and the 'Pretty Languages' of Yellowman," with Tacheeni Scott, in Karl Kroeber, ed., *Traditional Literatures of the American Indian* (Lincoln: University of Nebraska Press, 1981), 65-116.

17. "Life and Death in the Navajo Coyote Tales," in Arnold Krupat and Brian Swann, eds., *Recovering the Word: Essays on Native American Literature* (Berkeley: University of California Press, 1987), 388-401.

18. The proposed title for this essay is "From Entertainment to Realization in Navajo Fieldwork"; the collection of essays is to be published by the University of Illinois Press.

Jewish Models
Adapting Folktales for Telling Aloud

Peninnah Schram

PENINNAH SCHRAM REMINDS US *the dialogue between the oral and literary traditions has a long and honored history in Jewish cultures. This dialogue is the basic form in which religion, history, and world view have been recorded and passed down through generations. Further, as Peninnah notes in her opening, the Jewish people have long been considered a storytelling people by others as well as themselves. It seems natural, then, to consider models of Jewish scholarship and folklore for ways of preserving the orality of a spoken tale.*

In From Where We Stand, *Deborah Tall notes:*

> *Historically the physical life of Jews in diaspora, in ghettos, was cramped and oppressive, often literally cut off from the cultures that surrounded and ruled them ... Cultural identity had to be internalized, kept abstract, free of attachment to its physical setting. Yiddish is said to be the only folk language in the world that has no base in nature—its vocabulary is bereft of plants and animals, almost the entire natural world ... For Jews, holy places were not crucial because their single God was a spirit who could be worshiped anywhere. "Anywhere" meant that the where of one's life faded in significance. Identity depended on human community and common belief, not on a shared location. (105-106)*

It is instructive to see how similar pressures brought to bear on peoples result in such different responses, as noted in Peninnah Schram's and Barre Toelken's essays. Toelken notes that though Navajo territory has been considerably reduced in size and altered in two hundred years of displacement, the Navajo culture still maintains a primal relationship to the land that gave birth and still feeds its folklore. In contrast, in the Jewish tradition, where displacement has gone on for thousands of years, folklore centers not on the land but on the human community.

We were also struck by some of the similarities on the primacy of the spoken word in Schram's analysis of the Jewish tradition and Toelken's point of view about Navajo culture. Schram writes, "... words are viewed as equivalent to deeds or actions. Words are treated with great respect, and even an alphabet letter or part of a letter can be powerful." Toelken writes, "From a Navajo perspective, a story is an embodiment of reality, a creative act in the fullest sense, an evocation of the processes or life, a living drama. For the Navajo, language creates reality, not the reverse."

Over the centuries, Jewish people refused to trust their culture to paper alone. The Torah, the Talmud, and folk stories are truly "learned by heart," and never "out of place." Without the specificity of the forests of Europe, or the steppes of Russia, Jewish stories are at home equally in the deserts of the Middle East or the lower East side of New York City. Their landscape is the human heart—with the particular humor, wisdom, and trail of tears of the Jewish race.

*H*istorically, folktales had been transmitted orally from generation to generation. As a storytelling people, Jews traditionally have understood the importance of story. Stories were used to teach a child a value and a custom, to discuss points of Talmud through *aggada*, which are stories and maxims that deal with the spirit of the Oral Law rather than its letter, or simply to entertain. While on a journey or while plucking goosefeathers, Jews have been

telling stories in the oral tradition from the beginning of their history. Stories, after all, are effective ways to teach religion, values, traditions and customs, to introduce characters and places, to instill hope and resourceful thinking. Stories plant long-lasting seeds and connections for the future, teaching us how to live and how to die, how to be a *mentsh,* and above all, what legacies to pass on to future generations.

Then there came a time for the oral commentaries and the intertwined stories to be written down. That written record, the Talmud, is the focus of this essay. However, in order to use the Jewish model for adapting folktales for telling aloud, one needs to know the history of orality in the Jewish tradition.

Biblically, the world was created with the spoken word. The Torah *(Torah Shebikh'tav),* or Written Law, was given at Mount Sinai along with the Oral Law *(Torah Shebe'al Peh).* Rabbis say that the Oral Law is certainly as important, and some say more important, than the Written Law; it explains the written word. The Torah, called the *Chumash* in Hebrew and also referred to by the Greek term, *Pentateuch,* refers to the first Five Books of Moses. To be accurate, the complete Hebrew Bible, called the *Tanakh* in Hebrew, actually comprises thirty-nine books, beginning with Genesis and continuing through Chronicles. The Torah comprises the entire literary and legal tradition of the Jews.[1] "Torah" can be used synonymously with "Judaism."

Because the Torah is, in a manner of speaking, written in shorthand, Jews have needed to fill in the spaces between the words. Rabbi Avi Weiss, in a recent talk, spoke of the Torah as being composed of "black fire on white fire." This is his description: "The Midrash tells us the Torah is black fire on top of white fire. The black fire are the written letters of the Torah. The white fire are the spaces on which the letters rest. The black letters represent the cognitive message and the white space, that which goes beyond the cognitive idea. The black letters are limited; the white spaces catapult us into the realm of the endless, the limitless; it's the story, the song, and the silence." The image of fire is fluid and dynamic. So, too, is Torah.

Discussion, debate, argument, inquiry, and interpretation, all interactive oral activities, have taken place for all these centuries, and are essential to the study of Torah. This traditional type of study continues to be done in a group setting, often with a dialogic partner.

Since learning Torah is a process that continually involves wrestling with ideas, events, and meaning, the explanations of Torah and its applications of law were taught orally to generations of students by their rabbis. These explications, questions, and discussion became known as the Oral Law or Oral Torah. The teacher/scholars, called *Tannaim* (Aramaic for "repeater"), transmitted these teachings orally. Often referred to as "living books," these *Tannaim*, living in the first two centuries C.E., during the Talmudic period, served as an important link between the periods of the oral and the written texts. Written texts of the oral law had been interdicted up to that time.[2]

By the early Second Century C.E., Rabbi Akiva is credited as first beginning the codification of rabbinic teaching. By the turn of the Third Century C.E., Rabbi Yehuda HaNasi completed editing and collecting all the written and unwritten portions from the various schools, countries, and rabbinic authorities.[3] These teachings comprised the Mishna.

Over succeeding generations, groups of rabbis gathered to study these sacred texts, the Torah and Mishna, and teach them orally, in the same manner as in the years before. These interpreters and Jewish scholars, known as *Amoraim* (Aramaic for "spokesmen"), communicated lessons of the rabbis to the students, especially in the Land of Israel and Babylonia in the third to sixth centuries after the conclusion of the Mishna. From their clarifications of passages and disputes over other meanings and interpretations, there evolved a second text, the *Gemara* (Aramaic for "study"). Together the Mishna and *Gemara* make up the Talmud. The Talmud is comprised of *halakha* (the normative laws and codes of behavior) and *aggada* (stories, legends, folktales, animal tales, allegories, parables, and maxims that deal with the spirit of the Oral Law rather than its letter). However, often the law and lore are intertwined.[4]

The layout of the pages of the Talmud is mosaic in design. The Talmud text, written in the traditional square Hebrew typeface, is centrally placed on the page, much like a jewel in a setting. And the various columns, in other script or typefaces, surround and embrace the text like supporting beams. The main column, always closest to the binding, is that of Rashi (Rabbi Shlomo ben Yitzhak, 1040-105) who "is universally acknowledged as the greatest commentator on the Talmud" (Steinsaltz, 51). The other columns, credited to the great yeshiva academicians and students and grandsons of Rashi, include later commentary, erudite dialectics, and contradictions.[5]

Just looking at a page of Talmud, one can understand that it is not a simple matter of reading a text, but rather requires an engagement of all the faculties. The page has an aesthetic maze-like design, and each column interprets, enhances, challenges, and deepens the understanding of the central text. "In the words of a West Indian proverb, 'Behind the mountain there are more mountains'" (Crowley, 7). So too with the reading and study of Talmud (see example of Talmud page).

To further understand models, we need to explore Midrash. Midrash is the act or process of interpreting, primarily the Bible and other sacred texts. The word is derived from the Hebrew root "to search out." When there is a scene in the Bible that prompts questions because of a lack of detail, description, explanation, or dialogue, the rabbis asked those questions and created Midrash to fill in those holes.

> Midrash comes to fill in the gaps, to tell us the details that the Bible teasingly leaves out: What did Isaac think as his father took him to be sacrificed? The Bible doesn't tell us, but Midrash fills it in with rich and varied descriptions. Why did Cain kill Abel? Once again the Bible is silent, but Midrash is filled with explanation. How tall was Adam as he walked in the Garden? Look to the Midrashic materials, not to the Bible for such details. The human mind desires answers, motivations, explanations. Where the Bible is mysterious and silent, Midrash comes to unravel the mystery. Moreover, there are sections of the Bible that are simply confusing or unclear. Midrash attempts to elucidate confusions and to harmonize seeming contradictions ...

מאימתי

[The page is a full facsimile reproduction of a Vilna-style Talmud page, Tractate Berakhot, beginning "מאימתי". The main central Gemara text, the surrounding Rashi and Tosafot commentaries, the "רב נסים גאון" column, and the marginal glosses (מסורת הש"ס, עין משפט נר מצוה, תורה אור, הגהות הב"ח, גליון הש"ס) appear in small Hebrew/Aramaic print.]

> Thus it is obvious that knowing the Bible alone cannot be the basis for a person's understanding of Judaism. Without knowing the rabbis' interpretation of the Bible, one does not understand either Jewish thought or Jewish practice. ("Midrash" by Barry T. Holtz in *Back to Our Sources*, 180-81)[6]

Originally Midrashic literature, primarily sermons and teachings by the rabbis, was oral. In contemporary times, the process of Midrash continues with fanciful Midrashim created and also published (for example, *Does God Have a Big Toe?* by Marc Gelman). The oral Midrashic method continues wherever and whenever oral study of Torah goes on, whether in the synagogue, home, or classroom.

An in-depth analysis and discussion of the orality of the Jewish sacred texts, the Torah, Talmud, and Midrash, is beyond the purview of this essay. However, in the times before these texts were written down, and even after, this literature was talked aloud, discussed aloud, studied aloud, in the oral tradition—and much of it, if not all, was committed to memory.

How is such extensive memorization possible? As Walter J. Ong concludes in *Orality and Literacy*, "Think memorable thoughts. In a primary oral culture, to solve effectively the problem of retaining and retrieving carefully articulated thought, you have to do your thinking in mnemonic patterns, shaped for ready oral recurrence ... Jousse has shown the intimate linkage between rhythmic oral patterns, the breathing process, gesture, and the bilateral symmetry of the human body in ancient Aramaic and Hellenic targums, and thus also in ancient Hebrew." Thus we see that there is a physical component to the oral experience. "The oral word ... never exists in a simply verbal context, as a written word does. Spoken words are always modifications of a total, existential situation, which always engages the body" (Ong, 34). The students of Toral and Talmud recite and discuss these sacred texts, not only verbally, but with a rocking movement (called *shuckling*) and with added almost-balletic finger and hand gestures which reinforce the vocalization. In addition to the somatic and linguistic patterns, music may act as an

aid to narrative retention. When the Torah is read aloud, there are musical notations, called *trop,* that are sung along with the words. And in learning Talmud, there is also a certain sing-song mode utilized by the students and scholars.

The Jewish tradition highly values words, both oral and written, and is a culture where "courses of action and attitudes toward issues depend signficantly more on effective use of words, and thus on human interaction, and signficantly less on non-verbal, often largely visual input from the 'objective' world of things" (Ong, 68). It is interesting to note that in Jewish tradition, words are viewed as equivalent to deeds or actions. Words are treated with great respect, and even an alphabet letter or part of a letter can be powerful. The name of the fifth book of the Torah, translated as "These are the Words," is referred to as *Devarim,* "Words" (*Davar,* singular, also means "thing" or "event"). It is through words that truth is spoken.[7]

One of the most important prayers recited daily just before the morning service is:

> Blessed is He Who spoke, and the world came into being—blessed is He. Blessed is He Who maintains creation; blessed is He Who speaks and does ...

In this prayer, we hear how God, as Creator, brought all of creation into being and maintains it with no more than His word.

Words have such import that they can have world-shattering effects in their interpretation. The positioning and repetition of words have meaning beyond the plain sense of the text. Indeed, it is not farfetched that what is said has an effect in our lives as well as in Biblical narrative.

Many of the commandments that rule our lives deal with speech, such as "Guard my tongue from evil and my lips from speaking guile." Thus we see how, in Judaic thought, words and actions have an intimate relationship (Schram, *Tales,* 274-75).

Reviewing the God-inspired Jewish literature, I characterize the Jews, a pluralistic people, as a people always in dialogue, wrestling with meaning and the important questions of life—dialoguing and

arguing with God, and with each other, for the main purpose to improve themselves and the world. Tikkun Olam, repairing the world in order to make it a better place to live, is a central tenet of the Jews.

Together with the Oral Law, the oral tradition (lower case *o)* is central to the reinforcement and transmission of Jewish values. The oral tradition is the accumulation of Jewish customs and folk wisdom that is passed along by word of mouth. It stresses the human connection between the teacher-storyteller and the student-listener in transmitting stories that may or may not be found in the Talmud. In any case, there are many variables involved even when the Talmud is the source of the tale; the specific occasion of delivery and the individual storyteller, too, would affect the purpose and wording of the telling. In oral tradition, the emphasis is on the secular and the folk/people as well as on religious themes. In addition to the wealth of new interpretations added during every age, the oral tradition preserves various styles of telling and different versions of stories. In a sense, the oral tradition exists alongside the Oral Law; yet it remains separate.

Many of the folk stories were written down, collected, and published, primarily because of the efforts of rabbis and scholars, and more recently folklorists, ethnographers, and anthologists. However, many stories, especially in the Middle East, were never written down and thus "perished." Recently, there has been a resurgence of interest in the stories of the Jewish People. Much of this attention is due to the extraordinary work of the Israel Folktale Archives[8] in collecting and preserving the orally told stories, especially from Middle Eastern immigrants to Israel and newly arrived Ethiopian Jews. As a result, several major collections of stories have been published in the past ten years, comprised mainly of these folktales, and retold by Howard Schwartz, Pinhas Sadeh, Ellen Frankel, and myself, as well as by Beatrice Weinreich, who drew exclusively upon YIVO's Yiddish ethnographic archives.

What follows is an examination of the various approaches of bringing the written folktale back to an oral tradition, both in the print medium and the oral storytelling medium. This essay will also

attempt to show some of the differences between the written and oral styles and offer a challenge to writers, librarians, storytellers, and publishers to begin considering another way of transcribing the orality of a tale onto the printed page.

It is perhaps a contradiction in terms to speak of a written folktale, because the oral tale lives in the telling performance with its integral interaction between the storyteller and the audience. As Ong states, "Narrative originality lodges not in making up new stories but in managing a particular interaction with this audience at this time—at every telling the story has to be introduced uniquely into a unique situation, for in oral cultures an audience must be brought to respond, often vigorously" (41-42).

Sacred tales and folktales had been told for generations and were also written down in the Jewish tradition. Many variants exist of the same tale, especially in the Talmud and in Midrash. But the oral tradition of exchanging tales has been greatly diminished in the Jewish community, with the exception of the Hasidim. Two examples from the Yugoslav and Japanese cultures illustrate how elusive oral tales can be. Albert B. Lord recorded a Yugoslav bard singing "from ten to twenty ten-syllable lines a minute" (*The Singer of Tales*, 17). Upon examination of these recorded songs, Ong concludes that "though metrically regular, they were never sung the same way twice" (Ong, 59). There was a recent account by David Sanger about Japan's last surviving biwa hoshi, or lute priest, Yoshiyuki Yamashika, who chants his tales of "intrigue and treachery and loyalty (which) were passed down orally, rarely committed to paper."[9] Since this storyteller is ninety-one, and no other person in Japan can recount so many stories, scholars are trying to preserve these tales, but "each time he tells a story, it is slightly different." As one professor noted, "That makes it interesting, of course, but it makes the job of recording a dying art form difficult"[10] (Sanger, 4).

Once a tale has been committed to paper, it is as though it were engraved in stone, never to be changed (except perhaps in a second edition). However, the words themselves are a major part of the entire storytelling experience, but only a part. The oral tradition is a fluid process of change, interpretation, with new elements con-

stantly creating variants. In addition to the words, storytellers tell through their body language, or the paralanguage, of movement, gesture, eye contact, inflection, tone, rate, pitch, volume, and, not least, pause or silence. Paralanguage indicates more than what the words denote; it can also serve as a substitute for detailed description, which may be more necessary in a printed story.

The fear of forgetting, especially for a people steeped in the oral tradition, perhaps served as impetus to have the oral texts written by scribes. But while the written text preserves the content, at the same time writing destroys memory, as Plato's Socrates warned in Phaedrus. "Those who use writing will become forgetful, relying on an external resource for what they lack in internal resources. Writing weakens the mind" (Ong, 79). With the advent of the printing press after 1465, many texts became accessible to people more readily and economically. Remembering stories became increasingly less important because they were "in print," and thereby retrievable. Today, stories are stored in the computer.

Ironically, the more computerized we become, the more television and VCR capabilities we have, the more we are returning to the folktale, both in writing and in telling. It is a revival acknowledged by the increase in published collections. There is also a marked return to the oral tradition as evidenced in the numbers of professional storytellers, or revivalists, telling stories to varied audiences everywhere, to all age groups, and at many different kinds of events. Storytellers are no longer telling only at schools and libraries, exclusively for children's audiences, as was the case for many years prior to the 1970s.

The written collections of Jewish tales from medieval times attempted to preserve stories handed down throughout the generations, often based on Talmudic tales.[11] The collector's inextricable purpose was to teach, and to inspire faith and hope in God through an entertaining medium, story.

Around the same time, the twelfth and thirteenth centuries, secular tales and their structures derived from Arabic, Greek, and Indian, and other sources, were added to the Jewish repertoire of tales. In one of the fox fables, Hanakdan offers stories that might have

come from Aesop or Marie de France, but his foxes echo Talmudic discussion and quote Biblical sources.[12] He opens each of the 107 fables with an aphorism and closes it with a mini-sermon. These openings and closings are indications of an oral approach, but Hanakdan wrote down his tales, rather than entrusting them to the oral tradition. As for the structural adaptation, Ibn Zabara was influenced by the Arabic pattern of such books as *Kalila and Dimna* and by the Indian Bidpai fables. In his *Sefer Shaashuim*, he weaves several shorter linking tales into one major frame-story, creating a "chain" structure.[13]

In Stith Thompson's opening chapter of *The Folktale*, he writes that "the oral story need not always have been oral" (5). No doubt there were original plots and treatments that were printed first and then passed on orally as folktales. But more frequently, "a story is taken from the people, recorded in a literary document, carried across continents or preserved through centuries, and then retold to a humble entertainer who adds it to his repertory" (5).

In her introduction to *Yiddish Folktales*, folklorist Beatrice Weinreich notes, "Throughout Jewish history there has been a continuous reciprocal relationship between stories communicated by word of mouth and stories in writing. An example of this is 'The Trustees,' one of the pious tales in this collection. This tale, recorded in 1926 in Poland, is a variant of a tale that appears in a book of moral literature published in 1707 in Yiddish *(Simkhes hanefesh);* and an even earlier version of this tale is found in a Hebrew book published in Salonica in 1521 *(Yalkut shimeoni)*" (xx).

That stories have been told orally, later transmitted in written form, and then retold with new elements introduced or known details reordered is true of most, if not all, of the stories found in the various current collections of stories, including mine. Many tales can be traced back to Talmudic *aggadot*.

An example of a transformed tale is a didactic tale often told to me by my mother in the 1940s and 1950s. She had to repeat it often when I was a child, and even when I became a young woman. She told me this story as though it were an actual incident that happened

in her village in Russia. I also discovered that my grandmother had told the same story to a cousin, using this story to teach him patience.

My mother's version of the story:

> Once there was a couple who had a baby son. Soon after the birth of the child, the husband was forced to leave his home to fight in the Russian Army, and he was away for many many years.
>
> One night, he returned home. Just as he was about to knock on the door, he heard voices in the house: first a man's deep voice and then his wife's voice answering. He could not hear their words, only their voices.
>
> The soldier-husband was infuriated at the thought that his wife was unfaithful and had taken a lover during his absence. In his rage, he drew his revolver and prepared to rush in and kill the man in his house. As he forced the door open, he suddenly heard the word "mama," and he realized that the man was his son, now grown up. Fortunately he had stopped himself in time.
>
> The husband fell to his knees and begged his wife and son for forgiveness, shuddering over what he might have done.

Years later, I found the story in the 13th century *Sefer Hasidim* and then translated into English in the 1976 collection *Mimekor Yisrael*.[14] I doubt if my mother would have ever read the thirteenth century collection of tales. When I did, it brought home to me the power of a folktale transmitted from generation to generation—from oral to written to oral versions. This is the most popular path of a folk narrative.

While the intention behind the written collections of stories was to preserve the oral tradition, the writing itself became "trapped words" (McLuhan, 84). It was not always possible to capture the multi-dimensional orality of a spoken tale and place it on the two-dimensional flat page. Writing, perhaps printing even more so, demands a different style of "speaking," and allows the usage of more sophisticated words, and more complicated sentence structure. "Since redundancy characterizes oral thought and speech, it is in a profound sense more natural to thought and speech than is sparse linearity. Sparsely linear or analytic thought and speech is an

artificial creation, structured by the technology of writing" (Ong, 40). McLuhan cites J.C. Carothers' article "Culture, Psychiatry and the Written Word," about the role of written words in shifting habits of perception from the auditory to visual: "When words are written, they become, of course, a part of the visual world. Like most of the elements of the visual world, they become static things and lose, as such, the dynamism which is so characteristic of the auditory world in general, and of the spoken word in particular" (*Galaxy*, 29). Perhaps one can even conclude that the printed page reflects and shapes a broad range of behavior and ideas on the part of the reader and of a society.

In addition to the visual aspects of the alphabet letters and the "trapped words," there is also the convention of punctuation which enters gradually more and more after printing is introduced. Punctuation on the page developed more for the eye of the reader than for the ear, "whereas punctuation even in the sixteenth and seventeenth centuries continued to be for the ear and not the eye" (*Galaxy*, 105). We can deduce, then, that the Torah scroll, which is always hand written without any punctuation whatsoever, is clearly an oral document, meant to be heard.

English translations of these old Jewish texts, written originally in Hebrew, Aramaic, Ladino, or Yiddish, use language which is archaic, ungraceful, unpoetic, and unwieldy. Hamlet's command to the players, "To speak the words trippingly on the tongue," would be difficult to achieve with these untellable translations. The orality of these tales was not always successfully incorporated into the translations and, thus, the close connection between the written and oral tales is missed. For example, in a story there is a young man who is a "most worthless outcast." But when the visitor sees his immoral actions, he says to him, "... yet you behave like a profligate." The appellation, while correct, is not easy on the tongue and is a word not likely to be in the average vocabulary. Thus, I conclude this word is not an "oral" word, but rather a literary choice.

The oral tradition used various rhetorical devices through which people were able to remember and store stories in their memories. Some of these devices are vernacular language: short simple sen-

tences, short paragraphs, idiomatic language, asides, repetition, poetic rhymes, rhymed introductions and endings, and dialogue. A question (such as, "And so what did he do?") directed to the audience, is another rhetorical device often used in stories told in the oral tradition.

There is a dilemma involving the folktale and there probably isn't a formula to follow. On one hand, a folktale is often told and then transcribed in a short-hand version of a story, without lengthy description and details of characters. On the other hand, because of this sketchiness, places and characters in the story might need to be fleshed out by the storyteller. How does one decide where to add or omit in this process? Following are some of my cardinal rules for retelling any story. After reading and hearing many variants, analyze the story in terms of content and structure, so that one understands as far as possible what the story is about. Try to understand the function of the story and why it is told by a specific ethnic group. Focus on and shape the story so that it is the *story* that holds the spotlight so as to maintain the interest of the listener. It is also important to understand one's own style of telling, which often comes only after years of experience. Finally, a storyteller needs to follow her own intuition and exercise her own judgment and taste.

How one discovers the meaning and reason for telling a folk story involves some research and analysis. It is necessary to read about the background and history of a people. It is important to learn the values and customs treasured in that society, as well as the symbolic interpretation of the animals, objects, names, and so on, in the story. The reader is also responsible for understanding the connotative meaning associated with certain words. For example, there is a Jewish story from Eastern Europe about "love." A young religious man asks the rabbi for advice about conversing with a young woman. The rabbi counsels the young man to speak about the topic of "love," not romantic love or passion, but rather "about love—of family, food and philosophy." The young man meets the young woman, sits shyly for a time, and then remembers the advice of the rabbi. So he asks, "Do you have a brother?" She answers, "No." He's stymied because then he can't ask if she loves the brother.

Remembering the second part of the topic he asks, "Do you love noodles?" She again answers, "No." Finally, after a long silence, he asks, "If you had a brother, would he have loved noodles?" As we see here, a play on words is very much a characteristic of Jewish humor. With a misinterpretation of the word "love," for instance, by using a contemporary Hollywood version of "love," the punch of the story would be lost. However, in many of the Middle Eastern Jewish stories, love is very much a theme and it is a love, sometimes lustful, between woman and man.

Another type of love found in Jewish stories is the symbolic love between Jews and God, as in *Song of Songs* and in many Hasidic stories. There is one story by Nahman of Bratzlav, for example, that reads like a beautiful fairytale, on one level. Yet, in "The Lost Princess," the King is symbolic of God, the Princess, the female aspect of God (the *Shekhina*), and the Chamberlain, the Jewish people. Thus, it is important to interview knowledgeable people about the culture and to study the folklore, the traditions, and the religion of a people in order to be a responsible transmitter of the stories of that people.

Today most stories that storytellers adapt for telling aloud are from written texts. Therefore, I suggest that there are several ways to resolve this dilemma of a folk story published in a written style, or in a style that is awkward for contemporary audiences, by reworking the language when telling the story. Since folk stories belong to the folk, in a sense, the folk can also change them, if necessary, in order to return them to an oral tradition. In this sense, no one owns the folktale. The storyteller/reader should feel free to change and retell a folktale another way, without becoming a slave to a fixed text. "Stories in the oral tradition were never meant to be memorized," Mrs. Zenani argued, "nor were they meant to be frozen in time. The storyteller is constantly in the process of linking the present and the past: it is therefore crucial that the images be flexible, that their union be evanescent" (*World and Word,* 3, ft.1).

Therefore, when telling a story in translation that demands a certain word or phrase or expression, the teller needs to include that word or phrase in the *original* language. I believe this adds a certain

flavor of the people that otherwise pales when delivered only in English. The Hebrew words, *L'Khaim* ("To life," a toast), *huppa* (wedding canopy), *Barukh Hashem* ("Blessed Be God"), *Rebono shel olam* ("Creator of the Universe"), carry much more of the emotion and meaning than the English equivalents, if we understand them. Some sentences from stories in *Jewish Stories One Generation Tells Another* read as follows: "We must prepare to bring her to the *huppa* soon ..." and from the ending of a story, "I was there, too, saw their happiness, and drank a *lehaym*." Ideally, pronunciation guides would be necessary to help the reader/storyteller know how to pronounce the foreign words. The Jewish Storytelling Center at the 92nd Street YM-YWHA in New York City offers a service of audio taping the words, or entire story, when Hebrew, Yiddish, or Ladino words/phrases are part of a story.

My second suggestion is to break up long convoluted sentences. In written form, these complex sentences may be acceptable. But speaking them, as one would tell to another person, becomes unwieldly: "In the days that followed the man took charge of the palace, and happened to pass by the room which Asmodeus had forbidden him to enter, and he wondered what might be in there, since Asmodeus had permitted him to enter every other room." Or another: "But others among the dream interpreters felt that the king need only command his goldsmith to recreate the golden tree of his dreams, so that he might make it his own, and in this way he would be freed from the recurring dream. Finally, there were those among the dream interpreters who insisted that no such simple solution would suffice, and that the Emperor must set out alone in search of that golden tree and find it for himself, for until then the dream would continue to recur."

My oral retelling of the two examples would be as follows. As is evident in these two examples, there is some expansion in my versions. Let me point out, however, that a certain amount of condensation as well as expansion is characteristic of oral transmission.

In the days that followed, the man took charge of the palace. One day, he happened to pass by the room which Asmodeus had forbidden

him to enter. He wondered what might be in that room. He wondered *why* he was forbidden to enter that room. After all, Asmodeus had allowed him to enter all the other rooms.

In the second example:

> But there were others among the dream interpreters who disagreed. There were some who felt that the king could command his goldsmith to recreate the golden tree of his dreams so that he might make it his own. Only in this way would his recurring dream no longer trouble him. But there were also other dream interpreters who insisted that no such simple solution would suffice. Instead they announced, "The Emperor must set out alone in search of that golden tree and find it for himself. Only then will he be freed of that dream. Until then the dream will continue to return each night."

Third, where there is lengthy description, one can add dialogue (see my example above) to vary the rhythm or else find ways to use posture, gesture, facial expressions, vocal intonations to replace any unnecessary description.

And finally, when the language is archaic and old-fashioned, the story should be retold in the teller's own words. Here is an example of archaic English:

> "I do not murmur," she rejoined. "I am blessed in thy love, which many waters cannot quench, nor rivers sweep away. I do not complain, for in thine eyes I have found peace. And yet I have one wish," she continued, gazing at him earnestly. "It is that thou shouldst attain the full measure of thy strength. But I shall not be impatient or importunate ...[15]

One way the description of how Rachel gazed at Akiva can be accomplished is through focus and tone of voice. Certainly we need to replace the *thou*s and *thy*s with modern usages of *you*, and change the words so the language does not cause laughter, unless humor is the intent.

Another example of a rather quaint usage of words is in the following sentence: "Thereupon the pious man began to dwindle

away" ("The Loan" in *Mimekor Yisrael*, 1125). In this story, Elijah had loaned some gold coins to a man because he was so pious. In the context of the story, this line could mean that the man became less filled with his own importance because he had to return the original gold coins when he stopped being pious. It could also mean that he began "to dwindle" materialistically because he lost all his possessions, even his ship, and he became a ragpicker once again. All this meaning in the word "dwindled." However, I maintain that in the telling, this expression "to dwindle away" would not be understood and would need to be filled out with explanation and metaphor (although, I feel that the word "dwindle" is a wonderfully oral word).

However, this brings up another dilemma: How much of the current slang, euphemisms, modern usages should one include? There are two schools of thought. Some storytellers will include these modernisms. Other storytellers, and I am in this latter school, feel that the flavor of the language should be maintained and, therefore, modernisms, or contemporary language, intrude on the continuity and the "once upon a time, and far far away" quality. Modernisms can change the tone, or add clarity to an otherwise obscure text, or lessen the distance between an old tale and a new audience. We must be discerning among the words we choose to use, but choice is essential. We must not just rely on automatic habit-forming sloppy language.

I heard one storyteller who was telling a Hasidic tale and talked about stopping at an inn. He said, "And the rabbi stopped at the inn, probably the Hilton." The storyteller did get a laugh, but I feel that it broke the mood and seriousness of the story. Another example: In a story about the famous rabbi, Rabbi Yisroel Salanter, the storyteller said, referring to the rabbi, "And this guy told the people ..." The storyteller's rationale for using "guy" was to bring him closer to his pupils in the classroom. However, I maintain that rather than bringing the students closer to the teacher or to the character of the rabbi, it may even destroy the respect and regard for the rabbi as role model. After all, the students may reason, "even the teacher refers to this rabbi as 'a guy'." Indeed, it makes the great rabbi less than

ordinary. In another instance, the storyteller substituted "he goes" for "he replies" or "he says." "He goes" is a modernism that does not belong in a story because it distracts from the beauty of language and does not raise the standards of language for our students. It is casual and familiar language that is not crafted into art. If the storyteller presents an honorable attempt to inject some contemporary resonance into a traditional tale, his efforts to be both of the moment and yet respectful toward the original story's tone and symbolic structure should be in harmony.

Capturing the styles of telling had not been the concern of writers from the past. However, the telling and the text together form an inseparable combination that we need to preserve for future generations. Earlier in the Middle Ages, when stories, Midrash and parables, fox fables, and other collections of didactic tales were written down by the rabbis and scribes, the focus was on the story without reference to the style of telling. Often the written versions were taken directly from traditional folk stories. The writers were interested in transmitting what they heard, perhaps with some invention and integration of variants they had heard in their travels or elsewhere. When scholars and poets redacted the religious texts and narrative stories and the ballads, they most certainly mixed memorization and improvisation.

When folklorists and ethnographers collected stories before the mid-1900s, they took notes or used crude tape recorders more to record songs than stories. Of main interest to these collectors was transcribing the story and, sometimes, the context. The art of performance eluded the collectors who often chose to ignore the artistic performance for the most part, perhaps because they had no code to describe it. A live telling, like any live art form, such as a play or music recital, is evanescent. It is remembered in fleeting moments, images, feelings, but it can never be captured or translated exactly as it happened.

The folklorists-collectors from YIVO trained by Y.L. Cahan, head of YIVO's Ethnographic Commission, were instructed in how to include the life and art of the individual storytellers. Beatrice Weinreich includes a description by one early collector, A. Litwin,

of an exceptional teller of tales, a woman named Sonye Naymark, eighty years old, from the province of Mohilev, who told him two stories. She is also known as the town's *khakhome* (wise woman).

> She started to feel at home in my presence and spoke freely. And then the proverbs and stories began to flow. She tells her stories like an artist. Her language is unusually rich and colorful, and her style is sharp and peppery. She makes use of a rhyme, a Biblical verse, even a Talmudic proverb. (*Yiddish Folktales*, xxvi)

Weinreich also discusses the difficulty the collectors had in transcribing more than the words of the story itself.

> Some *zamlers* (collectors) were quite ingenious in their efforts to render the authentic performances of the tellers. S. Verite ... devised a system of dots and dashes to indicate emphases and pauses. Still, collectors remained poignantly aware of the difficulties of "writing everything down exactly as the teller told it, not adding or substracting an iota," as Litwin put it. For him, the written form of the storyteller's art was "but a weak echo of what I heard from her mouth. What's missing is the pose she strikes as she narrates, her gestures, her alertness, the naive enthusiasm with which she spins her yarns, the sound of her voice, her uncontrived yet artistic manner, which cannot be conveyed in words." (*Yiddish Folktales*, xxix)

There needs to be some way to transfer more of the performance style of a folktale to the printed page in order for the reader/storyteller to receive it as a fuller direct experience. In that way, those who do not often have role models or see a variety of storytelling styles would be able to translate the printed text and performance into a more oral telling of their own. Since more importance and attention is being given to folktales *and* storytelling, I propose a new way to set stories on paper which may better satisfy this dual focus.

Elizabeth C. Fine argues in her book, *The Folklore Text*, that

> interpreters [read storytellers] have confined most of their attention to texts from literary traditions, while folklorists have focused, for the most part, on texts from oral traditions. Although folklorists work

with nonliterary texts, they have tended to impose a literary or ethnolinguistic model of the text on orally composed and transmitted discourses. While folklorists abstracted verbatim transcripts from performances, they often ignored recording or commenting on the contextual or nonverbal features of a performance. As MacEdward Leach says of folklore collected in the past, it was collected more as written literature than oral literature: "... you discover that almost without exception it was collected with little reference to how it was originally presented. It is invariably collected as if it came from written sources, as if it were eye literature, rather than ear literature. Since it was collected as eye literature, it is edited and judged as written literature."[16]

For the past thirty years or so, folklorists and scholars in the academic field were struggling to communicate the flavor of the oral performance of text. For example, in his 1972 book, *Finding the Center: Narrative Poetry of the Zuni Indians*,[17] Dennis Tedlock tries to replicate oral performance with an elaborate system for pauses, loud noises, etc. However, in reviewing folktale collections, it is clear that the stories are always published in a linear fashion. Some line breaks, as for poetry, or capital letters for loud emphasis, or italics for vocal emphasis, are about as much as publishers will allow. There has not been any significant progress made in this area.

Thus we need a text that will preserve and at the same time present the "ear" literature, the folktale performance. Many stylistic features (such as opening and closing formulae, paralinguistic or kinesic features, and idiomatic phrases) should be described and included in the text. As Linda Dégh notes, "the text is nothing more than the skeleton of the performed folktale," and so she argues that the skeleton must be filled out "by recording the inflection, cadence, and tempo—the rhythm of the narrator. Gestures, facial expressions, and dramatic interplay must be retained."[18]

Elizabeth Fine explores this field and offers a valuable way to approach the translation from performance to print. Fine has worked out notations, symbols, and a methodology to transfer the text, along with the paralanguage elements, to the medium of literature, the printed page.

While I strongly affirm the need for work in this area, especially for archives as a record of ethnographic performance, I feel there needs to be a balance between the performance text which is difficult to read for the layman and the literary text which loses the artistic verbal performance. The text alone is a "skeleton."

In *Jewish Stories One Generation Tells Another*, I hoped to indicate voice inflection and other paralanguage cues. My publisher and several editor friends all gave me the same objections, namely, that too much experimentation on the page would be difficult for the reader to read and understand. Continuing my investigation, I spoke with a neurosurgeon who confirmed that there would be an eye-mind battle. The right brain and the left brain would be in conflict. When the reader knows the code, such as musical notations which are standardized and the norm, then no problem arises. However, in the case of a printed text without standard notation, the symbolic markings would create a frustrating, bewildering, and tiring experience for the reader trying to interpret the message. I accepted this explanation and edited out many of my notations, but allowed a few to remain to suggest the orality of the text.[19]

There is more work to be done in finding ways to translate the artistic verbal performance of telling a story into the print medium. Future storytellers, publishers, researchers, and folklorists need to find this combination of orality with the printed text. They need the multi-dimensional experience of storytelling, whether it takes place on stage, at a wedding, or around the fireplace. Perhaps, we should consider adapting the format of a page of Talmud to the translation of the oral text to the printed page. Just as a page of Talmud has a multi-faceted design where the text is in the center, surrounded by columns elaborating on the text, so too I envision a page of a story book (see Talmud page). The story would remain in the center focus. However, columns on all sides would hold the description of the style or styles of the storyteller:

- some annotation regarding the story within that specific culture;

- references to cross-cultural variants;

- a column for Midrash or stories triggered by the central story;

- approaches that differ regarding the telling of this section of the story;

- the characteristics of oral narrative performance with its focus on repetition of words, phrases, images, etc.;

- the description of paralinguistic features;

- the words or phrases which might be emphasized;

- where there might be audience participation;

- what others have said about the story;

- what the focus was on the part of the storyteller and his/her commentary;

- the role of the narrator who told that story to the storyteller.

These columns with linguistic and paralinguistic features would become standardized so that anyone picking up a book would know how to approach the study of the story in all its aspects—literary, verbal, vocal, and visual.

In this way, the oral tradition would become closely connected once more with the visual and verbal aspects of story. By having this type of published story, the reader/storyteller becomes more actively engaged with the printed page and the orality of the tale by reading, studying, comparing, "hearing," and "working" the columns on the page. Then people may begin to appreciate and understand better the dynamic creative/aesthetic performance process. This process involves the storyteller, the story, and the listeners who affect the telling of the tale that day. When the connection between the orality and recording of a tale becomes closer, storytellers can then more effectively, as Richard Chase says, "Lift the words off the page in order to make them go right."

NOTES

1. The calligraphy of the Torah scroll is accomplished by a trained scholar-scribe. This scroll, placed in the Holy Ark and handled with great reverence, is found in every synagogue. Portions are read aloud three times a week at a morning service, on Shabbat afternoon, and on every holiday, as well as when the New Moon appears. (However, the oral public reading can only take place when ten people, a quorum or *minyan*, are present.) Traditionally, it takes a full year in order to complete the reading of the Torah. For more description of biblical narrative, see "Bible: A Biblical Narrative" by Joel Rosenberg in Holtz, *Back to Our Sources*.

2. Oral repetition through the ideal of perfect memorization was the method they applied to their mode of teaching. As Jacob Neusner states: "The system of grammar and syntax distinctive to Mishnah expresses rules and conventions intelligible to members of a particular community ... [and] is formed to facilitate ... memorization and transmission of special rules" (*Purities*, pt. 21, 302 as quoted by Yaakov Elman in *Authority and Tradition: Toseftan Baraitot Talmudic Babylonia* [Hoboken, New Jersey: The Michael Scharf Publication Trust, Yeshiva University Press/KTAV Publishing, 1994].)

3. The records of dates for the completion of the codification of the Mishna are not certain.

4. For more discussion on this subject, see Robert Goldenberg, "Talmud," in Holtz, *Back to Our Sources*.

5. Included in the columns of the Talmudic page is also "the style of study and inquiry in the yeshivot of France and Germany in the twelfth and thirteenth centuries ... Indeed, in some cases one can view them as an extension of the Talmudic discussion" (Steinsaltz, 52).

6. All the rabbinic Midrashim were also collected. One of the largest Midrashic works is known as Midrash Rabbah. The great Midrash period was approximately between the years 400 and 1200 C.E.

7. The most respected persons in the Jewish society had always been the rabbi and the scholar, who study, and the scribe, who writes the words of Torah, which must be written without a single mistake.

8. The Israel Folktale Archives (IFA), founded in 1955 by folklorist Dov Noy, are housed at Haifa University. These archives are the most important repository of 20,000 tales collected from the various ethnic communities in Israel. Each story is classified and assigned an IFA number.

9. David E. Sanger's article, "Nankan Journal: Such Stories to Tell, But He's 91 and in No Hurry" in The New York Times, November 16, 1992, 4.

10. Ibid.

11. The written collection of Jewish tales from medieval times begin with the collections in the eleventh century: Ben Sira's The Alphabet of Ben Sira

(a collection of aphorisms and tales); Sefer Hayashar (The Book of Right-eousness—authorship unknown); Jacob ibn Shahin's *Hibbur Yafe Miha Yeshua* (a collection of faith tales). The other major collections are from the thirteenth century: Joseph ibn Zabara's *Sefer Shaashuim* (Book of Delight— a collection of fables); Berechiah Hanakdan's *Mishlei Shualim* (A book of "fox fables"); Yehuda Hahasid's *Sefer Hasidim* (The Book of the Pious—a collection of didactic ethical tales).

The sixteenth-century Yiddish collection of popular tales, *Mayse-Bukh*, is closely identified with Moses Gaster, who translated and published these tales in 1934.

12. See B. Hanakdan, *Mishlei Shualim (Fox Fables)* (Hebrew), ed. L. Goldschmidt (Berlin: Erich Reiss, 1921. Also Jerusalem: A.M. Habermann, 1946). Also see B. Hanakdan, *Fables of the Jewish Aesop: From the Fox Fables of Hanakdan*, trans. Moses Hadas (New York: Columbia University Press, 1967).

13. For an example of this type of story, see "The Leopard and the Fox" in Schram's *Jewish Stories One Generation Tells Another*, 246-55.

14. See "Restrain Your Anger for One Night" in Micha Joseph Bin Gorion's *Mimekor Yisrael: Classical Jewish Folktales*, 3, 1244.

15. From "The Shepherd's Wife" in A.S. Isaacs's *Stories from the Rabbis*, New York: Charles L. Webster, 1893, 63.

16. Fine, 2, quoting from MacEdward Leach's article, "Problems of Collecting Oral Literature," *PMLA* 77 (1962): 335.

17. Dennis Tedlock, *Finding the Center: Narrative Poetry of the Zuni Indians*, from performances in the uni by Andrew Pevnetsa and Walter Sanchez, New York: Dial Press, 1972.

18. Fine, 4, quoting Linda Dégh, *Folktales and Society: Storytelling in a Hungarian Peasant Community*, 53.

19. For examples of spacing text to suggest orality, see *Jewish Stories One Generation Tells Another*, 190, 255, 265-68.

BIBLIOGRAPHY

Bin Gorion, Micha Joseph. *Mimekor Yisrael: Classical Jewish Folktales*. 3 volumes. Bloomington: Indiana University Press, 1976.

Crowley, Daniel J. *I Could Talk Old-Story Good: Creativity in Bahamian Folklore*. Berkeley: University of California Press, 1966.

Elman, Yaakov. *Authority and Tradition: Toseftan Baraitot in Talmudic Babylonia*. Hoboken, New Jersey: The Michael Scharf Publication Trust, Yeshiva University Press/KTAV Publishing House, Inc., 1994.

Fine, Elizabeth C. *The Folklore Text: From Performance to Print*. Bloomington: Indiana University Press, 1994.

Frankel, Ellen. *The Classic Tales: 4000 Years of Jewish Lore*. Northvale, New Jersey: Jason Aronson Inc, 1989.

Habteyes, Lois Hassell. *"Tell Me a Story About Long Time": A Study of the Folkstory Performance Tradition in the United States Virgin Islands*. Unpublished dissertation: University of Illinois, 1985.

Holtz, Barry W. *Back to Our Sources: Reading the Classic Jewish Texts*. New York: Summit Books, 1984.

Lord, Albert B. *The Singer of Tales*. New York: Atheneum, 1965.

McLuhan, Marshall. *Understanding Media: The Extensions of Man*. New York: New American Library, 1964.

————. *The Gutenberg Galaxy*. New York: New American Library, 1969.

Ong, Walter J. *Orality and Literacy: The Technologizing of the World*. New York: Routledge Chapman & Hall, 1982.

Sadeh, Pinhas. *Jewish Folktales*. Trans. Hillel Halkin. New York: Doubleday, 1989.

Sanger, David E. "Nankan Journal: Such Stories to Tell, but He's 91 and in No Hurry." *The New York Times*. November 16, 1992.

Schram, Peninnah. *Jewish Stories One Generation Tells Another*. Northvale, New Jersey: Jason Aronson Inc., 1987.

————. *Tales of Elijah the Prophet*. Northvale, New Jersey: Jason Aronson Inc., 1991.

Schwartz, Howard. *Elijah's Violin*. New York: Oxford University Press, 1994.

————. *Miriam's Tambourine: Jewish Folktales from Around the World*. New York: Oxford University Press, 1988.

————. *Lilith's Cave: Jewish Tales of the Supernatural*. New York: Oxford University Press, 1991.

————. *Gabriel's Palace: Jewish Mystical Tales*. New York: Oxford University Press, 1993.

Steinsaltz, Adin. *The Talmud: The Steinsaltz Edition—A Reference Guide*. New York: Random House, 1989.

Thompson, Stith. *The Folktale*. New York: Holt, Rinehart and Winston, 1946.

Weinreich, Bina. *Yiddish Folktales*. New York: Pantheon Books, 1988.

Zenani, Nongenile Masithathu. Collected and edited, with an introduction, commentaries, and annotations by Harold Scheub. *The World and the Word: Tales and Observations from the Xhosa Oral Tradition*. Madison, Wisconsin: The University of Wisconsin Press, 1992.

The Continuing Circle
Native American Storytelling Past and Present
Joseph Bruchac

JOSEPH BRUCHAC WRITES from across the divide of two cultures: Abenaki and Slovak American. His journey paradoxically reveals how, for him, moving forward is essentially a journey back. The cultural underpinnings of a family affect all of its members, for even when adults deny a past, children experience pieces of it. Their world view, ethics, faith, and understanding of the relationships of people to one another and to the environment all grow out of this deeper cultural substrate. Although the tenets were not articulated and defined as "the Abenaki way," his grandfather's child-rearing practices were distinctly Abenaki and culturally bound. So that long before Bruchac could recognize and articulate what it was to be Abenaki, he was steeped in their ways.

In a sense, the journey Bruchac articulates in this paper embodies the process we're inviting readers to consider in this book: the exploration of the relationship between oral cultures and print cultures. In modern times this relationship has generally been skewed towards valuing print over orality. Though literacy itself is a neutral tool, used by dominant cultures it was often used as a weapon. Even with the best of intentions, many times the cultural context of orally told stories was

often absent, misinterpreted, or misused in its transcription. Now, oral cultures are devising their own systems for using print technology as a means of cultural preservation and perpetuation. After generations of having the tool of literacy, many native nations now use the tool to present the stories the way their aesthetics dictate.

Bruchac also reminds us that, as storytellers, we must commit ourselves to careful cultural research. The research itself might suggest ways to proceed through ethical and aesthetic questions raised in telling stories from cultures other than one's own. Learning to be culturally sensitive in our treatment of the stories and the cultures from which they come, whether Native American, Irish, or Laotian, is a requirement for all of us.

*A*lmost twenty years ago, I was invited to do some storytelling for an evening program offered as part of a special, one-time only "Native American Literature Course" at Skidmore College. The program included a Euro-American professor who had written his Ph.D. thesis on Sioux music, Duane Niatum, who is a Klallam Indian poet from the Pacific Northwest, and myself. In the audience was an eminent scholar who has enjoyed a long reputation as the expert on the Iroquois and it was Iroquois stories I chose to tell that evening. In the discussion that followed, the scholar made this simple declaration: "There are no more Iroquois storytellers."

Any discussion of Native American storytelling—past or present—has to begin with the recognition that there is a peculiar blindness in American culture about the realities of Native American life, a blindness which is as prevalent among those who have "studied" Indians as those who get most of their information from John Wayne movies and reruns of "F Troop." If things are not stereotypically visible or easily understandable from a Euro-American frame of reference, then they do not exist. Indeed, at the time when William Fenton made that statement, the old style Iroquois storyteller—usually a man in his middle years, wearing a gustoweh cap and clothing made of deerskin, traveling from long house to long house to share

the tales kept in his storytelling bag—was not to be found. But then, and now, the stories of old were being remembered and recounted—sometimes in English—by many Iroquois people. The hardest thing to comprehend may be how cultures change and yet still remain the same.

The climate for storytelling as a whole has changed drastically for the better since 1973. National festivals feature storytellers; the telling of traditional Native American stories—sometimes even by Native tellers themselves—is commonplace. Most people no longer believe that all of the Native American storytellers are long since departed. Yet many of the misconceptions about Native American stories and storytellers still exist and all too many non-Native storytellers still get their American Indian tales only from books and not from the mouths of Native tellers themselves. Moreover, even when they do hear stories told by Native tellers, there is often a lack of understanding about the place of those stories and about the responsibilities involved in telling them or the knowledge and permission which are often required in Native cultures before one tells the stories of another.

Despite the writings (past and present) of innumerable non-Native experts, storytelling is very much alive within virtually all of the still existing Native American communities in North America. In many cases, stories are still being told in the original Native languages, but English has become an important language for bearing the traditions, especially because it enables the communication of those stories within the Pan-tribal context of contemporary American Indian life. Just as colonialism is a shared past and present experience for Native Americans, familiar to every American Indian, English remains one of its legacies and a legacy which, more and more, is being used by Native storytellers to ensure survival.

Some historical context is necessary. When the first Europeans arrived in North America—and immediately began a slave trade which, along with the introduction of new diseases, quickly decimated the populations of the West Indies and the East coast—there were at least 400 distinctly different tribal nations in North America, each with their distinctive languages, cultures, and oral traditions.

Uncounted millions of Native Americans died. Those who did not perish found themselves faced with laws and institutions so foreign to them that their new masters and their ways might have come not from another continent but from another planet. In the United States, the land of the free, the Native American was the least free. Few know, for example, that slavery of American Indians was still legal after Lincoln's Emancipation Proclamation. And although America is the land of religious freedom, until the 1930s all Native American religious practices were forbidden by law. Faced with genocide, the theft of their lands, and religious and social persecution, it is a wonder that any Native Americans survived at all. It is also no surprise that among the 1.5 million Native Americans counted in the United States in the last census, there is often a feeling that those surviving traditions must be protected and sometimes kept secret from those outside their tribal nation. In the past, disclosure usually meant destruction.

However, despite this bitter legacy, the Native peoples of America have been and remain among the most generous people in the world and the amount of sharing from Native cultures in the past can be seen in many ways—from our American system of democratic government and the foods we eat to the wealth of Native American stories which are to be found in print, stories which were usually given by Native elders to ethnologists and historians who were usually non-Indian. There is a tradition of sharing traditional stories with outsiders, especially outsiders who looked like they really needed the teachings in those tales! This was not done purely out of benevolence but in a spirit of enlightened self-interest. Storytelling seems to have always served at least two purposes among Native people—to entertain and to instruct. Perhaps if these new people heard the stories and learned the lessons in them, they would be less likely to do things dangerous to the Native people and their continued survival. That is why the Iroquois League began making concerted efforts at treaty-making councils in the early 1700s to urge the various colonies to join together into a democratic union like the Great League of the Iroquois. Having one unified group to deal with rather than a dozen or more different colonies would make life easier

for the Iroquois. They did this through storytelling, inviting influential Colonial representatives to listen as they told the tale of the long-ago founding of the Great League out of the chaos of inter-tribal disputes that existed before the arrival of The Peacemaker and Hiawatha. One of those Euro-American delegates who listened well and acted on the knowledge he gained was Benjamin Franklin, one of the framers of the U.S. Constitution.

Euro-American culture, the dominant culture in 20th century America, has been a "Youth Culture." Knowledge and power are concentrated in the hands of the relatively young, and growing old means "retirement," relative uselessness to the culture as a whole and even "being a burden." Native American cultures, to the contrary, place emphasis on old age being a time of wisdom and honor and the old are seen as living treasures. Because it is the elders who are entrusted with the primary responsibility of sharing those traditions with the young—for in the circle of life, the old and the young are the closest together—it was often from elderly individuals that Europeans heard those stories and had the often mistaken impression that they were speaking to the "last" person who knew those traditions. It is also politely said by those who are younger—even if they themselves are in their sixties—that they do not know as much as their elders know. Yet it is understood that when they take the place of the old ones, the same things will be said about them. Unless one understands this cultural difference, one is not going to understand the nature of the Native American oral tradition. It is held most strongly by the old, but it is usually not concentrated in a single person.

The role played by storytelling in Native North America also needs to be understood. I've already mentioned that storytelling was associated with teaching. It may be generally said that throughout Native North America most stories were lesson stories. A well-told tale will be remembered longer than saying "You should!" or "You should not!" In fact, because harsh physical punishment and even shouting angrily at children was almost universally frowned upon, a misbehaving child would, as a first step towards correction, be told a lesson story. In my own experience, this role of stories remains the

same today and even very short stories—jokes, for example—are often told not just to make people laugh but to get across in an indirect but very forceful way, the fact to one of the listeners that he or she has done something wrong and that the lesson in the joke is directly applicable.

Some kinds of Native American stories, like jokes, circulate freely among the community, but even where such stories are concerned, it is standard practice to credit the person who told it to you. The acknowledgement of sources and the understanding that something very much like copyright exists in Native American oral tradition is another overlooked or totally unknown aspect of American Indian stories for many non-Native tellers. Some stories, in fact, clearly belong to a particular individual or a particular family. No one is to tell those stories without the direct permission of that person or that family. How can non-Indian tellers know which stories fall into this category? They usually cannot tell it when they get a story from a book. But when they hear a Native teller relate a story that they would like to tell themselves, it is their responsibility to directly ask permission of that Native teller. And if permission is refused, they must understand that it would be irresponsible for them to then tell that story. There are certain stories which I have been given permission to tell which I do not tell at large public gatherings where many non-Natives are present because I know that there will be people in that audience, even when I caution them not to do so, who will steal that story and even publish their own version of it. I know of at least one Native American teller who now refuses to perform at a certain storytelling festival because his stories were stolen there. There are other kinds of stories and other uses for stories, including a use in healing, but I will not go into those. This essay is not the right place to discuss them.

Insofar as non-Natives go, the most important point that I wish to make is *not* that only Native Americans should be allowed to tell Native stories. I do not believe that. However, I do believe that many Euro-Americans who are telling Native stories do not understand the stories they tell. They sometimes tell "made-up" Indian stories, Victorian romances involving doomed lovers from different tribes

jumping off a cliff together. Virtually all such stories were invented by Euro-Americans. They also sometimes tell authentic Native stories wrong, or tell them in ways which are offensive to Native people. Imagine, for example, what it would be like if someone told a story about you which was not true or which made you look foolish or evil. I do not believe that one can order anyone to stop telling such stories, but I can offer some simple advice which may prevent non-Native tellers from spreading harmful stereotypes and offending Native people. For example, if you wish to do a good job of telling a Cherokee tale, you would be well advised not to do it without careful and specific research into Cherokee history and culture. Libraries are useful, but first and foremost, one should seek advice from Native people themselves. One of the best research methods is to consult a Cherokee person who knows that story. Equally important, you should really listen to what that person tells you! I do not mean that reputable printed sources are unreliable—although in the case of some Native cultures that is very close to the truth—but that there are so many Native storytelling traditions that going directly to the source, to a knowledgeable person of that particular tribal nation, is the most reliable approach.

To most, if not all, Native American storytellers, a story is not just a story. It is alive and it carries great responsibility. For example, there are generally certain times when stories are not to be told. There is a general prohibition against telling most traditional stories in the summer, with the exception of historical narratives or stories from one's personal experience. This prohibition is found not only among the Native peoples of the Northeast (where it is said that stories should only be told between first and last frost), but also among the Lakota and other peoples of the Great Plains (where the first sound of thunder from the sky marks the end of storytelling season). I have been told of similar restrictions by Native storytellers from many other tribal nations on this continent. In some of the tribal traditions of the Southwest, stories are only to be told at night.

Stories, for Native storytellers, are not just words strung together. They are the oral re-enactment of powerful happenings which often relate very specifically to a particular Native nation and

a specific physical place. Stories make things happen. One of my Onondaga teachers, Dewasentah, says that the telling of stories in the summer will cause snakes to come into your house. Larry Little-bird and other Native friends of mine from the Southwest have said that telling Coyote stories at the wrong time—or even mentioning Coyote's name at the wrong time—is an invitation for the trickster to visit you and bring you more trouble than you want.

There is never room in a brief essay to say everything that should be said about Native American storytelling. It is a circle and thus is best talked about not by one voice but by many voices in a continuing discussion. What Native American storytelling was, is, and will be is being expressed today by the voices of a growing number of Native American storytellers. People who have kept quiet about their living storytelling heritage are now, after many years of silence, making it known to the larger public that Native stories do not just exist in books put together in the last century by non-Native ethnologists and folklorists.

For the last few years, I've been putting together a list of active Native American tellers, people of Native ancestry (Aleut, American Indian, Inuit) who perform their work for audiences outside their own Native community. I began the list in part for myself. I wanted to have in one place as many names, phone numbers, and addresses as I could find of my contemporaries in the Native storytelling community. I also made the list in response to the often voiced comment that there were almost no contemporary Native American tellers. At first my list had only a few names on it, but it grew and continues to grow. It now includes more than fifty Native American tellers from Alaska to Florida and from Maine to southern California representing more than thirty different tribal traditions. Let me point out that I only list experienced Native tellers who are recognized by their own tribal communities and who are willing and able to travel outside their communities.

There is an abundance of variety of Native American storytelling traditions from across the country. Take the Northwest. The Institute of Alaska Native Arts, in Fairbanks, Alaska, has a list of more than twenty Alaskan natives who identify themselves as storytellers. In

Washington and Oregon, several groups bring indigenous storytellers together. One list of Native storytellers made by The Cedar Tree Institute numbers over a hundred. The Cedar Tree Institute is designed to support and encourage Native storytelling and offers annual conferences which bring together educators, counselors, ministers, historians, writers, teachers, and therapists who wish to use story in their work and lives. Native teachers and master storytellers work intensively with attendees over a five day period. (A similar Native-run storytelling conference is Hama-ha in New Mexico.) The En'owkin Centre, a Native-run college program in Penticton, British Columbia, emphasizes the importance of storytelling and maintaining indigenous languages as part of a post-secondary education and it has identified dozens of Native Canadian storytellers, most of whom tell either primarily in an original Native language or in a Native language and English. Until recently, Vi Hilbert, a Skagit elder and internationally known storyteller, published her own newsletter devoted to storytelling and the preservation of her language—the *Lutshootseed Newsletter*.

In almost every region of Canada and the United States there are now active professional Native American tellers, many of them working in unexpected areas. Not only are they doing storytelling performances and workshops in both Native and non-Native schools, but they are also working in areas where they come in contact with other segments of the public. Several years ago, I took part in a program in cooperation with the National Parks Service to develop a stronger storytelling component for National Park interpreters, relying on Native American stories to explain the history of their parks. In many cases the park employees who do the telling are themselves Native Americans. Wilson Hunter, a Navajo National Parks worker, has even started a Native American Park Interpreters Association.

There is also a growing awareness of the link between Native American writing and storytelling. This is a link which has, of course, always existed—when one reads the Pulitzer prize winning Kiowa author N. Scott Momaday's *House Made of Dawn*, one sees clearly how much he and most other contemporary writers of Native de-

scent owe to oral traditions. There was, at one time, in both the Native and the non-Native community, the feeling that writing something down from the oral tradition removed it from that tradition and weakened it. Now, however, there is an awareness that writing down a traditional story from one's own tradition will ensure that it is told in a better and more respectful way and also help to pass it on to future generations. Tom Porter, a Mohawk tradition-bearer from the Akwesasne community, spoke at a gathering of Native writers two years ago about the link he now saw between the telling of the old stories and writing. "There is an old prophecy," he said, "that I never understood until now. That prophecy said, 'One day our children will speak to the world.' Now, I see that is what we are doing."

I am in regular contact with elders from many different tribal nations who have decided that this is the time for them to write down and publish their oral traditions. In some cases, these are traditions which knowledgeable non-Native scholars said vanished a century ago. Not that it is always easy to find those stories. Persistence is important. Robert Perry is a Chickasaw storyteller who discovered this when he tried to collect a certain kind of traditional story from his Chickasaw elders. "No one knows any of those stories anymore," they said. But when Bob spoke to some elders from a nearby and different tribal community, they said, "We got plenty of those stories" and shared enough of them for him to put together an entire manuscript. When Bob went back and showed that manuscript to the same Chickasaw elders who had told him, only two years before, that they did not know such stories, their response was totally different from the earlier one. "We have plenty of stories like those," they said. "Even better than those." Then they began to tell them to him.

In some places, even more modern technology is also being used in this way. For example, at Cornell University, Iroquois elders have been videotaped relating important oral traditions in the indigenous language. These recordings are being made with the understanding that those tapes will be used not by the general public but by members of their own tribal nations, or by those given permission

to view them. This is one way to counter the problem of Native children not learning their language and traditions when they are young. If, later in life they do wish to learn, it has been preserved in a fashion closer to the old way than mere print can accomplish. It can even be used to keep future generations in touch with the oral and the visual aspects of traditional telling.

At this point, as a storyteller working within the Abenaki traditions, I think it may be useful to speak of my own journey as a storyteller. Although I was raised by my maternal grandparents, and it is from my mother's father that I inherit my Abenaki ancestry, I was not raised in a traditional way. In fact, my grandfather denied his Abenaki ancestry and called himself French-Canadian. (This was, I would later discover, common practice among dark-skinned Abenaki people like my grandfather. It was a way to protect themselves and their families from the racial prejudice which still exists against Native people in many parts of New England.) Having Native ancestry was our family secret. Like most family secrets, it was something everyone knew (including the people who lived around us) and no one dared to talk about. It was not until my grandfather and his brother Jack, who looked just like my grandfather and whom I did not meet until he showed up at my grandfather's funeral in 1970, had died, that his brother's widow talked openly with me about the Abenaki ancestry in the family. Wolf Song, another Abenaki storyteller friend of mine from Vermont, had a similar experience. When, in his adult years, he began talking openly about being Abenaki, at least one of the older members of his family was afraid that the police would come and take her away because she was Indian.

However, as a young child being raised by grandparents, I was given certain things which prepared me to work with Native elders later in life. First, being raised by loving and approving old people meant that I would always be at home in the presence of elders. Second, though I was not told the old Abenaki stories, my grandfather was a storyteller. He told to me about his life, working in the woods, about horses and logging, hunting and fishing. He did not talk often, so I was always waiting and listening for that time when

a story would come. Thirdly, my grandfather never struck me when I misbehaved. Instead, he talked to me. And he told me something which I never forgot, something which would later make me realize just how Indian my grandfather really was. "My father never hit me," he said. "No matter what I done. Instead, he'd talk to me." Fourthly, I knew that there was another life which my grandfather had but could not speak of. He would sometimes disappear for days at a time, off to visit relatives in Vermont. He never spoke much about those relatives, his brother, his nephews and nieces, but I knew that there was a larger family there and I wanted to find it and to know their stories, too. Even as a child, I somehow knew that without those stories the circle of my life would be incomplete.

As soon as I was old enough to go off on my own, I found myself seeking out Native elders. Even though no one in the family would talk about it, I had grown up with a grandfather who looked Indian and was surrounded by things that pointed to his ancestry. It was commonly said around the town (though not to his face) that "Jesse Bowman was as black as an Abenaki." Even his own words provided that evidence. I remember, for example, his story—which I taped—of how he left grade school in the fourth grade. What caused him to leave? Another kid, he said, "called me an Indian. So I flattened him and jumped out the window and never come back. I went to work in the woods with Seneca Smith."

As a student at Cornell and then Syracuse University, I went often to the Onondaga Reservation and listened to the old people I met there. The way they looked and the way they talked was familiar to me. I put the stories they told me into poems and I read every book I could find about the Native people of the Northeast, looking for the stories of my relatives. I spoke freely of my desire to seek out my Native roots, slender and hidden though they were at that time, and elders were generous with a young man who had that interest and the patience to listen to them—pointing me in directions I have now been following for three decades. After finishing college and after the three years my wife Carol and I spent as volunteers in West Africa (another place which showed me the power of storytelling), I returned to live in the house where I was raised by my grandparents.

My grandfather was still living, having kept himself alive to wel-
come us and his new great-grandson back into the home he had held
for us.

It was with the birth of our sons that I became a storyteller. There
was so much that I wanted to share with them, so much that I had
wanted to hear when I was young but had never heard. My older
son, Jim, is now twenty-five and he grew up hearing stories. Some-
times, though, he heard those stories only a few days after they were
shared with me by one elder or another. For as I was teaching, I was
also being taught. I paid close attention to the way the stories were
told to me and I was amazed at the difference between the style of
oral narrative and the often stiff, mannered fashion in which those
stories had been written down. The oral narrative was so clear, so
direct that, by comparison, many of the written versions seemed to
have been dictated by wooden Indians.

By now I was hearing stories from a wide range of elders living
in the Northeast, not only Onondaga, but also Mohawk, Abenaki,
and even Pueblo, and each time I heard a story, I used the scholarly
skills I had gained from obtaining a Ph.D. in comparative literature
to seek out the written versions. I never carried a tape recorder with
me, but relied, instead, on my memory and on hearing the same story
told more than a single time. Then, using both the written versions
and the oral version which had been given to me, I began to try to
write down my own tellings. I found myself leaving out details
which did not ring true, but seemed to be impositions of a Euro-
American voice, and including elements which had been given me
by the oral tellings. I constantly consulted dictionaries of the Iroquois
and Abenaki languages, asked elders how things were said and what
the exact meanings of the Native words were. If a story had a lacrosse
game in it, I learned all that I could learn about lacrosse and how it
was played, what the game meant to the particular nation whose
story it appeared in. When I wrote a story down, I strove first for
accuracy and second for clarity. Then, I read the stories aloud to
myself again and again. Finally, I told them to my most critical
audience—my two small sons. And whenever I reached the point

when my younger son, Jesse, could tell the story back to me, I knew that my storytelling had succeeded.

In 1974, I was asked by John and Elaine Gill, the editors of The Crossing Press, if I had any stories which I told my children. They knew me as a poet whom they had published in their literary magazine *(New: American and Canadian Poetry)*. They wanted to try publishing books for children and they thought, having seen me with my sons, that I probably had stories which I told to them. I did, I said, and the result was the publication—before I was known as a storyteller—of my first storytelling book, *Turkey Brother,* in 1975. Because these were Iroquois stories, I showed my versions of them to my Iroquois teachers, Dewasentah at Onondaga, for example, before publishing them. It was only with their approval that I felt able to continue. It was in the year of that book's publication that I did my first public storytelling performance. I was invited, as a visiting author, to read from my book to an audience of fourth graders at the Caroline Elementary School near Ithaca, New York. But, instead of reading, I put the book down and began to tell the stories. I had read my poems to young audiences before, so I was used to standing in front of a crowd, and no one there knew it was my first such performance. As I told the story, I found myself not thinking of how it began or ended, but simply following along with it, describing it as I saw it happen before me. I trusted the story because I knew that it knew more than I could ever know. And the story did not let me down. It took me safely around its circle, and as I spoke, I heard my grandfather's voice join the voices of my ancestors.

It would be very hard for me to discuss in detail how my style today has changed from the style I used in that first performance, for I cannot think in terms of past and present when I think of stories. When I begin to tell one of the old stories it takes me into that timeless place and I understand why there is no word for *time* in the Abenaki or the Iroquois languages. Of course, I have changed. I know more stories now, having learned thirty or forty stories each year since 1975. I have a firmer grasp of the Abenaki language, and my pronunciation of Iroquois words has improved, so that I am able to insert

more words and phrases in those Native languages into my tellings. I had already learned sign language in 1975, taught me by my Pueblo teacher, Swift Eagle, and I used my hands then as I use them now to shape a story. It seems to me that my stories and my voice have been strengthened the way a tree is strengthened as it grows older and becomes more firmly rooted. Having worked for many years with the Abenakis and having been accepted as an enrolled member of the St. Francis/Sokoki Band of the Abenaki Nation has been part of that strengthening.

Today I find myself growing closer to the age my grandfather was when he brought me into his home. And my own sons are now telling the stories I taught them to other children. Many of the children they share their knowledge with are Native children, and Jesse, who carries my grandfather's name, works with the Abenaki Nation in Vermont and in Canada. He has become fluent in speaking Abenaki.

The ideas of "past and present," of time as a straight line, have never really worked when talking about Native American culture. Instead, there is a sense of a continuum and a connection which can only be represented by the circle. And so it is that when I look at Native American storytelling and my own storytelling journey I see a circle. It connects those who have spoken in the past with those of us whose voices are still carried on the winds of breath and those who are yet to come. It is a circle which is growing stronger.

RESOURCES

The Cedar Tree Institute, P.O. Box 98228, Tacoma, WA 98498

The Enow'kin Centre, P.O. Box 218, Penticton, B.C., Canada V2A 6K3

Hama-ha, c/o Larry Littlebird, P.O. Box 2900, Santa Fe, NM 87504

The Native American Authors Catalog, P.O. Box 308, Greenfield Center, NY 12833

The Wordcraft Circle of Native American Writers and Storytellers, 2951 Ellenwood Drive, Fairfax, VA 22031

Who Says?
The Storyteller as Narrator

Carol L. Birch

WHEN WE SENT THIS PAPER *out to be read, Joseph Sobol identified a central dilemma in this book: how to foster a dialogue that does not use the vocabulary of literate cultures to dominate oral works. Specifically, the term he objected to was "literature" when referring to stories whose origin and form is oral. He stressed the importance of Walter Ong's* Orality and Literacy *in addressing the issue, suggesting that every storyteller/story-writer read it. As Sobol further added in his letter to us:*

> *Storytelling performance is not literature—it shouldn't be and it couldn't be. Literature means writing—etymologically and associatively. Storytelling is oral performance: it predates writing, and if we're lucky it may survive it. Most excellent personal storytelling is not "literature," nor is it "literary"; it is direct, immediate, and contingent on the living voice to make it shine. The fact that fine storytelling overlaps with fine literary storytelling only serves to further confuse the matter ... we're doing something different here. If we keep working at it, [we] may achieve something that reads well but feels quite different from former literatures—a kind of dramatic, rhythmic, prose-poeming that sings the story right off the page.*

Birch's piece, because it deals with stories from printed sources, lies right in the center of the confusion where "fine storytelling overlaps with fine literary storytelling." She attempts to identify some issues which might need to be addressed and some models which may enable story-tellers to better lift written stories into "song," not leaving them to languish as rote recitation.

W ho says?" asks a child, arms akimbo and chin thrust out. We've all witnessed this scene of a youngster deciding what she'll do—or not do—after she has weighed the reliability and authority of both who is standing before her and *who is being quoted as having "said" so!* Adults just grow more subtle. Yet, I believe receptive audiences are actively evaluating the reliability and authority of the storyteller standing before them. They want to know *who says* also. It affects their choices to stay or go, how closely they will listen, how fully they will trust the teller and the tale.

A key element of successful storytelling is dialogic. An audience at a storytelling event—as opposed to those listening to a prepared speech or play—justly expect their presence to help create a singular occasion. The story is not the same story it was when the storyteller practiced it before the concert began, nor when he told it to fourth-graders or any other audience. A storyteller needs to acknowledge and adjust to, with some immediacy, the audience's responses, which provide a fresh and limitless source of energy, making each telling of a story a unique event.

Another key element is that story*telling* is most effective when, *for the most part*, the person standing on the stage is recognizable as the person who is actually telling the story. This is true even if the story originated from the most distant and omniscient of authors, and even if the story is communicated through a proliferation of characters on the stage.

When a storyteller like Kathryn Windham talks about her father, she stands before us with the gifts of her grace, the force of her personality, and a fine discernment evident in her stories. As Jim

May remarked at a storytelling festival, Kathryn "stands there with her whole culture behind her." We know, quite literally, where she's coming from, and that knowledge enhances and reverberates throughout her story. It affects the authority with which she speaks and with which we hear her. It contributes to her very presence on the stage, giving us a string of associations that whisper in, under, and through her stories. A story needs these voices echoing and whispering in the background—the reverberations of time, place, history, ethnicity, culture—the pulses of a person's life and a people's identity. Unfortunately, when someone is telling a story from a printed source and has done no work beyond learning the progression of the words, listeners cannot hear personal or cultural resonance. Metaphorically speaking, they might "hear" only the white noise of the paper from which the story came or even the rustle of a turning page.

Effective storytellers are effective narrators. They are compelling, in part, because they tell a story in a distinctive voice, a voice that is distinctly *not* the narrator of the written piece. They are compelling when they find their own voice and speak with conviction and with attitudes which can make their points of view springboards for the audience. Storytellers have to give up trying to *be* the literary narrator of the piece and trust the tension between the two narrators—the one within the text as it was initially created and the story*teller* who literally gives audible voice to the story.

Melissa Heckler suggested another way of speaking about this: storytellers have to give up trying to *replicate* the literary narrator and take responsibility for *being* the narrator that day with that audience. The contrast and sounding of each narrator's point of view, with the voices of the individual characters in the story, bring dynamism and resonance to a telling.

In emphasizing the need for a stronger narrative voice, and by using Kathryn Windham as an example, I do not mean to imply that storytellers, to be effective, need to tell personal stories. The trend in recent years toward personal stories is not a trend to greet with uncritical joy for two reasons. One, it is open to blatant misuse. And

two, creating a high quality oral performance piece is not easily accomplished. As Carol Shields says:

> Accounts of personal quests are often characterized by an air of high sincerity, and by insufficient irony. The narrators are tempted to dwell overlong on ghosts from the past, to attribute unwarranted significance to casual occurrences, to offer one epiphany too many. (*New York Times Book Review*, 17 September 1995)

The arts often attract people who act out, indulge, or generally exploit the raw material of their troubled lives. Unfortunately, storytelling seems to be no exception, and the personal story can bring out dismal displays of excess. The experiences of our lives become fiction easily enough, but all fictions do not possess a transfiguring potency. Everyday life retold can sound quite banal. Great fiction is created when the personal is refracted and incorporated into a more universal experience where the flash of truth illuminates some aspect of the human condition. Several personal stories number among the most moving stories I've ever heard, yet rarely does the personal story achieve greatness. Although loneliness is a universal experience and friends may be touched by a story of that lonely time, the story is not necessarily appropriate for platform storytelling.

Storytellers are attracted to personal stories both in the listening and the telling for many reasons. As listeners we respond to the emotional depth inherent in the best of these tales. As tellers we want the closure that telling personal stories seems to give the raw experiences of our lives. We want to feel our lives matter and that our experiences are worth retelling. Unfortunately there are emotionally indulgent, ego-centered, and insincere motivations which dilute the evolution of the art of storytelling in our time. David Small (*New York Times Book Review*, 12 November 1995) bemoans a trend rampant in the arts which equates being overwhelmed with quality. Sometimes it seems that newer storytellers are no longer willing to bring that blend of energy and realism that I call *conviction* to stories, except when the events and people in their stories are real in only the most literal way. It requires tremendous intention, intelligence,

integrity, and imagination to speak words from printed sources with fresh spontaneity and with absolute conviction, making *fictitious* events and people seem *real*.

Many storytellers who do retell stories from printed sources readily acknowledge that it is easier for them to tell the story after they've heard someone else tell it. (This essay does not include a range of ethical issues storytellers must address whenever they tell someone else's story from oral or print sources.) In the writing profession, editing is almost always easier than the tremendous creativity required when a pen is put to blank paper. Similarly, when listening to a story, audiences can easily recognize the strengths and weaknesses in both the story and the telling. Listening to the sequence of a plot makes readily apparent at what point the story became difficult to follow. Listeners can identify and evaluate the storyteller's decisions regarding characters and gestural languages, choosing to include or exclude them in their own retellings. Of course, the skill with which potential tellers edit a story is directly related to the range of experience and the depth of perception they bring to storytelling. I would also suggest that hearing one interpretation makes it easier to develop one's own approach.

Many people who tell stories today attend festivals, return home, and try to retell the story *just like they heard it*. They never get beyond putting their energy into duplicating the very words, gestures and styles of storytellers they admire. Studying the styles and duplicating the techniques of masters hold a vital place in the formal education and practical training of most artists. In music theory classes, students get to compose music very quickly, but it is first in the style of Bach, then Mozart, and on through the masters. There is a thorough grounding in preexisting forms, before there is total artistic freedom. And yet conversely, the student is not only evaluated on how well he copies; there is some creative spark and gift for composition which a student is expected to demonstrate. Students are not generally perceived as having become artists in their own right until they show that they can do more than copy styles. They need to shape the material of their chosen art into something unique, incorporating what they've learned into a per-

sonal vision and interpretation that further strengthens the foundation or extends the known forms of the art.

In trying to identify what separates the finest tellers from those who are very able, it seems to me that the most effective storytellers do two things: *they capitalize on who they are* as they tell a story and *they tell the story to the people who are in front of them.* After more than twenty-four years as a listener, storyteller, and teacher, I've heard thousands of retold stories from the most informal practice sessions to formal concert settings. Innumerable storytellers have left me overwhelmed and moved by the conviction of their presence, which resonates and informs their tales. Other times I feel as if I've been left floundering in a story-world skewered either by the affectations of poor acting skills or by a vacuity in the storyteller's delivery style—the pitfalls of too much and too little. The overacted, over-emoted stories are easier to analyze and the problems are easier to address. What seems much more difficult for storytellers to understand and move beyond is the weak performance. By this I mean that the storyteller has clearly moved beyond the basics in terms of the story and his or her own speaking skills, but an utterly compelling element is missing. These weaker storytelling events often result from quite earnest and sincere attempts *not* to overwhelm a story. Yet, in the end, the story is overwhelmed by a poor telling of it. I've heard approaches which seem comparable to the following instances:

- The disembodied voice heard in theaters intoning words like, "Tonight the part of Rosencranz will be played by John Smith."

- The artificially mellifluous tones of a poor FM radio announcer, whose voice travels up and down a scale for no apparent reason.

- The unwaveringly bright delivery from a smiling face on television news making the grim announcement, "Four thousand people died today when ..." with no register of the devastation reported.

- The "seasoned" reporter who speaks with a sober dispassion that supposedly reveals a mature objectivity.

Highly motivated, serious storytellers who struggle with techniques borrowed from other performance arts often ignore basic qualities of interpersonal communication that ground storytelling outside of the oral interpretation of literature, acting, and other more presentational forms of communicating a "story." The storyteller is actually the one who is speaking and she or he is actually speaking to the people who are in attendance. Three models which encourage the practice among storytellers of *seeming not to be present as themselves*, and *seeming not to be speaking to the audience before them* are:

- the literary model of submersion of self in the literary narrator,

- the theatrical model of submersion of self in character, and

- the storytelling model of submersion of self in deference to the story.

The Literary Model of Submersion of Self in the Literary Narrator

The author of a story is not the same as the narrator of the story. An author strikes a pose in creating a story; this pose is the literary narrative voice. The presence of a narrator is felt in written and orally composed stories, spontaneous and labored ones. It is true for family stories, the reports of journalists, and absolutely any translation, version, or retelling from the simplest tale to the most complex literary creations. The stance can be an uncommon or common one, speaking as an entity (human or not) who occupies a time or physical space that is actual as Illinois or as imagined as the Rootabaga Country.

No matter how remote or unseen a narrator may be in a piece of literature, she or he is suddenly center stage in the audible version of a story. Every narrator has a point of view; every narrator has attitudes! The author's vision leads him or her to choose among events and characters that will comprise this story, arrange them in

an intentional sequence, and then express and emphasize details, both large and small, in a distinctive language and style. As the author does these things, she creates a narrator who assumes attitudes towards the characters and events *within* the story, and towards the unseen readers *outside* the story. The options for attitudes are as varied in literature as they are in life. Just as people speak in a tone of voice, a narrator displays a tone of voice through *what she says* and *how she says it*. The narrator in the print version of a story is comparable to the person who orally tells a story. He may speak directly to you from a bar stool, or you might eavesdrop on him while riding a bus. Narrators have as much, or as little, intelligence, humor, common sense, courage, and compassion as the others from whom we've heard stories throughout our lives. Narrators exhibit moral sensibilities, expressing a range of feelings and judgments. For example they may express sympathy or outrage about things reported in the story, as well as towards the people to whom these things have happened. They may also express a range of attitudes towards the reader/listener, for daring to inquire, for not already knowing, or as an empathetic confidant! Most storytellers would be more credible, if they had as much of a sense of the narrator as they do of the characters in a story.

When Kathryn Windham finishes a tale, listeners have a sense of her point of view. More effort is required to discern the point of view in a printed story than an oral one. Nonetheless, an over-riding sensibility—a specific person—is palpably reflected in the attitudes expressed—in print and telling—with each choice of image, every word and turn of phrase. In a very real way, making art is making choices. In writing, so many of these choices involve words. Words are slippery *and* sonorous. They have multiple meanings in both denotative and connotative forms which can be interpreted differently even by people within the *same* culture, and the possibilities for differences increase geometrically across eras, settings, and cultures. In her paper on language in folktales, Cynthia Helms points out that in early print versions of "Sir Gawain and Dame Ragnell," the answer to what women most desire in the world is *sovereignty*. Yet, contemporary picture books interpret sovereignty differently,

as *free will* or as having one's *own way*. A world of difference separates the selfish associations attached to someone who wants her own way and the evocative echoes in free will. In choosing the answer to the riddle, an author also chooses a narrative stance within the tale.

Each person who comes in contact with a story changes it, based on his or her conscious and unconscious cultural values and personal perspectives. People alter a story when they poeticize, bowdlerize, clarify, interpret, and modernize it. Even on paper, the adage remains true: *it's not just what you say, but how you say it.* Storytellers who work from printed sources must analyze the story to determine the narrator's point of view, not to duplicate it. Duplication, strictly speaking, lies within the provinces of recitation, or other models from the fields of oral interpretation and theater. Though storytelling shares many common elements with these disciplines, it is not the same as these performance modes. To me the vital distinction is that telling a story requires the resonance which can only be derived when a storyteller brings his or her voice to amplify, question, reject, or in some fashion play off of the voices of the literary narrator and the characters in a piece. Authors select words to communicate a point of view through the narrative voice; *if* and *how* a storyteller speaks these words communicate the story*teller's* point of view.

In storytelling workshops, people seem to enjoy re-telling a story in the voice—i.e. from the point of view—of someone like Mae West whose persona endows sexual overtones to every word and punctuation mark. As they laugh, they also seem to grasp how thoroughly the stance, the point of view of the narrator, affects every aspect of the story. Similarly, people seem to enjoy the humor that comes from changing the point of view in a readily known tale like "The Three Little Pigs" from the traditionally sympathetic stance toward the pigs to sympathy for the wolf. Yet, I have noticed these same people flounder when asked to identify the narrator's voice and point of view in stories they tell.

Some students benefit from describing the narrator in literal, physical terms; by doing so, they develop a sense of the narrator's presence as a kind of metaphorical weight. They can see how the

narrator functions in the landscape of the story, as gate-keeper who opens wide the door into the story or who limits access. They begin to realize that a personality shaped by age, era, setting, ethnicity, history, and culture is at work on and in the tale. Like any stranger confronted by a person with a tale to tell, people doing the exercise realize that they need to answer basic questions: Does this person seem reliable? Is he unwittingly or intentionally biased, clumsy, unaware? Is he the village fool—or am I a fool for believing him? How does he know what happened here, or there? Is this person grandstanding for others? Am I exercising good judgement about this person, this community, this story? Do I recognize the joke, or the truth?

Often storytellers come to storytelling with such a keenly felt appreciation and respect for literature and authors that the result has been a self-censoring—a tendency to try to eradicate any personal point of view they might have, or to meld their view into the narrator's point of view. In the oral interpretation of literature, holding the text in one's hands is an acceptable convention making readily apparent that the speaker is not speaking personally, but rather making a written text audible. Holding the book also contributes to a sense of ease many people exhibit when reading picture books, folktale collections, or even chapter books, no matter the style, the culture, or the point of view. For example, when I read "David He No Fear" by Lorenz Graham, no one mistakes me for the narrator in the text, even very young children. Graham, an African American missionary to Liberia, rewrote Bible stories with poetry and humor, incorporating the idiomatic English he heard spoken there. With picture book in hand as a Euro-American woman, I can read Goliath's challenge to David, "Do you Mommy know you out?" Without a visible text, I think children, as well as adults, might question my use of this idiomatic sentence and ask, "Who's Carol trying to be?"

In retelling Carl Sandburg's *Rootabaga Stories*, many storytellers resort to dutifully awed tones because of their reverential attitudes toward these tales, the Midwest, or Sandburg himself. These lively

and often poignant stories, which turn on metaphor and an exuberant use of words, can be reduced to sound without sense.

> In spite of the playfully fantastic in images, names and narrative, Sandburg never loses sight of the concrete Midwestern world, the base in physical reality from which his imaginative world springs. *Rootabaga* Country is not above or beyond the American Midwest. It is the American Midwest, in another dimension … The music [of the words] is Sandburg's and the details are from his own, real, windswept prairies. (Joanne L. Lynn in *Children's Literature*, vol. 8, MLA, p. 125)

Although the stories derive a great deal of meaning from sound, in the end, they are not all sound and no sense. Discerning the importance of the narrator means much more than fleshing out an imagined person; it also entails developing an understanding of the importance of landscape and how it informs the story.

A storyteller without a text in hand who tries to replicate a story by eliminating his personality produces an effect from boring to jarring. The results are almost always singularly unsatisfying. In the worst cases, the storyteller can be truly offensive. For example, imagine if I tried to *be* Kathryn Windham or Jackie Torrence; it would be equally bizarre too for me to try to *be* Carl Sandburg's verbally dazzling and tough old man of the *Rootabaga Stories* or Ray Bradbury's twelve-year old character Douglas Spaulding. If I tell the stories others have created, I need to speak as myself, emphasizing the harmony and dissonance of my alignment with the narrator's and each character's point of view. Like Sandburg's narrator, I may also feel "It is too much to be too long anywhere," but the humor or weariness with which I speak the line will say more about my own humor or weariness in concert with the mood of the audience and the event than about Sandburg or his narrator.

Generally, stories from printed sources are most effective when conversationally communicated, rather than acted out or dramatized. The storyteller speaks with the authority of a person who has *seen* or *heard* what happened and who has an attitude about it all! The pride or humility we all bring to painful or cherished memories,

the conviction or righteousness with which we sometimes speak—all these and more are the attitudes storytellers need to bring to the material and to the audience. A good part of a storyteller's effectiveness is his ability to speak from a recognizable point of view.

Early in my storytelling career, I realized narrative sections needed to sound as lively and compelling as dialogue. To accomplish this I made sections of the narrative sound as if they were "spoken" by characters so that any number of attitudes enlivened the text. Nearly all the narrative sections become indirect or direct discourse. Even the basic line, "Once upon a time, there was an old king," was given more immediacy when spoken snootily by a sour courtier or reverentially by a loving grandchild. The vital ingredient was to speak as *someone,* as opposed to a disembodied or dispassionate voice. Although I recognized the narration needed a voice right from the opening of the story, it took years for me to realize it could be *my* voice.

When a storyteller takes responsibility for what she says and how she says it, then she can speak in a unique voice, giving the story a literal and metaphoric voice no one else could. She offers her point of view to the audience as any persuasive speaker would, without jamming it down the audience's collective throat. The storyteller, like the author who has preceded her, is responsible for what she says, but not for what every member of the audience hears. Both points of view are merely springboards for the listener's personal understanding of what happened. An effective storyteller demonstrates her vision in her telling, and her vision suggests how an audience might view the same events. But her vision cannot be so dogmatic and didactic that individuals in the audience feel they have no reflective powers or interpretative opportunities. Part of what an audience might give the receptive storyteller is a new and refreshing take on the people or events in the story. Wise storytellers also listen.

The Theatrical Model of Submersion of Self in Character

Although there is an enormous range in the options actors and storytellers have for interacting with an audience—recreating a text and using the space of a stage—the basic intention at the heart of

their respective art forms separates the two types of performers. Intention ultimately affects decisions made and techniques employed. A basic intention in acting is for the actor, as a distinct personality, to be unseen, with only the character he is portraying visible. In storytelling, the personality of the teller is part and parcel of the occasion. This function can be readily seen in interpersonal communication when people give narrative overviews, or when they focus on recreating characters for one another. The impulse is such a natural part of daily conversation that it has all but gone unnoticed as a storytelling technique. Without much effort or self-consciousness, people almost always communicate more than one thing when they speak about the true or fictional events and characters in their lives.

The personality of the speaker as narrator: When friends enjoy a particular television show, they regularly fill each other in on the latest developments. The speaker summarizes concluding story lines and sets up new ones. These summaries are not dry or monotone reports, but ripe with the delight and horror the speaker feels. They are expressive and full of gossipy innuendo, as the speaker gives free rein to his opinions and attitudes about the eventful lives of fictional characters.

The personality of the speaker in character portrayal: Similarly, when the speaker goes on to recreate the characters and dialogues from a show, or when someone mimics a co-worker, friend, or family member, the listeners often respond with "Yes, that's him!" Among friends, enemies, and families there rarely is any evidence of the distilled dispassion someone like Billy Crystal brings to his imitation of Jack Benny. Generally speaking, imitations of the beloved and hated figures of our lives include judgmental overtones. We don't just imitate them, we communicate our attitudes toward them, so that others quickly realize the obvious, often adding to their first remark: "Yes, that's him! He's such a stitch, nerd, gentleman, creep." Fill in the blank. Everyone *sees* the judgmental, non-verbal cues inherent in the mimicking; they don't see just Uncle Joe. The speaker

does enough to suggest her uncle's personality, while also communicating how she feels about her uncle.

Through verbal and nonverbal clues, effective storytellers bring out the nuances, both large and small, which delineate the characters within the story and direct the point of view of an audience towards the characters. Friends recreate the dialogues among their favorite soap opera characters, while communicating their approval and disapproval of the latest turn of events. People retell the treasured and spiteful stories of their shared pasts: the key characters in a mishap at the funeral of a relative, their mother's aphorisms for living, the family pet's discovery of another animal in the house. What most of these characterizations share is a narrative duality: *a simultaneous display of the speaker suggesting the character while commenting on that character.*

These dual intentions have almost nothing to do with the *purer* characterization to which actors usually aspire. An actor's resonance in character portrayal might hint at or show the humanity under her character's less approachable exterior manner, but the actor stays *inside* the character. Except for the aside, rare in drama, actors are not given any opportunity to show their love, approval, compassion, contempt, fear, or other direct judgements of, and responses to, the characters they are portraying.

Plays depict actors talking as if they were behind a wall the audience can see through, often referred to as the fourth wall. Monologues are still presented to an audience by a *persona* who obscures the actual personality of the one who is speaking, even as the audience is addressed directly. Storytelling, as an oral medium, is created when the storyteller's point of view weaves through and around the narrator, the events, the characters, and the responses of the audience. This startling reciprocity sets storytelling apart from theater.

Language within the world of storytelling makes some of these distinctions difficult to talk about, because many times listeners respond with remarks which relate to theatrical realms. "You *were* old granny" or "You and this place and this audience all completely

disappeared for me. I was in that field (house, car, barn, etc.) with Jack!" Such is the power of the imagination to fill out and fill in all the spaces of our story realms. It does not denigrate the richness of stories nor the effectiveness of the tellers to suggest that a great deal of this power to see what is not there lies within the listener.

The most effective storytellers never cease to be personalities at work on and within their pieces. No matter how clear and moving their characterization is, their presences are revealed in a narrative thread they never stop spinning. It is this duality that makes them storytellers, not actors. Their directorial hands are at work in their tales. Though they may bring a character out to the center of the stage, like a lunar eclipse of the sun, their own light is readily apparent. It shimmers on the edges of the characterizations. Their fires are never extinguished; the tellers never entirely disappear.

One source of storytelling's astounding resonance is the experience that the storyteller's personal vision reverberates throughout the telling of another's tale. Storytelling vibrates with a sounding which brings the storyteller's personality and culture to bear on the story, possibly creating a more varied, profound and richer experience than the singular voice of *an acted character*. A wonderful tension is created when storytellers bring characters and events to life in concert with a live audience, subtly commenting upon all of it by the way they lead the audience through the landscape of the unfolding story.

The Storytelling Model of Submersion of Self in Deference to the Story

In the library world where I was trained and work, the tradition has been to focus on the story, not the teller. This tradition is rooted in the beliefs that storytellers should trust the material, that stories have power, depth, and meaning sufficient to themselves, that attempts at making stories more palatable in terms of the newest fashions is misguided at best. It is tied to a deep commitment which sees storytelling as a way of leading children from the spoken tale back to the riches of the book from which the story originated. This tradition was reinforced by negative reactions to sloppy

performance decisions, the cavalier treatment of notable texts, and the self-conscious cleverness or self-aggrandizement of the "I'm-a-Star" school of storytelling. In all that follows, I am not rejecting the values listed above. Yet, I hope to suggest a model that does not swing between the polarities of an externally imposed conformity and insensitive storytelling behavior. In trying to promote excellence, librarian storytellers have all too often floundered without *internally moderated* storytelling decisions.

There seems to be no way around it: to be effective from a platform, storytellers need to judiciously exercise some control over annoying, distracting, and self-defeating communication behaviors. For example Ed Bell, a storyteller from Texas, spoke with a rasping voice that may have been exacerbated by his posture. It limited the extent to which he could modulate his voice. Yet, it would have been ludicrous (at best!) to "correct" an important aspect of his distinctive style. The focus here is not so much on eradicating poor communication behaviors, as it is on learning to use what you have—containment, not annihilation.

Nonetheless, in the development of every storyteller as an artist, there comes a point when the strengths and weaknesses of her own personality are the source of her most fundamental challenges. People seem to begin with tapes, books, and workshops to focus on techniques, instead of focusing on where they come from, who they are, and what they already have. In pursuing something outside themselves, they metaphorically lean out head first—a stance that can eventually lead to toppling over. This is another reason people are drawn to personal stories, because they sense the material will lead them back into themselves. The truth is, we will all be better artists and storytellers when we speak from who and what we have been, are, and could be.

When Brother Blue retells Andersen's "The Ugly Duckling," he shows his tenderness for anyone damaged by others who cannot recognize the beauty each person possesses. It is a theme his work touches on again and again.

Hey everybody, gather round. / I'm Blue, and I got a story for you. /
Anybody ever pick on you / cause you was too tall or too small? / ...
Listen, inside everyone / there's some kinda beautiful / ... I've been
through / that ugly duckling thing / 'cause you know you have to go /
through some stuff in life. / Remember what I say, / you will have to
use it some day / when they pick on you / —which they're sure to do. /
You are here to rise in your own beauty. / Everyone is beautiful in a
special way ...

In his amplification of Andersen's point of view, he takes a
literary story from one culture and makes it resonate in another
culture. Transposing the formal language of a Danish story into an
African American rap vernacular is not meant to be seamless. Blue
adds to his story by playing off the seams where cultures are stitched
together as in the oft repeated question: "What are you, some jive
turkey?" His version is authenticated, in part, by his carefully de-
fined stance as a persuasive presence. We know *who* is telling his
tale, and who he is informs how he portrays the characters in the
story. He's told us, "I've been through that ugly duckling thing." He
does not bury his narrative voice in the barnyard squawking of
ducks or street smart squabbles, rather his duckling says: "I'm Blue
and I got a song for you." The authority with which Brother Blue
speaks comes from his utter lack of pretending anything remotely
Danish or Andersenesque. Like Kathryn Windham, Blue speaks as
himself with the full force of his culture behind him. Blue brings rural
Danish characters into an urban, American landscape. As the
narrator, Blue guides an audience through his unique version of a
story which contemporary picture book versions often water down
to banality. Though his linguistic choices eradicate the Egyptian-
speaking storks, moats, and forests of burdock plants proliferating
in Andersen, Brother Blue has not altered the tone or values at the
heart of his source story. His touches may very well form a bridge
into the truth of the story that children in America can more easily
follow:

Once a upon a time ago / back back quack quack / a rhyme ago, a
nickel and a dime ago / there was a mama duck you know / and she

was very hip / she was trip / she was sittin on her nest one day / and I heard her say / in her hip way / come on little babies in the nest / I'm tryin' my best / to get you bornin' this pretty mornin' / quack quack jump back / come out here little ducklings ...

When the ducklings are born, they are "seven times pretty." Yet, mama calls, "Come on number eight, you late." The seven ducklings see the eighth and sing "a song—UGLY—seven part harmony." In both versions the ugly duckling suffers. Too young to be on his own, he is unable to provide for himself. Nearly dead, he is taken into a barnyard where he tries to adjust to its cruelties and rigid hierarchies. The end of the story echoes the line from his introduction "you are here to rise in your own beauty":

Spring will do the thing / sing a song somethin' sweet / melted that snow / kissed everything you know / gave this so called ugly duckling / something called—Wings / and this thing rose in the sky / so high so beautiful / like snow you know / flyin'!

Effective storytellers build bridges. The storyteller says confidentially to listeners: "You don't know? You've never seen it? Oh, come here—I'll lead the way ..." Then the storyteller offers a hand to lead listeners from the familiar bank of their ordinary lives across the river of Forgetfulness and Remembering to another shore. Looking back on their lives from the perspective of a new bank, audience members often find startling perceptions. To paraphrase T. S. Eliot, in the end all our journeys lead us back into ourselves and we recognize the place for the first time.

Another model to explicate this process of storytelling suggests stories exist as murals. The image of a mural seems preferable to a storyboard, because a storyboard reinforces the idea of sequence, whereas a mural presents the entire story *simultaneously, in a single sweeping vision.* These murals have always existed and will always exist, even when they are unseen, even when no one is telling their silent stories. The murals hang in the recesses of a person's mind and a culture's shared consciousness. The memories and the projections of the human mind and a people's experience are suddenly illumi-

nated at the moment a storyteller begins to tell a story. *As storytellers, when we tell stories, we turn on lights. In a very tangible way, storytelling enlightens the world.* When an audience gathers before a mural that is cloaked in darkness, one storyteller could merely strike a match. Another might try to direct the audience's perception by shining a flashlight onto only certain portions of the mural, or pull a master switch to illuminate it in its entirety. The moment of transformation occurs when, inside the mind's eye of each person, the flat projection of the mural turns into the landscape of the tale. There may be a disorienting moment. Yet, the disorientation is comparable to the moment when Lucy, her brothers, and a sister had one foot still in an English wardrobe and the other stepping into Narnia.

Quite subtle, and even unconscious characteristics of personal style shape—and therefore alter—each story. The personality of the storyteller contributes to or detracts from stories. *One cannot stand before people and not be there.* One's presence is an added form of non-verbal communication, as clearly as mime. For too long, a debate raged as to whether or not gestures could be used in storytelling. Yet, standing is gestural language; holding the hands together and/or having arms at the side is gestural language. The question is not "can a storyteller gesture?" but "what are the most effective gestures to use when telling a particular story to a particular audience?" Similarly, if storytellers do not use the theater model of submerging themselves in a character, then their very presence does have an effect on a story.

Storytellers need to reflect on the ways in which families and friends have required a certain presence of them that has shaped who they are and how they communicate. I offer a sketch of my life to show how my past influenced the kind of storyteller I am. I hope it will also reveal the extent to which strengths and weaknesses are two sides of the same coin. Although I didn't grow up hearing folk-like tales nor many ritualized family stories, I did receive a great gift from my family for a future in storytelling. By their example and in their words, they encouraged me to feel and express a wide range of emotions. In my home, people generally did not wonder (for long)

about how anyone in my family felt. You were told, even if you didn't ask and didn't want to know. For example, no one asked "What's the matter?" and heard any thing like the depressive-to-molten, passive-aggressive "Nothing" I've heard since I left home. Within the family, the answer was more likely to be "What's the matter? I'll tell you what's the matter ..." As a child, self-preservation didn't require me to hide what I wanted.

In my family, we said what we wanted directly. There wasn't a passive, indirect model for behavior. If you wanted a big piece of gooey chocolate cake, you didn't pretend not to or slyly sneak some, you said: I want that cake. Maybe you got it, maybe you didn't, but negotiations were forthright and highly audible. Similarly, my parents never taught me to say "please" and "thank you." Gratitude was supposed to be readily apparent in the tone of my voice, the expression on my face, and my stance whenever I requested something.

I was literally never permitted to whisper. My parents, especially my mother, hated whispering in adults and children, and she demanded that I say whatever I wanted straight out. This was sometimes disastrous, as I learned what were appropriate and inappropriate requests for her initially and later, for those out in the wide world. Imagine my painful chagrin, when I learned these were not widely accepted or shared behaviors. I was surprised most to discover that people often did not know what they wanted, and next to find out that most are taught *not* to show it (let alone boldly). These more generally familiar restrictions meant that I simply could not count on what people said as being what they meant. The frankness of my speech and feelings were sometimes received as endearing, but more often as a source of laughter, either with me or at me. I also elicited scorn, outrage, and hurt feelings. I learned that outside the context of my family, my bald remarks were sometimes inappropriate because they assumed a relationship and level of trust that did not exist.

The peculiarities of my childhood allowed me access to a range of emotions and provided me with years of practice in revealing them in my facial expressions and voice. This emotional expressiveness has served me well as a storyteller—sometimes. There are

liabilities also. I do not tell stories *well* that rely on the narrator's slyness, sarcasm, self-deprecation, indirection, or use of heavy irony. It isn't that I cannot say the words but the tenor of my reflexive self is in conflict with these delivery styles. When the door leading into stories hinges on such qualities, the results are clearly not worth the effort for the audience or me. This emotional clarity can also work against me when I am feeling unsure of myself, upset, or preoccupied with issues unrelated to the story. My emotions may show in my non-verbal cues, creating one more obstacle for me to surmount in appropriately bringing the story to the audience.

For years in my youth, I labored resistantly at a piano. How I hated practice, my parents who made me miss life away from the bench, and the teachers who tried to lure me into the work and the pleasures of musical expressiveness. I endured this torture because I wanted to be a choir director, a position requiring serviceable sight-reading and accompaniment skills. When I became a teenager, voice lessons began. Among musically skilled people, I was only fair-to-middling, yet each area of musical training helped me. As my awareness of the relationship between sound and sense developed, my sense of timing improved. I developed an interpretative style, learned the phrasing of a line, and the power of the rest—that pregnant pause and tension, in the silence between notes or words. However, my pleasure in phrasing can cause me to overuse the pause. At one event, an exasperated sound engineer was overheard asking the emcee about my storytelling: "The way she starts and stops mid-sentence—what is this? A stylistic thing?"

I have always been grateful to Ellin Greene, with whom I studied storytelling at Rutgers University, for her encouragement and her focus that emphasized the vitality and primacy of the *story* over storytelling techniques. Similarly, a doctoral program in communication at the University of Southern California gave me a theoretical context in which to consider the fundamental issues involved in adapting a piece of written literature for oral/aural performance. Such gifts, when not properly used, can also cause problems. The analytical orientation of my training can distance me from the audience by too close a focus on the material.

So these are the gifts I received, first from my family and then from a variety of teachers and mentors. These gifts contribute to and inform my storytelling. I would be foolish, at best, to go up on a stage without them. In leaving them in my chair, I would be leaving pieces of myself behind. Unfortunately, I see very able storytellers tell stories without the distinctive quirks and strengths of their personalities.

Fine tellers proceed without the grace, wit, irreverence, earthiness, and verve so familiar to their closest friends. On stage they become stiff, constricted physically and/or emotionally. Although this tendency is not limited to white, educated, middle-aged women like myself who were raised to be nice at all costs, it does seem to be more readily apparent in us. When we doubt our quirky visions, *when we doubt our very voices* for a range of familial, social, and cultural reasons, we often end up standing there not even as a ghost of ourselves, but as *the ghost of someone we think we should be.*

In *The Elements of Style,* Strunk and White advise writers to "Make sure the reader knows who is speaking." Storytellers need to remember this advice and make certain the listeners know who is speaking—not just who the characters are, but who is relating the events to them today. In other words: *Who says?* At the beginning of a program, or a story, the audience may not know who the storyteller is, what the story will be, or where to follow. For the audience, "Who says?" is often a real, though unspoken, question.

Too many tellers seem to be trained in the ballet school of storytelling. The storyteller walks out to the center of the platform, assumes a position, puts her head down and up, and begins delivering the story by intoning the words while manipulating her face and body. It is just as problematic for me as a listener when a storyteller *introduces himself in one voice* and then *adopts another voice to tell the story.* This problem is not limited to the artificially sugared sweetness of Shari Lewis imitators. Apart from trying to get a quick laugh, it is jarring to hear a teller speak with a Western drawl one minute and assume a Cockney accent the next.

People obscure more important issues when they ask: "Am I *allowed* to use accents?" There isn't one answer to this question. Each

teller needs to answer a series of questions about underlying assumptions and overt objectives. Ruth Crawford Seeger, in *American Folksongs for Children,* focuses on dialect in folk music, yet the questions she raises apply to storytelling.

Storytellers have to give up trying to be someone else or trying to be invisible altogether. Who and what we are is our most basic resource. Learning to use the self as an instrument whether in medicine, teaching or art is a process of learning to balance our unique capacities with the accumulated wisdom of the field. Finding appropriate ways to use this instrument effectively is the process of maturing into an effective storyteller. Not doing the study and practice required precludes sustained success as a storyteller. There will always be people in platform performances who approach storytelling without the deeper study of a culture and its stories, without practicing and processing the arts of storytelling, and without self-examination, all of which may result in work that is showily attractive but cheap or insincere.

Most of us shudder at those who engage in self-indulgent poppycock and call it storytelling. It concerns me that the focus in this essay on bringing more of one's own personal voice to printed material may be used to rationalize abysmal behaviors. There is no protection from that kind of misuse and misinterpretation of my ideas. Yet, I would submit that I have seen more stories languish from dispassion than passion. On one hand the ideas presented here may seem self-evident, yet they are also difficult to identify and discuss. We can bring more authenticity and vitality to stories from printed sources—so that the answer to "Who says?" is resoundingly clear. I hope my contribution will encourage us all to find appropriate and compelling ways to illuminate story worlds so that they brilliantly spin and "sing right off the page."

Playing with the Wall

Bill Harley

IN THIS ARTICLE, BILL HARLEY borrows a concept from storytelling's younger sister, theater. Moving from the intrinsically intimate settings of kitchen tables, front porches, and campfires, storytelling can require powers of amplification and magnification of the personal to project to ever larger audiences. Harley introduces the flexible model of the theatrical concept of the fourth wall, offering it as method with which storytellers may play.

Intimacy between audience and teller, particularly in the less-than-intimate settings of theaters, tents, and auditoriums, can be an elusive, though essential, trait. Based on his experience as a listener and performer, Harley contends that a playful use of the fourth wall can create a sense of intimacy between teller and audience.

As Harley demonstrates in this essay, a storyteller does not stand behind characters, playing the elaborate keyboard of a calliope to activate the lines they speak, nor does the storyteller move behind a manipulated, and ultimately false figure, pretending, like the Wizard of Oz, to be that which he is not. The fourth wall does not rise and fall like a lumbering garage door or cumbersome curtain. Rather, Harley's model of the wall is lighter and more transparent, allowing the storyteller a range of motion and emotion with which to engage the audience. Except for

instances like the Stage Manager in the play Our Town, *these opportunities to both retreat from and engage with the audience are rare in modern traditional theater.*

We feel that we can not repeat too often our basic conviction that there are no rules that fit across the board of storytelling; there are only models with which to think. For example in her article on the narrator, Carol Birch expressed the belief that in bringing a character to life the storyteller is visible like the corona of the sun behind the moon during a lunar eclipse. In this essay, on the other hand, Bill Harley makes a strong case for the storyteller, at some points, being utterly committed to staying in those characters behind the fourth wall. This dialectic is not Russell Baker's "chewing gum of the mind," but a nourishing kind of food for thought on which we hope people will enjoying feasting.

S torytelling's success depends upon the intimacy created between teller and listener. When the teller is powerful and the story well told, there is often the feeling in the audience that the teller is "speaking only to me"—a palpable vulnerability is present. When storytelling fails, the audience member feels she is closed off from the story—that the performance would take place in the same exact manner whether the audience were there or not. As a result, the listener doesn't invest in the story, and little is shared.

In exploring what makes good storytelling, I've found it useful to use the concept of the "fourth wall" found in theater, first introduced to me by my friend and director Benny Reehl. Understanding how the fourth wall works does much to separate good storytelling from the rest; good storytellers have a clear understanding of what the fourth wall is about, though in many cases it may be an unconscious and intuitive understanding.

In order to explore the topic of the fourth wall, I would like to set a few ground rules. First, my language and understanding of theater concepts may differ from those of you more familiar with the formal theater. My apologies—I have, as I always do, appropriated someone else's work for my purposes. Second, I will be speaking

about a contrived performance setting with a "professional" story-teller—I do this not because this type of event is more important than any other kind, but because it is my style. Third, I am ignoring all the other crucial elements which go into good storytelling and focusing on the aspect of the fourth wall—an understanding of fourth wall doesn't insure good work. Fourth and last, I am not introducing a theater concept so as to engage in a discussion about the difference or similarity between storytelling and theater. I am extremely utilitarian in my approach to performing, and am interested in what works. As Picasso said, when art critics get together, they talk about art; when painters get together, they talk about where to buy turpentine. This is turpentine.

Fourth Wall for Storytellers

In a traditional western theater, there are four walls on a stage, only three of which are seen: the back and two sides. In front of the performer, between her and the audience is an invisible wall, the fourth wall—a psychological distance between herself and the audience. Most action in traditional western theater occurs with the wall up; actors are performing as if the audience were not there. They address and respond to each other, and not the audience. Of course, performers are affected by the audience—the audience response may encourage or discourage a better performance—but the performers are not conversing with the audience (this is not a hard and fast rule, especially in modern theater, and I know it).

A storyteller's main relationship is with the audience, and that relationship can be defined by how she is using the fourth wall. A storyteller is likely to use three positions in one story.

First, she may address the audience:

Once there was a king.

There is no one else on stage; she is speaking to someone other than herself—she must be addressing the audience in a general fashion. The fourth wall is down.

Second, characters in the story are speaking:

One day, the king said to the queen, "I must have a son."
"No, four daughters are enough."
"No, I must have a son."

When this dialogue occurs between the king and queen, the fourth wall is up—it is as if two actors are on the stage and we are watching events transpire as if we were not there.

Third, the storyteller responds to the environment. Later in the story, an audience member laughs. The storyteller stops, looks into the audience at the laugher, and says, "That's exactly what the queen did." Here the wall is broken down completely, and the storyteller *and the whole experience* is being influenced by the audience and the broader environment.

Each one of these positions has a different function and effect. The storyteller who uses all of these positions effectively brings a dynamic to the storytelling which keeps the performance fresh and vibrant. Once again, I hasten to repeat that the use of these positions may be unconscious or intuitive, and that these different modes are not completely rigid. But when the storyteller doesn't know where she is in relation to the audience or the fourth wall, things fall apart. Let's take a look at the effects and problems of each position.

The Narrator at Work

The first position, a general addressing of the audience, is the most common and in some ways the most challenging. We often use this mode to move narrative along. It is the storyteller, not the characters, telling the story. Even though the fourth wall is supposedly down, in this position it is easy for the storyteller to lose sight that she is actually communicating with the audience. A storyteller not doing her job well stares off into space, addressing some unknown person or group, not physically communicating with the audience. The voice becomes formalized and loses conversational tone. Or, the storyteller is aggressively approaching the audience, performing "bigger" or "smaller" than the audience through voice level or movement and not adjusting to the environment. Communication has obviously stopped, since the storyteller is not

addressing the living people in front of her, but rather some idea in her head. The audience senses that though they are being addressed, the wall *is* up and the same words would be spoken whether they were there or not. The connection is lost and *rigor mortis* sets in.

Audiences are forgiving—they may overlook the message that their presence is unimportant *if* the plot is riveting, or the language is exemplary, or the voice is pleasing, or the performer has on a beautiful shirt. But sooner or later, the unintentional distance created by the performer will interfere with the performance. The challenge of presenting narrative when addressing the audience is in keeping a tone that is conversational, that seems to be *almost* inviting response. If the storyteller is discovering the story for the first time (again and again), if the words to describe an incident are found as if for the first time, then the audience feels engaged.

Done properly, this "inviting in" seems almost artless. Rosalie Sorrells, folksinger and storyteller, has an "artless" delivery that belies her skill in this narrative mode. She pauses, she stares off for a moment, as if looking for that proper word to get it just right, and she has an amazing knack for establishing eye contact with individual members of the audience. All of these encourage an intimacy which can draw the audience in.

Why does the wall go up in this place, where a storyteller is supposed to be speaking to the audience? Fear and protection. Discomfort with the experience. Lack of interest in the sharing of the story (too many shows in too few days). If the storyteller is unsure of the story, of the character's motivation, of the amplification system, or of the audience, the wall goes up. The thought in my mind when the wall goes up for protection, is "Get this story done and just get me out of here!" Though such behavior is sometimes recommended for survival, it's not good performance. When the storyteller is at ease and centered in the experience, the wall will drop down again, and the audience will be invited in.

The problem of keeping the narrator close to the audience, receptive to them, is one of the most vexing in performing, because it demands a presence and ease on stage which is not easily attained. It requires a constant attention that is hard to teach. I have found that

an inability to drop the wall and let the audience in is often some-
thing that has a farther reach in the performer's life than just the stage
persona. Maybe therapy would bring about the needed vulnerabil-
ity. But therapy can take years.

Putting the Wall Up

The second posture, with the fourth wall up, can provide a focus
and encourage the audience member to come *into* the storyteller's
world. Well done, when the wall is up and a character is speaking,
the message is "My world is so interesting that I am lost in it—come
see what is here, if you wish. Take a look inside." The storyteller is
not *going out* into the audience, but rather drawing in, and we must
choose to come along and see—we are leaving our world. Obviously,
this other world must be interesting, or we'll stay where we are.

Of all the storytellers I know, the one most strongly committed
to this use of fourth wall is Jay O'Callahan. We know that Jay is not
really four different people, but we will believe it if he gives us
reason. He does, through his clear delineation of characters. In one
of Jay's simplest and most touching stories, "Orange Cheeks," he has
the intuitive sense to go completely behind the wall at the climax—
the mother discovers her son has written on the wall and nails a
tablecloth over the writing. Rather than have the narrator describe
what happens, Jay becomes the three characters and speaks only in
dialogue. We see the mother's frustration, the child's fear, and the
grandmother's kindness, and see their relationships defined by their
behavior. As in the best of writing, Jay does not "tell," he "shows."
Through his posture, vocal timbre, and choice of language, Jay
becomes each character at the moment when the story hangs in the
balance. Jay's ability to become three characters in one scene and not
leave us confused is a testament to his clear understanding of the
fourth wall (and of course, the characters in his story).

The possibilities for botching a closed fourth wall are enormous,
and sloppy closing of the wall is an aspect of a lot of bad storytelling.
A storyteller unclear about the fourth wall may have the narrator
seem to take part in the story or the character address the audience
and not another character. The audience may not be able to detect

the exact problem, but the fuzziness in the storyteller's performance encourages a feeling of unease in the audience members. Of course, the narrator taking part in the story is potentially very interesting, but only with the teller's conscious intent. Mistakes are the unconscious running the show. When a storyteller enters into that closed world of fourth wall, she must be convincing enough for the audience to follow, and that requires a discernible change in the storyteller's method. The change may be slight and subtle, but it must be there. The change could be a pause before the character speaks, or a shift in vocal timbre, posture, or facial expression. Often the change involves several or all of these. The change must also be consistent throughout the story. If the voice of a character isn't consistent, or the posture of a character is at one moment like the narrator's and the next like Quasimodo's, the audience becomes unwilling to participate and refuses to suspend disbelief. The audience is willing to believe there are three characters and a narrator up on stage if the storyteller gives them reason to believe. Whatever else, the storyteller *must be committed to staying in those characters* when the wall is up.

First person stories present special problems and opportunities, since the narrator is also an actor in the story, and the line between one and the other can become even fuzzier. But it is still there, and often powerful. Describing something that happened in her life years ago, the teller might start off talking to the audience, then drift off into a reverie—her eyes go up and there is a slight smile on her face as she describes the smell of her grandmother's kitchen—the audience can see that she is, at that moment, remembering not for them but for herself. For her, for that moment, the audience is not there; the wall has gone up. The audience senses it is a special moment and willingly comes into her world. The memory finishes, there is a slight pause, she looks out at the audience, smiles, and continues with the narrative. The storyteller has drawn the people into her world, and has come back out to theirs again, while staying in first person.

Breaking Down the Wall

The last mode, responding to the audience or the environment, has a function different from the other two. Responding to the audience involves leaving the story completely and inserts the storyteller into this moment, here on *this* stage talking to *these* people. In effect, it is saying, "I know that I'm telling you a story, and you know it, too. It's a convention we're using to entertain ourselves." It professes an understanding of the structure of the experience. The possibilities of this mode are exciting, and also dangerous. Of all the possible relationships with the audience, this is one that should be used the most sparingly, since it throws the power of the story into jeopardy; the story becomes something to play with and the content of the story becomes secondary. If a storyteller stays outside of the story for too long, the narrative thread will be lost, and the subtext becomes "I am clever." Some performers want to send that message, and most of us are tempted by it.

This last mode has at least two different effects. First, if done effectively, it is most often humorous. The train comes down the tracks in Jonesborough in the middle of the National Storytelling Festival, right behind the performance tent. It is impossible to ignore. How does the storyteller respond? "Right then, the king heard the train come towards the castle." The audience laughs.

The crying baby, the sneeze, the strange laugh from the man in the back row, the lights in the auditorium failing, or the storyteller herself forgetting a line—these are all opportunities to enter into a relationship with the audience outside the story, and the end result is usually laughter. The opportunity is one to take advantage of, because when the storyteller can effectively handle these distractions or changes in the environment, it sends the message that the storyteller has poise and will be able to take care of the audience. When this happens, the bond between the audience and teller is strengthened. During the course of a performance, I look for places to interact with the audience in this manner. These moments are interesting for all of us, since the storyteller is not completely in control and everyone knows it.

A master at breaking the fourth wall—or "metastorytelling"—is Ed Stivender. Stivender willingly responds to the audience, is committed to showing the mechanics of storytelling technique and story structure in the middle of a performance ("This is the first motif from the Stith-Thompson index, which will be repeated later"), and is quick enough to respond to the environment. We go to hear a story, but we also go to play with Ed.

Another, more subtle method of dropping the wall to speak or respond to the audience involves commenting on the story itself. One of the most brilliant performers I've seen in a theater setting, Vladislav Polivka, a Czech theater clown, used this method a number of times to great effect. Engaged in a dialogue with the one other performer, several times he stopped, mimed the breaking of a glass wall, stepped into the audience, and explained what he was trying to do in the piece. When he was finished, he stepped back on the stage, assumed his role with the other performer, and continued. The move caught the audience by surprise, disarmed them, established a new, more intimate relationship with the artist, and oriented the audience to look at the piece in a new light.

Another, more common method of dropping the wall involves taking information from the audience to build the story. Len Cabral, telling "The Little Old Lady and the Pumpkin," says, "Her daughter sat her down and made a stew for lunch. A wonderful vegetable stew. And what vegetables do you think were in that stew?" The audience volunteers the makings of the stew, and there is usually laughter, as Len responds to individual offerings ("Beets, you can't beat 'em") or someone suggests a fruit or a non-edible object. Like the other methods, drawing information from the audience shows the poise and creativity of the storyteller while establishing a new relationship. Also like the others, if done too much, it can destroy the narrative thread of a story and dramatic tension in a performance. We lose sight of the story.

Playing with the Wall

Once a storyteller has a good understanding of where the wall is and how it works, the problems and possibilities become clearer.

Some of the most common faults of storytellers can be explained in relation to the fourth wall. Two of the most common are (1) having the narrator participate in the story and (2) having the character loosed upon the audience.

Mixing the closed fourth wall dialogue of the characters with the narrator's position is perhaps the most common mistake storytellers make. When the wall is up and characters are interacting, the audience is not there. If they are not there, you can not talk to them, but time and again I see the narrator somehow participating in the story, using the movements and voices of the characters while the narrator speaks to the audience. When there is a chase scene and in one moment the character is screaming "Run! Run" and the next moment the narrator is screaming "They ran! They ran!" in the same voice, we become confused as to who's in charge. Is the narrator actually there with the characters in the story? When the narrator is describing the wolf climbing up on the roof while he is miming the climbing action, the wolf becomes less powerful, because he is also our friend, the storyteller.

The other possibility, just as confounding, is when the character is speaking to the audience. Sometimes the character yells at the audience, when he, she, or it is really still talking to someone in the story. I think that a character yelling at the audience is an interesting idea, but a storyteller needs to make sure that if she is talking to the people seated there she actually has something to say to them. For instance, when the wolf yells at us, "I'll huff and I'll puff, and I'll blow the house down," we may feel that we are the pigs under attack. It feels like bad children's theater. We feel assaulted and confused when the storyteller emotes at the audience. Go yell at the other characters, but not at us. But if the storyteller focuses his yelling with the posture of his head and body at an angle from the audience, then turns, in character, to the audience and says, "I love saying that!," a whole different relationship is established, and it is clear the storyteller knows who is who. Another sign of confusion occurs when the character turns her head one way and another, addressing different parts of the audience, while really speaking to one other character in the story. A storyteller with strong sense of fourth wall stays focused

in one position while a character is speaking. If the focus wanders, the audience senses something is wrong and loses its commitment to the story.

A Sense of Where You Are

Many simple but troubling performance problems are solved when the storyteller has the presence to ask herself, "Who is speaking?" "Is the wall up or down?" and "Where am I in the story?" These questions are easily answered when the time is taken to ask them and the performance becomes stronger and more interesting. Similarly, when the storyteller understands the fourth wall and mixes the modes of address in one performance, she provides a dynamic that helps the audience. No one would enjoy seeing a movie shot entirely in close-up, or even worse, at a middle distance, which is most often used to show narrative movement (equivalent to narration of the story line in storytelling). And while broad panoramic sweeps of the beautiful landscape are nice, we don't want to stay out there—we hunger for the detail of the story. The audience may grow tired when the narrator never lets the characters speak, or when the characters completely run the show without any communication with the audience on the part of the narrator. Having a sense to mix it up helps every aspect of the telling.

Hard and fast rules? Not likely. For every rule of thumb I've introduced, I can think of good storytellers who break it and succeed—storytellers who stay behind the fourth wall the whole story and are riveting, storytellers who spend most of their time playing with the audience, barely getting to a story. But I would suggest that these tellers also know their strengths *and* their relationship to the audience and the wall, and therefore they get away with it. Observations about the way things work are of greatest help when something is broken or the bounds of our own work need to be extended for growth. In those cases, some thought about the fourth wall often helps.

With all these observations made, I repeat that most fourth wall relationships are established by performers intuitively, unconsciously. I am reminded of Carl Jung's admonition to his students to

"Learn everything you can, then forget it." I view most of the "tricks" I use as things I do to "hang around" the area of a good performance, trying to be ready for those moments when something else happens that is beyond technique, beyond intellectual exercises. Being conscious of what I'm doing keeps me closer to the place where a real communication between the teller and audience happens. When those moments happen in a performance, we all have a part in the story and there are no walls at all.

Between Teller and Listener
The Reciprocity of Storytelling
Rafe Martin

RAFE MARTIN'S ESSAY ADDRESSES the reciprocity in a story event. The audience works with the storyteller. Martin delineates facets of the storyteller's preparation and education, as well as a conscious cultivation of knowledge within listeners. Each realm has internal and external aspects which are increasingly important in the development of fuller perceptions of stories and for storytelling as an art form. Martin reminds us how integral story listening is for the success of a storytelling event. On the continuum of audience involvement, there are storytellers who ask little from the audience except receptivity and audible appreciation of the storyteller's technical virtuosity. In contrast, there are storytellers whose work depends on an audience's contribution of thoughtful, vibrant attention. Unadorned platform storytelling requires a presence and intelligence from the audience that more visually explicit performance arts do not. This itself poses questions about when it is appropriate to "jazz it up" and when to trust both the potency of the material and the power of imagination.

Kay Stone analyzes in her essay a particular storyteller and audience; Martin reflects on the general principles which underlie the construction of her analysis. Although he does not directly mention the

fourth wall of the theater model, Martin incorporates the concept as part of a storytelling grammar. Both the evanescence and the permanence of storytelling are honored here.

> Some time, perhaps soon, it will come to be recognized that it is as important to cultivate the imagination as it is to cultivate the will or the intelligence ... For imagination is one of the great faculties; it is the one faculty common to all exceptional people—to soldiers, statesmen, saints; to artists, scientists, philosophers, and great business men. Says the Serpent to Eve in "Back to Methuselah," "She told it to me as a marvelous story of something that never happened to a Lilith that never was. She did not know that imagination is the beginning of creation. You imagine what you desire; you will what you imagine; and at last you create what you will." The day may come when that sentence will be written above all places of education: "Imagination is the beginning of creation. You imagine what you desire; you will what you imagine; and at last you create what you will."
>
> —Padraic Colum, *Storytelling, New and Old*

O ral storytelling has the uncanny power of allowing us to enter the imagination. Told stories aren't projected via images as on TV or in movies. They're not set in fixed text as a book. Unlike theater, no costumed persons move on a stage amidst literal scenery speaking unchanging dialogue. Instead all scenes, landscapes, terrains, topographies, human and non-human characters, events, insights, and emotions of the story must be transmitted through the most archaic tools—voice, language, and body. And they come alive within us. True, written text also requires our ability to form images from non-visual cues: we *see* the three-day chase of Moby Dick, but on the page are only the squiggles we recognize as written language. The chase is within *us*. But in the told tale, each word and gesture of the narrative locates it in a specific, present occurrence, charged (almost magnetized) with emotion by the teller's body and voice. Each moment of the told tale is alive, distinct. Yet the story is not so

much a performance—a term highly invested with associations to theater—as a *presentation* or *demonstration* of its own life. And, as there is no set text, narrative details and a teller's way of presenting them constantly shift and evolve. Why? The art of storytelling depends on the combined skills of both teller and listener. The teller works with the imaginative, creative powers of the listeners' minds. And the two sets of skills—of the teller and of the listener—must mesh for a told story to finally "work." Indeed, part of the art of the storyteller depends on the teller's ability to "read" an audience.

Yet what is it that tells us that a particular telling is more than just a crowd-pleaser but the expression of an art? What are the skills, the internal recognitions, and the tools that help a teller present a tale well? What are the aesthetics of storytelling? From the audience's side of the equation, what are the skills, even the knowledge, that help us, as listeners, make a teller's best work possible? And what will ground us in a meaningful critical approach to the storyteller's art?

I'd like to begin with the critical ground, the field of receptivity within which the told tale's life is played out. Paradoxically, critical awareness depends on an ability to transcend or suspend personal judgements for a time—the likings and dislikings that underlie what we may more ordinarily mean by criticizing—and see the work whole. This may seem obvious, but there can be a particularly strong pull towards what one personally likes and dislikes in storytelling. The experience of watching and hearing a tale is an intimate one. A particular person's voice and gestures are coming alive, forming images within us. The experience feels entirely natural, but conscious, albeit highly intuitive, artistry is at work.

To like or dislike a story—or a storyteller—may seem natural, too. Told tales, after all, aren't neutral but come to us filtered through a teller's background, through his or her insight, emotion, and personality, and through his or her body and voice. And told stories *require* that their listeners *respond.* When has text ever made such personal and public demands? But what if, in responding, we dismiss a tale because we do not like the *type* of tale it is? Perhaps we like personal-life stories and have just heard a mythic or traditional

tale, or vice-versa. What do we do with a tale that disturbs us? Let's say it strikes against some ingrained preconception. Then days, weeks, months, or even years later, a door in the mind swings open and we say, "That was an amazing story!" Was the tale a poor one before and now good? Or had we simply been applying the wrong level of critical response—liking and disliking—to a complex linguistic-gestural-emotional-psychological-mythic experience?

This shouldn't mean that we're now to ignore our preferences and *think* ourselves into an intellectual appreciation of a tale or teller that leaves us cold. Still, perhaps there are ways we can nurture and deepen those very processes of change and growth which are bound to occur in our understanding—and so, in our critical response to, and enjoyment of, told stories. I'll try to touch on a few of these ways a bit later in this article. I want to include them because, subconsciously, all our attitudes and understandings about not only narrative, but about all the arts, about our bodies, psyches, and about life itself affect how we tell, how we hear, and how we respond to stories.

What if we don't like the *way* a story is told? Not how well or poorly it was told, but the *style* in which it was presented. Some tellers rely on vocal characterizations, creating distinct voices for each character in a story. Others may tell a tale with only slight suggestions of characterization through voice. Surely one style can't be inherently better than the other even though we ourselves might *like* one style more. So, an awareness of any such predilections on our part will be crucial to a genuinely critical response to the tale. The same would apply to gestural styles. One storyteller may sit in a chair, another stand in place, a third be extremely mobile. While one teller's style may be physically dramatic, another may rely on patternings built of voice. A third may modify his or her style of telling to some degree depending on the meaning, the pattern, character, feel and tone, as well as the culture of origination (if a traditional tale), of the story being told. Styles can change, too, depending on a teller's grasp of the nature, interests, and skills of the audience. None of these stylistic choices necessarily make a better storytelling or storyteller; stylistic choices can't predetermine aes-

thetic effects. Listeners, then, need to be aware of their own stylistic preferences so as to not let them predetermine or unduly influence critical judgements.

The job of storytellers, after all, is to make a story *live*. How they do it is their business. Experiencing whether or not the story lived is the listeners' realm.

Entwined around critical and aesthetic issues in storytelling are questions of the depth and richness of a tale itself. Can there be a superb telling of an ill-conceived, poorly patterned, or meaningless and shallow tale? Not, I think, unless the teller develops the story quite a bit from the original material he or she is working from, though perhaps there could be a technically satisfying telling of such a tale.

A potentially wonderful, rich, soulful story can also be readily defeated by the language—verbal and gestural—of the teller, which doesn't necessarily imply failure. What's wrong with a teller's reach exceeding his or her grasp? And a simple little tale can, with clear and crafted language, and, perhaps, expressive minimalist gestures (future storytelling reviewers take note!), take on an unexplored and, an as yet unrecognized, depth and life. Still, while we need ways and languages to pinpoint what the problems or successes of a telling have been, I think we'll still also need to keep a fundamental question on file in the back of our minds—"can the told tale and the telling *really* exist apart?" The oral tale *is*, for the time of the telling, the telling itself. There is no independent, *ur*-text, hovering ghostlike above the actual telling. The presentation of the told tale is not the repetition of a previously established and memorized set of words-as-text unless one is dealing, perhaps, with sacred material in a ritualized setting or with theater. Rather the telling is the life of the tale itself. Given this, we'll still need to find ways to talk appropriately about the many levels inherent in an experience of a single telling of a told tale.

What does seem clear is that the ability to tell a tale well depends greatly on imaginal skills—i.e, sympathetic or intuitive understanding, receptivity to spontaneously arising imagery, an ability to recognize—indeed, to enter fully *into* literal realm—the structural

patternings inherent in narrative and having a "feel" for language—
verbal and gestural. I think that those interested in telling should not
push to polish "how-to" presentational skills which can alleviate
anxiety, perhaps, but also potentially diminish the power of the tale
—which begins as something seen, and felt in the mind, the vast
creative mind of the imagination.

Cultural anthropologist Richard Nelson, in his fascinating book,
Make Prayers to The Raven: A Koyukon View of the Northern Forest,
makes the point, discovered in moving from told to written versions
of stories, that "written words have less power but more permanence
than spoken ones" (p. xv). Storytelling is inherently a realm of
power. The stories must be re-created, not just re-performed. If
tellers let technical skills grow out from their own experience, un-
derstanding, and inner seeing of the tale, the telling that emerges
tends to have the power to move an audience. It has power because
the teller is able to speak from, move from and share the *reality* of
what his or her *own inner experience* has been. There is no need for
manipulation here. The teller simply shares the truth of his or her
own unique imaginal life.

Skills, then, are no more—but certainly no less—than a way of
sharing one's own intimate experience of the tale without blocking
or clenching. Good skills take fullest advantage of the natural abili-
ties of voice, body, and mind already there. There is no "push" in
this, no need for performance skills to get the upper hand and *force*
an audience into such seeing. A well-told tale implies a teller's ability
to first see the story uniquely, to find something potentially new in
its truth for herself, and then to have the ability to make what she
has experienced in her mind come alive for listeners. A well-told tale
means bringing to life a valid and unique vision of the tale. It means
having a story to tell, having the ability to shape that story and
having the technical facility to bring it forth. To speak critically of a
told tale, then, we may need to artificially separate, that is, act *as if,*
the tale and its presentation were not identical.

Having made these distinctions, we can ask ourselves the follow-
ing kinds of questions: What did the storyteller seem to be aiming at
in his or her telling of the tale? Approaching the tale and its telling

psychologically, we might ask if the teller understood the underlying or "inner" import. Looking at the tale mythically, from the perspective of archetypes, we might ask if the teller got, or missed, key points of the story's pattern. From an ethnographic perspective we might ask, did he bring to life an appropriately detailed sense of the story, true to its culture of origin? And if the teller didn't *seem* to fulfill such demands, mightn't we ask if there were not some element in the vision of the story that would make even that lack significant? Was the teller aiming for comic effect? Finally, did it all mesh as a presentation of the tale—or was it just so many incidents, images, words?

Turning to the presentation, rather than the vision and understanding—if the teller was successful, how was the telling managed? What was it about face or voice, words, or gestures, about the structure that brought us into the experience of the tale, that opened up a plane of the imagination that became, for a time, trustworthy? Can we say something about the richness and precision—or lack of it—in the teller's language? About the expressiveness, freedom, accuracy or appropriateness of the gestures? About the range and sensitivity of voice?

Still, in the heat of the actual telling what tellers want is to *feel* the story's pulse beat. And they want that mysterious "click" between teller, story, and audience to once again occur. When that happens, things mysteriously cook; self-concern disappears and entirely new details appear. And what does an audience want? It wants to be taken out of the stream of daily responsibilities and repetitive, trivial concerns. It wants its humanity touched, its heart moved, its funnybone tickled. And it wants its intellect engaged too. The mind's desire for pattern needs to be satisfied, the fragmentation of our lives for a time healed. So questions of how things worked—when they did work—might be taken up after the telling. They become a way of further engaging one's mind in the art and a way of entering into the aesthetic delights that were, in fact, involved. In time they become a natural part of our immediate seeing.

In general, to be alert and knowledgeable listeners, the kind of audience who can bring out the best in our storytellers, we need to

become aware of our expectations and how they condition our liking and disliking of certain styles of tellings and types of tales. We might want to become more aware too of tellers' affinities in these same areas. In general, however, to nurture and educate a story-based imagination, tellers and listeners would both do well to continue looking deeply into myth and archetype, those universal narrative patterns which express the inner life so long stored in the world's tales. Ethnographic awareness, too, enhances the tellers' and listeners' grasp of stories. The more traditional stories we know, the clearer our instinctive perception of archetypal patterns. Traditional stories are so close to archetypal areas of the imagination their patterning remains clear, and they serve as great and wise teachers for all storytellers today. The more we know about different storytelling traditions and cultures, the less likely we will be to misread or ignore key images and image clusters. Perhaps, then, when we, as listeners, are aware of archetypes and tradition, tellers won't miss the boat in their retellings for they'll know that the audience will be alert to these cues.

Tellers and listeners will benefit from reading the work of poets and writers, those whose work lies entirely in the magical realm of words. Good writers offer us a heightened respect for the power of words and a sense of the possibilities inherent in the story structure—beginnings, middles, and endings.

Listening to that remarkably sensitive vehicle, the human voice, so readily available to us now on an endless variety of recordings from around the world—song, story, poetry—would also seem to be a fruitful area for our research, our learning, and delight. Hearing new dimensions in the voice may open up possibilities in our tellings precluded by our own conditioning with language. Film, dance, photography, and painting offer ways for us to observe archetypal gestural languages which all bodies instinctively carry. Such awareness can help tellers and listeners alike.

For tellers, an education of the imagination can bring greater breadth, depth, detail, and structure to their work. Listeners and tellers are both more likely to see how each story, heard or told, is part of a universal web of stories connecting cultures, persons, times,

and perhaps, lifeforms. Like the sophisticated audiences of traditional cultures, listeners, who have a fund of experience to draw from, will recognize what a given storyteller is actually accomplishing in his or her telling of the tale.

This inner work, a preparation and education of the imagination, becomes increasingly relevant—if storytelling is to gain recognition as the art it is.

What of imitative tellings? Obviously they can't receive the same critical response as the work on which they are based. The patterning, images, language, even voices of characters in such tellings are often borrowed directly from someone else's recording or live performance. Trying out styles and borrowing images have a legitimate place in any storyteller's learning curve. And, the patterns of traditional tales, patterns which underlie all our formal literature, have been fundamental to human experience and thought for an extraordinarily long time. So, while individual tellings can be *unique*, perhaps very few story patterns are really *new*. Therefore it seems all the more important that imitative tellings be critically distinguished from more original art.

While copyright remains a legal and ethical issue, even more important may be the ability to recognize and applaud work that sustains, or even contributes to, the long-term growth and development of the storyteller's art. The greater a storyteller's and an audience's awareness of story pattern, literary structure, myth, and ethnography, the clearer the thinking in this area will become. Guidelines will arise out of a broadening base of awareness and knowledge. Knowledgeable listeners alter the nature, depth, and sophistication of the art.

So far I've presented a loose series of reflections on the theme of critical awareness and the art of storytelling. I'd now like to try to talk about some of what goes on in the experience of telling stories.

Words, bodies, as well as the invisible workings of the imagination, memory, and logic are the tools of storytellers. Underlying how these elements are organized into the oral tale is a teller's perception of sound and silence. Body and gesture have their

own analogies with sound and silence. Stillness is the body's analogy for silence; movement, for sound.

So, an experienced storyteller will not be afraid of silence, doesn't always need to cover it with words or movement. Such a teller is willing, at times, to let the audience absorb the story in silence. This silence implies trust: teller of audience, audience of teller, teller of the tale and of the moment. This non-manipulative trust is a key to stage presence—that elusive combination of the physical and psychic ease of the teller before the group. It's conveyed clearly in moments of unhurried, naked silence when a teller is vulnerable yet unconcerned, willing to simply be where he or she is. An audience can feel this and responds instinctively. An experienced? good? alert? storyteller instinctively understands too, that each gesture and word revealed to the audience grows out of its opposite—the silence that is there before the story has begun and will be there after the telling is done. In being willing to accept the silence underlying the action and language of the told tale, the teller is also making a kind of primal statement: joy in the story or faith in the story's worth outweighs the primal anxiety of standing alone before a group. A kind of freedom is demonstrated in this and in this freedom is the origin of the told tale's specific delights—one person, body, face and voice—and a world of characters and events appear! In silence the told tale's unique music starts. Rhythm is the alternation of speech and silence.

Out of an awareness of this fundamental reciprocity, the mutuality of sound and silence, arise the workings of the story, expressed through voice and gestures, sound and body, in pitch, tone, pace, and rhythm. There can be gestural rhythms in which key movements of body or physical action are repeated, as well as verbal rhythms in which language pacing, specific images, and words are repeated at significant moments. Rhythm can include actions or voices which syncopate *against* each other or against the meaning too. For example, a physical gesture may move surprisingly against what the words *seem* to be saying. Voice tones may suggest irony or humor when the words themselves indicate sorrow or anger. The structure of the story itself is built of repeated units—words, gestures, images,

symbols, tones, inflections and events that repeat, gain detail and weight, and so evolve. By sequencing these building block units, the teller structures an audience's experience of the story's form.

Some stories, and some tellers, work mostly with a lively interaction between themselves and the audience. Some tend toward moments of greater "inwardness" or withdrawal. Interaction by the teller "outward" toward the audience draws the listeners in so that they actively participate in the story, adding words or phrases at the proper times. The distance between teller and audience in such moments disappears. All work together. Interactive tales for young listeners draw naturally on this and, in them, story structure may come so close to rhythm that the boundaries between story and music can blend. Pattern takes over completely and begins to carry the tale. But interaction with the audience—eye contact, gesture—can also lead in the opposite direction, towards the highly aggressive, syncopated, and ironic interactive rhythms of stand-up comedy where rhythm is broken, pattern denied, and surprise given its due.

If, however, the teller turns "inward," away from this kind of active holding and leading the listeners, towards greater absorption in their own vision of the tale, a more formal, archetypal "space" can take form. In such moments, complex, intense emotions, deep calm, or finely crafted visual details can emerge. We sense here the power of the *teller* as well as of the narrative. The further we go in this direction, the more the boundaries between story and the visual arts begin to fade. Powerful and detailed images become accessible to us. These images seem to arise out of moments of dynamic stasis, moments in which the teller risks our seeing him or her standing alone on a bare stage, deep in the story. These moments can take on the heightened perception, the finished completeness of the timeless. There is often a sense of distance, but *not* separation. And such moments can be part of the larger shifting rhythm of the tale.

Both movements have their strengths and internal logic. Each is appropriate to certain kinds of tales, as well as to certain moments in a tale, but may also be more or less appropriate for certain kinds of audiences. In addition, each may also form a more—or less—natural match with the essential personality, that grab-bag of strengths

and weaknesses, that comprises the psyche of a teller. Appropriate (i.e. successful), use of either style will in the end involve aesthetic, albeit highly intuitive, decisions on the part of the teller.

Language, the precision and deftness of word use by the teller, can create effects of startling beauty. But harsh, bitter, and even seemingly inappropriate or failed language can have its place in the aesthetic of the tale. The key is word appropriateness. Some words may be chosen because of what they do for *us*, the listeners, how they help create clear and resonant images in our minds. Some words, on the other hand, may be chosen because of what they reveal about *the character* who the teller at that moment has become.

The same holds true for gestures and voice tones. Neither beauty nor ugliness is in itself aesthetic or unaesthetic. For it to be truly "aesthetic," it must work in terms of the total integrity of the work as a whole. So, having a certain character say, "Shit!" can quite appropriately tell us a lot about that character and that moment in the tale—even if it is reductionist language. So we need to stay alert. We don't want to dismiss a story because a certain character was disturbing—or because of the way a certain character was portrayed. We have to see in stories what the wise and foolish, the good and evil, create *together*. What does each bring to our understanding of the whole work? The critical concern based on this total aesthetic must be: has the teller seen the whole form? Has he or she grasped the import of the tale or failed to recognize and convey it? Did the teller grasp the mythic pattern surely enough and clearly convey it to us? Is the interrelation of highs and lows, good and bad, the clever and dull, complete? Did the gestures bring the many faces of the tale to life? Did the teller's voice carry forth the violence of the violent, the tenderness of the tender, the haughtiness of the haughty, the wisdom of the wise? In short, did the teller succeed in giving life to all of this as well as giving shape to the tale?

To return to one of my earliest points, a storyteller is a good pattern-builder—and also a flexible one. She or he must build and vary the pattern of the story—and of a longer performance built of several stories—to structure an experience that *works*, for a particular audience. It is the ability to grasp pattern, to communicate pat-

tern, and simultaneously change, reshape, and vary pattern—often on an instant's notice—that allows a teller to present a *told* story.

It is a skill of imagination. This, more than any technical facility, seems to me to be always at the core of the many talents and devices at work in the storyteller and the telling. In this act of patterning, the storyteller, like the Roman god Janus, looks in two directions at once. The teller must be able to look within to the unique images and understandings of the tale arising in his or her own mind, even as he looks outward to the needs, understandings, and rhythms of the audience. In the act of telling, the storyteller must be constantly gauging, constantly modifying and reshaping the story. In the act of the telling, the teller is intuitively responding to such questions as: are the listeners getting it? Is the heat making them restless? Is the lighting too dim? Is that noise too distracting? In the act of telling, the teller must work with such inner and outer contingencies (and many more!) to bring the story and its listeners onto the same wavelength and into a unified realm of imagined experience. This means building, as well as simultaneously changing, patterns. It requires focused concentration.

To attend a live storytelling is, in a sense, like seeing a sculptor or painter or composer at work. The act of creation draws us in. But in our listening minds, the story is something we have created in concert with the teller. The images we see are triggered by the images and patterns in the teller's mind, expressed through voice, gesture, language, pacing, pitch, and rhythm.

"Good" storytelling might be said to be storytelling in which the many expressive choices and actions of the teller are in tune with, and appropriate to, the weight, depth, meaning, and style of the tale. (And, perhaps, we might add here, to the needs, tones, and depths of the audience.) When the teller has been successful in bringing the tale to life, the telling will seem entirely natural, almost effortless. Good storytelling, too may open up realms within us, as tellers and listeners both, which the culture itself has left dormant. This is true for the simplest tale, if it is told in the appropriate spirit and style.

What of good telling to which an audience does not respond? A teller can tell a fine story, with deep sensitivity and feeling, and yet

the subject, the style, the culture may leave a particular audience cold. Can we look to some higher aesthetic than that of the audience's response or happiness? Or is a telling so intimately bound to the interactive presence of the audience that that audience's response must be a determining factor in the story's success or failure? In a sense this is simply true—as it is, for all art. For the audience to reject the story would be like for the canvas to reject the paint. What can happen then? Still, must a teller be only bound to what any given audience can receive? Perhaps at such moments, when this is in question, the teller must go on telling for the ideal audience, the ideal listener, the listener who carries all archetypal patterns, all literatures safe within the heart. At root, each telling is an act of faith, not just in the response of the listeners but in the worth and presence of the tale. In essence, as with the private and vatic musings of the poet, the expressive and public language of the storyteller ultimately draws upon a realm of mystery and sacredness.

Narrative is a complex, powerful, and mysterious tool, certainly one of the oldest technologies on the planet. Deep in the psyche, the world itself is a tale. Every story partakes of this mystery, every telling renews some recognition of this fundamental delight. At a practical level, stories provide us with proven ways to organize, test, and simulate in the mind universal patterns of thought and behavior. Told stories especially give us direct reconnection to the *power* of narrative as something highly personal, yet deeply communal.

In essence, stories have a function: to guide us in living well. Tellers have a purpose: to let the story live. Audiences create a realm in which this becomes possible.

The art of live storytelling depends on the vision, the imagination and skill—the dreaming, if you will—of the teller but also remains deeply rooted in the fundamental interests, skills, and responsiveness of the listeners. It's an art which offers the riches of the imagination without requiring spectacular special effects or equally spectacular budgets. It's an art which whispers persistently, demonstrating over and over the crucial thing in a rootless and anxious time: "My friend, it's all already there, in your own mind."

Old Stories/New Listeners

Kay Stone

KAY STONE RECORDS FOR US a unique story, a practicum of sorts, of what can happen when two scholars are stirred to action by a man and his stories. She shows us how, in the act of studying another's culture, one can be prompted to preserve what is literally a dying tradition. Stone was privileged to be an early witness to Joe Neil MacNeil and John Shaw. We are equally privileged to have her fine written record of what is a most singular and inspiring collaboration between a practitioner of the oral tradition and a practitioner of the academic tradition. This unique collaboration serves as an inspiring cross-cultural model across an artifical divide between an oral culture and academic study.

The dialogue between MacNeil and Shaw, as reported by Stone, underscores how extensive the riches can be when people do not force material—or a relationship—into predetermined packaging but rather trust each other enough to risk uncharted territory. Neither academician nor teller foresaw the exact relationship to the other, to the material, or to audiences. They both showed flexibility and courage in response to the triadic relationship of their work which ultimately suggested a form for them to follow. They gave the stories and the culture from which they came primacy, gradually learned to meet the needs of the audiences, and

arrived at a delightful integration of their styles with the needs of the material and their listeners.

There are many reasons an oral tradition may "die." Stone illustrates the dependent nature of the relationship between story/audience/teller and memory/culture. Without a willing audience, stories can wither not only as the teller's memory fades, but as his will and role as the storyteller is no longer nurtured by the reciprocity of a relationship with listeners.

This paper is itself unique because of what it observes and records. It examines the connective tissue between storytelling and storylistening. It is the only essay strictly written from the perspective of an audience member. In a very tangible way, John Shaw provided a renewing forum for Joe Neil MacNeil. Kay Stone bears witness to this process and provides a widening forum for the work of both men. This is what the literary tradition can do—even after the words have stopped sounding, they can be heard and rediscovered by new audiences.

O n a February morning in 1986 I sat with dozens of other people at the annual Storytelling Festival of Toronto listening to a frail, elderly man reciting a long story in Gaelic. After a few minutes he stopped and sat down while a younger man stood up to translate a summarized segment of the story into monotonous English.

"This isn't going to work," I thought to myself. "It's too tedious." We had heard the two men tell a livelier story the previous night and had come in anticipation of being entertained once more. Instead I was beginning to get a headache from trying to follow the complicated story in two languages, only one of which I understood.

I forgot my discomfort half way through the lengthy tale of a good-hearted young sailor and his encounters with pirates, a corpse, and the King of Egypt's daughter. The chanted cadence of the Gaelic, the gentle intensity and non-theatrical style of both performers, and the story itself, were compelling enough to hold me and the rest of

the audience for most of an hour. Also, it was obvious that the man speaking to us in an unknown tongue relished the tales he was telling—and eventually he also came to enjoy *us*, his uncomprehending but patient listeners, as the festival weekend progressed.

When I spoke with Joe Neil MacNeil, the narrator, and John Shaw, the translator, I learned that they had not faced a formal audience together before and had no idea what to expect.[1] This was surprising, since they seemed entirely competent despite the occasional awkwardness of balancing narration and translation. I spent the remainder of the weekend following Joe Neil and John from one performance to another and talking to them informally about stories and storytelling. I learned Joe Neil had learned his stories in his own community as a young man but had ceased to be an active narrator when the Gaelic language declined. John found Joe Neil's earlier stories recorded on archival tapes and sought him out. Their work together over the next few years eventually led them to the Toronto festival, and here my story begins.

My interest is in Joe Neil MacNeil's return to active storytelling in the late 1970s and John Shaw's indispensable role in this personal revival. Joe Neil's earlier role as narrator in his own community is described in the book he and John Shaw published together, *Tales Until Dawn: The World of a Cape Breton Gaelic Story-Teller*.[2] John has been so directly involved in Joe Neil's success in reaching listeners beyond his own community that to describe just one of them is to tell only half of the story. What they have accomplished together is, in my experience, a unique approach to "tandem" storytelling.

My initial contact with Joe Neil and John was as an eager listener and not as a folklorist-researcher engaged in a careful study of narration. I emphasize this in hopes that others will find in my comments some useful information for their own work. My observations are based on attending every performance Joe Neil and John offered at three of the annual Toronto festivals, from conversations with them during the festivals, and from letters exchanged with John Shaw over the past five years. I have been curious to know how they evolved from the more usual roles of informant / researcher into dual performers; why they chose to take their traditional art to a major

professional festival; how this change of performance context has affected both the tellers and the tales. Joe Neil and John offer a manner of performance that touches on issues relevant to the "storytelling revival" of the past two decades.

Joe Neil MacNeil—Eos Nill Bhig—was adopted into the MacNeil family of Middle Pond at the age of six months. At this time Gaelic was still a fully vital language in Cape Breton, and the only language spoken by Joe Neil's adoptive parents. He says of himself: "I spoke only Gaelic when I was young, but I used to make some effort to pick up a bit of English here and there, though I spoke only the odd word" (*Tales*, 3). His curiosity with language, and eventually with storytelling, was to lead him into a life-long diversion that eventually caught the interest of scholars studying Canadian Gaelic.

Like Ray Hicks of Beech Mountain, North Carolina, Joe Neil is not a casual teller of tales but a master performer with enumerable lengthy stories learned within a traditional oral community. Both men have succeeded in bringing an ancient body of oral literature to new audiences unfamiliar with the stories, the language, and the culture in which they were developed. However, neither teller initiated this on his own; both were "discovered" by outsiders who appreciated their stories and saw the potential for carrying them to a wider audience. In the case of Joe Neil, it was John Shaw, a Gaelic researcher, who "discovered" him in 1975. John was working in the archives of the College of Cape Breton in Sydney, Nova Scotia, when he heard a tape of a lengthy Gaelic tale and was impressed with the linguistic abilities and esthetic sense of the storyteller:

> A recording that caught my attention was a version of *Nighean Righ na h-Eipheit* [The King of Egypt's Daughter], delivered with a sureness of detail and a command of Gaelic that I recognized as the work of a master story-teller. The same command of language—without apparent effort or limitations—impressed me again when I met Joe Neil some weeks later. (MacNeil, xv-xvi)

After this meeting Shaw decided to begin recording what Joe Neil could call back to memory of that story and others. The two men worked together for the next few years patiently reconstructing fragments of tales that gradually returned to life as full, vibrant oral compositions. One concrete result of their collaboration was a book (actually two, one in Gaelic and the other in English) containing Joe Neil's wealth of oral lore arranged according to families and individuals from whom he had first heard the various items. Of the fifty-two full-length narratives recorded in the book (not the whole of his repertoire), there were only two for which he could not remember sources. He claimed not a one of them as his own, saying modestly in his preface:

> Please do not regard me as deserving of any special praise but see this book as a tribute to those living in times past who were gifted, kindly and sensible, and generous with their store of tales. (MacNeil, ix)

Joe Neil is so entirely generous and modest that you would never know from his own words that "their store of tales" was not so easily available to him because the tales were told only in Gaelic. By the time Joe Neil was of school age, children caught speaking Gaelic were vigorously punished by the teachers. Shame was the most effective weapon, so much so that many gave up their own language in public. Joe Neil, however, clung tenaciously to his language despite this. He noted that an illness kept him out of school for the first year:

> And I am sure that is the reason even until today that I have such an interest in Gaelic, for Gaelic is my first language and it is still the language that I prefer. (*Tales*, 4-5)

I did not detect a hint of bitterness in his words, but rather a quiet pride in the beauty and strength of the language. He goes on to suggest that he was somewhat different than other children in that he sought out older people instead of avoiding them, and this of course gave him even stronger connections to well-spoken Gaelic— and to the old stories. But as the older tellers died, Joe Neil was left

without sources for stories, and also without an audience, since many of his own generation could not speak the language well enough. Fortunately Joe Neil had an excellent and active memory, which allowed him to call back the wealth of tales he had learned years earlier, once he had a reason to do so.

In the years of careful work with John, Joe Neil regained his role as an active rather than passive tradition-bearer. He not only recalled and described what he remembered from earlier years, he was able to return it to life. Still, he no longer had any listeners—other than John—for whom to perform. There were still a handful of Gaelic-speaking contemporaries very eager and willing to listen to Joe Neil, but they could not function as a regular audience because they were too few and too scattered to form an actual community of listeners. John understood that such an audience was necessary for Joe Neil and began to seek out performance occasions in which Joe Neil might be comfortable.

In 1986 they travelled to the annual storytelling festival in Toronto to seek their fortune, in the manner of the folktale protagonist and a magical helper. Shaw comments on their debut in a letter I received in the fall of 1990:

> You may have seen our first performance ever, in Toronto, in, I think, 1986. This was for an English-speaking audience. The manner felt, at least, to be *ad hoc*. I doubt this had ever been tried before, but this was the only way I could think to present the stories, Joe Neil, and the language to a mainstream audience. This was also the only active way that presented itself to bring the material to a larger audience.

I remember that first night. Some seventy-five people sat around tiny tables in an old synagogue that was now an art school by day and a performance space by night. Candles burning on each table provided the only source of light. Joe Neil and John were the first performers, invited by host Dan Yashinsky to take the stage as the honored guests of the festival, which was to begin officially the following day at a large old church on Bloor Street several blocks away.

The setting was anything but elegant and perhaps this was for the best, since Joe Neil seemed surprisingly at ease in the casual setting. There was no formal stage, just a small space on the bare wooden floor, and no microphone to separate him from his listeners. After they were introduced, Joe Neil and John came to the front and sat down in grey metal folding chairs, bringing the chairs closer and turning them slightly inward so that the two men could see each other as well as their listeners. After exchanging glances and looking out to greet us with shy smiles, Shaw stood up and briefly introduced them and described what they intended to do: MacNeil would narrate in Gaelic and Shaw would summarize in English.

They nodded to each other, a shared signal that was repeated each time I saw them perform; then Joe Neil stood up and began to speak in Gaelic. His focus was inward rather than out to us, though he acknowledged our presence with occasional nods. He told the story with a minimum of movement, facial expression, or voice changes, though his personal involvement in the story events was apparent from the calm intensity of his voice. Sometimes he looked out over our heads as if he were seeing the action of the story in the distance; other times he looked intently at John, the only one who understood his words in this audience of non-Gaelic speakers.

Despite the seeming distance between us, it was obvious that something interesting was taking place, as there were none of the usual signs of audience restlessness. There was a cadence and a power to his tales that seemed to break through the language barrier; and there was Joe Neil himself, so unselfconsciously immersed in his story that even an uncomprehending audience was no hindrance to his flowing words.

After a few minutes he stopped abruptly and smiled out at us, nodded to John, and sat down. John took the floor and began a brief summary of the exploits of the legendary carpenter and trickster Boban Saor, who exchanged clothing with his inexperienced apprentice in order to fool some strangers who had come to see if he was as masterful as people believed him to be.[3] John sat down and Joe Neil continued the story of Boban Saor's clever prank with greater enthusiasm, responding to our growing interest in the story now that we

had some clues to its progression. By the time John had summarized
the final segment, the audience as a whole was completely attentive,
including the few youngsters, who had ceased fidgeting.

It was an excellent choice of stories; we, like the strangers who
had come to test Boban Saor, were curious to know if this legendary
master, Joe Neil, was as good as we had been told—and if his
"apprentice" was worthy of his mentor. Translation alone would not
have been sufficient to hold our attention. What John had accom-
plished was transformation, not merely translation. We, like the
stranger, left convinced that we had indeed been in the hands of
experts who were equally skilled in their work.

"Boban Saor" was much briefer and lighter than others Joe Neil
and John told during the formal part of the festival over the next two
days. The much more complex "The King of Egypt's Daughter,"
mentioned above, seemed at first to be far less engaging than "Boban
Saor." As a wonder tale or fairy tale (termed *Marchen* by folklorists)
it was it much longer and obviously more serious; both tellers were
so caught up in the intricacies of the tale that they seemed less aware
of the audience; thus we felt more distant, cast adrift like the young
sailor in the story. But, like him, most of us found our way to solid
land and were rewarded for our perseverance by following the
adventures of the tenacious young protagonist.

Joe Neil was delighted by the warmth and receptivity of the
listeners, and responded by coming further out of his stories as the
weekend progressed. Instead of focusing on John, as he had been
doing, he looked out at his listeners to note the reactions, both when
he was narrating and when John was translating. As the weekend
progressed, both men were able to test their abilities as effectively as
had the characters in their stories. One would not have guessed that
Joe Neil's fine tales had been largely dormant for years, and that John
himself had no performing experience. John emphasized this in a
letter:

> Joe Neil, as far as I know, was not an active storyteller before I met
> him, although he clearly had the capability to be so. He recorded some

stories for an archive in 1975, and had recorded earlier for at least one Gaelic-speaking fieldworker. (letter, 1990)

In my letter I had also asked John how he and Joe Neil came to work together as actual performers rather than as informant and collector, which is the more usual relationship. He replied that he gradually realized that Joe Neil deserved a good audience, and the only way to find one was to agree to accompany him as a translator, since Joe Neil felt that the stories had to be told in Gaelic. Shaw understood that it was necessary to take Joe Neil and his stories into a new context. On his part, he was willing to do the necessary work, including learning to face an audience himself in order to do so:

> The crux of it is that this is the *only* real audience going for Joe Neil's material. Dealing with this new audience, I feel, has been an important experience for Joe Neil & has had a constructive effect on his understanding of the importance of his own tradition and the larger context of which it was a part. Now that nearly all of his own generation is gone, along with their acuity of mind and ability to listen well, the mainstream may be the source of people who are broadminded and thoughtful enough to relate to the material. (letter, 1990)

Since both men are by nature modest and reserved, it was an even greater challenge to brave an unknown audience in Toronto. John described the difficulties of his own situation:

> I felt very much the mediator here between Joe Neil's very high standards of content accuracy/verbal skills and a well-disposed, expectant audience with no previous exposure and who knows what expectations. At first in my job there was not much room to move: It was all I could do to keep the details straight and put them into some kind of coherent English. My verbal understanding of the stories had always been as I had heard them in Gaelic, and giving them in English, especially at first, felt like trying to play a tune you knew on a fiddle left-handed. (letter, 1991)

Learning to perform together required a great challenge for both men. Joe Neil had been accustomed to an intimate community

setting where both his narratives and his language had been fully familiar to his audience and where he was acquainted with his listeners. Shaw was not a storyteller at all and had to develop the basic skills of presenting a coherent narrative accurately and engagingly without imposing himself on the story at all. By the end of the 1986 festival, it was obvious from the enthusiastic responses of listeners and the growing ease of these two tellers that they had accomplished their impossible task.

One of the festival organizers, Dan Yashinsky, recalls Joe Neil's comments at that first festival:

> I remember Joe standing up at a brunch at the Festival a few years ago and talking about how even *he* thought he'd forgotten all of his stories until John came around and started listening to him. His own community had stopped giving his story tradition much value, at least publicly, and had certainly stopped providing a continuity of listeners with whom he could exercise his powers of memory and performance. And as Joe tells it, they were both surprised by what came forth. "We were scraping the bottom of the barrel," Joe said—and then they seem to have turned the barrel into one of those magic fairy tale vessels which provides abundant, and always replenished, stores of good stuff. (letter, 1991)

The two were so well-received that they were invited to two more festivals and were delighted to accept. Their performance skills continued to develop over the three years, particularly in the case of John Shaw, who did indeed learn "to play a tune you knew on a fiddle left-handed."

Joe Neil, too, had responded to the challenge of attentive listeners. This was most clearly revealed at the 1990 festival where he chose to relate a forty-five-minute tale in English that he had found in a Scottish collection. Since he no longer had a living source for new tales, he was compelled to seek them out in print. His task was doubly difficult: not only was he drawing from less familiar material in written rather than oral form, he also chose to tell the story in English rather than the original language—and without

John's help. However, he still had the advantage of his experiences within a rich oral tradition to support him.

I sat directly in front of Joe Neil in the first row, eager to take in every word. At first he was obviously anxious about standing up there alone, without John sitting beside him ready to help. But once he had launched into his story he displayed the same unselfconscious concentration that he had in his Gaelic presentations—a calm intensity that demonstrated his deep involvement with the story and its characters. We now had the great privilege of hearing his eloquence and precision firsthand. Though he called it "reciting," the story was in his own words.[4]

John Shaw notes, in *Tales Until Dawn*, that each narrator had his own artistic techniques for bringing a story to life, some relying on language and style, others on elaboration of detail or vivid imagery, while some delighted in lively dialogue between characters.[5] Joe Neil, Shaw says, was particularly talented in both imagery and dialogue, as was apparent when we were able to hear him perform his own story in English. My handwritten notes scribbled on the festival program capture one of the many vivid phrases used in his lengthy story of a heroic quest. Here is a description of a threatening ogress his hero has encountered in a mountain cave:

"She had one great eye in her head like a pool of deep dark water, and her gaze was as swift as a winter mackerel."

His very fine, dry humor was also apparent in his choice of words and phrases as well as in his sly glances at his audience. For example, he commented on the raven who wanted a quid of tobacco as payment for helping the hero: "I guess he wasn't afraid of the cancer."

John emphasized that along with Joe Neil's artistic skills, his deepest interest in the stories was with the characters and their interactions:

> His main concern is with the psychology of the story, using the relations between events to elicit the pathos or humour from the characters' situations with a frequent emphasis on the moral

implications of the tale. This is all expressed through language which, although not ornate, is slightly formal. (*Tales*, xxxii-xxxiii)

We were able to experience Joe Neil's involvement with the tale firsthand, and to appreciate more directly the consummate artistry of his performance. The "slightly formal" language did not detract in the least from his involvement with each of the characters. In this way, Joe Neil resembles the skilled Siberian narrator, Natal'ia Osipovna Vinokurova, whom Russian scholar Mark Azadovskii has studied in depth.[6]

I questioned Shaw about Joe Neil's response to his experience of narrating a complex tale in English; Shaw wrote that he thought it had been as significant for Joe Neil as it was for us:

> Joe Neil viewed telling a full-length story in English as a challenge, and it took some courage to do this. I had encouraged him in this, and after an instant's confusion when I left him on his own, he went about the work quite naturally, as I knew he would. It seems to me that telling stories in English ["translating" is what Joe Neil calls it] is part of a constant effort to stretch himself and extend his skills. Since he was 80 Joe Neil has worked on and mastered, from books, at least two of the truly big Gaelic stories which to my knowledge have not been told anywhere for close to 40 years now [including Scotland]. (letter, 1990)

John Shaw, too, has been willing to take up the challenge of stretching himself by learning and occasionally telling stories in a second language learned as an adult, and not as part of his own background. He set off for Scotland as a young man, wandered about the more isolated regions learning Gaelic as he went. When he returned to the United States, he began to study the language and culture formally, and in the 1970s succeeded in finding a research job in the only Gaelic-speaking region on this continent—Cape Breton Island.

Shaw, with his knowledge of Gaelic and his deep respect for the tradition, would seem to be the most obvious person to carry on MacNeil's tradition, but when he was asked by someone in the

audience if he considered himself to be MacNeil's apprentice, he said that he could not do so. Later when I pressed him further, he responded:

> In order to be a true apprentice to Joe Neil a person would have to be training to be a full-fledged Cape Breton Gaelic storyteller with Gaelic as the primary language. Although I would view this as one of the more worthy and productive intellectual pursuits this part of the world has to offer, to do so would be unrealistic because these days there is no real audience for this. (letter, 1990)

He went on to say that while the tales might be taken into an English language tradition they would, in his opinion, eventually lose their power: "The long tales, which are the heart of the tradition, have been unsuccessful at crossing the language boundary as active material." In their book, he comments further that the longer narratives have not "crossed over into English," though some of the shorter and more humorous genres as well as a few belief legends (stories of strange happenings) have been more successful (*Tales*, xxv).

While the future of Gaelic storytelling in Cape Breton is in doubt, MacNeil and Shaw, at least for a brief but significant time, have managed to re-enliven a great narrative tradition. Both men together have been able to achieve what neither could have fulfilled separately. As Dan Yashinsky notes:

> The thing is not to merely record the stories in a mechanical way, but to put yourself directly in the path of the tradition. What John's up to is the affirmation of oral tradition not only as an "artifact" but as a living source of value, something in need of live practitioners. (letter, 1991)

John had no intention of becoming a performer himself, but saw himself mainly as translator and as cultural broker between Joe Neil and "mainstream" audiences. He did, however, recognize improvements in his own presentations:

Our performing has been sporadic, but within the last year or so [1989-90], due to practice, I've been able to do my part more easily, describing in English the visual scenes that Joe Neil gives through Gaelic. The feeling is one of more freedom in bringing across the nuances that I hear in Joe Neil's telling while giving the content of the tales. This is all easier and more comfortable than it was at first. In many ways my mind is able to work very easily with Joe Neil's; I think if I did the same kind of summarizing with another storyteller it would take some time before I felt comfortable. (letter, 1990)

It was the experience of actual performances before living audiences, after ten years of working together to reconstruct the stories, that allowed John Shaw and Joe Neil MacNeil to return an ancient art to full vitality. This is certainly a "storytelling revival" in the most complete sense—though both Joe Neil and John might argue that the tradition and the stories had never quite died at all, and were in need of a healthy transfusion rather than full resuscitation. New listeners provided exactly that.

Traditional communities almost everywhere in the contemporary world have undergone rapid and radical transformations that have resulted in the loss of artistic forms and expressions like oral narration. We should remember, though, that changes in social and technological patterns have always been a natural part of human existence; tellers who wished to keep their art fully alive have met challenges with innovative responses. I emphasize this to avoid the stereotype of oral tradition as an unchanging, "pure" expression that suffers from innovation. Quite simply, active narrators cannot survive without good listeners, and when their audiences change they must respond without losing the rich heritage upon which they depend. It may even be necessary to seek out new audiences in unfamiliar contexts.

An engaging example of narrators actively pursuing their own audience is described by narrative scholar Linda Dégh. She worked with two aging Hungarian women who had been active tellers in Hungary, then in their former ethnic neighborhood in Gary, Indiana, but now lived alone in separate suburban areas. They managed to

keep their stories alive by telephone calls to each other but resourcefully sought out new listeners as well, regaling delivery men, canvassers, postmen, or anyone else who turned up on their doorsteps. The fact that their hapless listeners could not speak Hungarian did not discourage the women, who were determined to maintain their lengthy legends and tales at all costs.[7]

It is not so surprising, then, that skilled artists like Joe Neil MacNeil and Ray Hicks have succeeded in accommodating themselves and their stories to new audiences and new contexts. Even if listeners could not always follow the language of their tales (Ray Hicks's Beech Mountain English is often as incomprehensible as Joe Neil's Middle Cape Gaelic), the proficiency of these artists has been compelling enough to captivate audiences unfamiliar with the oral communities in which the tellers and their tales originally blossomed.

These two tellers have succeeding by meeting the challenge of entertaining new listeners in performance contexts quite unlike the more intimate settings of their original communities. While they have certainly had to make their own adjustments to this new context, their listeners have also had to adapt to understated performance styles and to stories that are difficult to understand. Each blossomed by meeting the challenges and enjoying the stimulation of festival audiences. Rather than maintaining the material with which they were most comfortable, they have found other sources for narrative material. Ray Hicks has added more biographical content to his performances while Joe Neil MacNeil, with John Shaw's help, sought out traditional Gaelic material from printed sources. In other words, they have not passively maintained oral tradition but have found new ways of keeping their rich legacies fully alive. Joe Neil, of course, had the benefit of John Shaw's generosity, perception, and good judgment.

Bert Wilson's useful continuum of situational, conscious cultural, and professional storytellers is useful here. While less experienced situational and conscious cultural tellers might be more easily discouraged by the loss of supportive and familiar listeners,

the more active professional tellers are ready for an opportunity to perform and are willing to adapt to the situation.

However, innovation is not subordinate to tradition. The sense of stories being part of a wider inheritance, not merely one's personal possessions, inspires a balance between traditional stability and individual innovation. Respect for the community of tellers and for the tales themselves is paramount. As Shaw notes, Joe Neil's only audience for a while were the occasional collectors who came to listen respectfully and to record his tales. Joe Neil was willing to comply because he sensed this respect. As John notes for tellers of Joe Neil's calibre:

> Characteristic of outstanding Gaelic informants is their willingness to record for the serious collector. Once the informant's confidence is gained, such a task is perceived as a duty growing out of their unspoken role as guardians of their people's tradition. (*Tales*, xvii)

Shaw's deep respect for Joe Neil MacNeil and recognition of his latent potential brought a rich store of tales out of the archives and into the challenging setting of active performance.

Ray Hicks, too, has been more than willing to share his rich store of traditional and personal stories with serious collectors as well as large festival audiences. Like MacNeil, he regards himself as an heir to a rich local tradition. Folklorist Cheryl Oxford, who has worked extensively and intensively with Ray Hicks and his relatives Marshall Ward and Stanley Hicks, emphasizes Ray's conscious sense of responsibility:

> Perhaps because of his long apprenticeship in the communal wisdom of his mountain kin, Hicks is unwilling to relinquish his patriarchal role as storyteller to just anyone. He believes that these stories impart the collective memories of a kindred people.[8]

Both MacNeil and Hicks are so immersed in their art that they sometimes seem altogether oblivious to the platform performance context; at other times they respond directly and engagingly. Oxford

describes Hicks' penchant for fixing his total attention on specific listeners:

> In contrast to these moments of reverie, however, are examples of Hicks' flair for showmanship and comic relief. He may emphasize a point in his telling by holding a member of the audience with a wide-eyed stare, leaning closer while watching for a reaction, as if daring her to laugh or express disbelief. (Oxford, 13)

While MacNeil is less aggressive in manner than Hicks since he is aware that listeners cannot understand the tales he tells, he has become delightfully aware of his listeners. He looks out at the audience and offers occasional smiles and nods as his narratives progress. Both tellers are also eager to talk about stories and story-telling before or after performances. They do not think of storytelling as an activity separate from other parts of their lives, nor something to be guarded as a personal treasure. They are fully aware of themselves as skilled artists and also retain a keen sense of obligation to those from whom they learned their stories.

Part of this feeling of guardianship is a deep understanding of the inherent timelessness of their stories, a continuing relevance that goes beyond specific historical community and individuals. As Joe Neil remarks about some of the stories he remembers:

> They were exceedingly lengthy tales and their subject matter was so strange. In a way they were just as strange as some things that could happen today, but at the same time so understandable; you could understand everything that was there—every misfortune and hard-ship that they encountered. (*Tales*, 16)

Joe Neil and John have each had to learn as they performed, constantly accepting the challenges of balancing narration with translation and improving their performance skills for a less knowl-edgable urban audience. But their listeners have also been willing to adapt. Toronto audiences have listened eagerly and respectfully to Joe Neil's lengthy, incomprehensible narratives and John's careful translations. They have responded to the verbal artistry and personal

warmth of the man for whom storytelling seemed as natural and fundamental as breathing, and also to his helper whose obvious respect made the performances comprehensible as high art. Toronto storyteller and author Celia Lottridge, for example, recognized what the two had accomplished and acknowledged their impact on her as a storyteller:

> You know, when we had Joe Neil here, he does come out of oral tradition, and he's made himself a person who takes a tradition he really grew up with and stories he heard orally, and he's seeing himself as the lone person who's really doing that. I mean, he's gathered up stories that maybe he wouldn't have told if he had just gone on in an oral culture. But he still comes out of that background. I've found that listening to those people [Joe Neil and John] to be extremely illuminating, and it puts what I do into some broader context. (taped interview, Toronto, June 1993)

As Celia and others noted, both men were so fully engaged in the stories as lived experiences that their sense of presence invited audiences inside their tales. I overheard one listener remark to a friend: "Well, now I know stories aren't just something you tell or hear—they're something that *happens* to you when you tell or hear them."

In three years of observing Joe Neil and John perform at the Toronto festival (1986, 1987, 1990), I have noticed that they have altered the context as much as they have been altered by it. This is significant in a performance milieu where many modern tellers feel that traditional material needs to be dramatically transformed (often through parody) to suit contemporary listeners. On the other end of the scale are those who feel that traditional tales are to be told in their "original" form (that is, word for word as they exist in print) in order to retain their purity. For Joe Neil, stories, even those he sought out in books, were always alive and relevant and authentic. They did not require purist preservation or heavy-handed modernization.

Joe Neil MacNeil reflected thoughtfully on storytelling as an immediate experience, even when he was speaking nostalgically of

his own early experiences. What he remembers most clearly is the immediate personal face-to-face exchange:

> You were alive with them [the tellers he recalls by name] there in the flesh and participating in the whole event. You could talk to them right there, but if you ever chose to address the gadgets I mentioned [radio and television] they could never answer you. So there was the pleasure and a sense of unity. I think that people felt very united, united physically and united in spirit. (*Tales*, 10)

For Joe Neil, of course, unlike most of us who bring stories to a stage setting, storytelling grew from a communal base rather than from individual efforts. He modestly stated, as Shaw said earlier, "My own experience was ordinary enough," meaning that he had been only one of many skilled narrators who felt a deep connection to his tales as part of a much larger whole. His devotion as a "conscious cultural storyteller" inspired him, when the opportunity presented itself, to evolve into a fully skilled "platform performer"— with the help of a scholar who wanted to record as well as to bring to full life the verbal artistry of master narrator.

This article is an attempt to recreate in words what has been only partially verbal. Anyone who has tried to transform oral material into print will understand my sense of dissatisfaction with the one-dimensional results that can only hint at the exhilarating reality of being there at the re-living of an ancient traditional art.[9]

Both scholars and storytellers are professionally engaged in a revival of sorts—that is, in attempts to recreate anew what originated in some other form of expression. Scholars, in this case folklorists and anthropologists, try to recreate the event as accurately as possible by describing it in ways that measure, weigh, compare and contrast. The highest ideal is to present in words (and this includes charts, graphs, and other statistical tools) what has existed orally for a few fluid moments, not only for the scholarly viewer but for the participants as a whole.

I take to heart Del Hymes' counsel to remember that "the stories were entertainment, too":

> Scholars are sometimes the last to understand that these stories were
> told and told again, not simply to reflect or express or maintain social
> structure, interpersonal tensions, or something similar, but because
> they were great stories, great fun. (*"In Vain,"* 22)

Storytellers have a challenge different from scholars, being at-
tuned to the living event in a different way—as a model for
presentation within their own experiences and interests as
performers. They "recreate" the event not by describing it as
accurately and objectively as possible but by retelling the story
themselves, to another audience in a different context. The danger
here is ignorance of the rich soil in which any given story took root
and flourished as well as lack of understanding and respect for the
generations of people who contributed to this continuing artistic
creation. The story itself is only a part of this creation, one link in a
long chain of human interaction and reflection.

I have learned a great deal from the combined performances of
Joe Neil MacNeil and John Shaw. As a folklorist, I was impressed
with their dedication to storytelling as a living legacy of both com-
munity and individual artist, and with the careful way in which they
brought this art into a new performing context without losing the
integrity of either the tales or the telling of them.

As a storyteller, I gained new perspectives on issues now central
to "platform performance" contexts: conscious standards of excel-
lence in training and expression; the ethics of public presentation
(notably "ownership" of tales); relations between tellers and
listeners before, during, and after performances; the individual
artist's commitment and responsibility to a wider community as well
as to the stories themselves. Any one of these topics would require
another essay, so I only mention them here to suggest further
possibilities for exploration.

The last words belong to Joe Neil MacNeil. In describing one of the
tellers remembered from childhood, Joe Neil echoes his own joyful
approach to storytelling:

Angus [MacIsaac] was full of a kind cheerfulness. He used to tell stories and he could make them up as well. He made them up in great numbers and with ease. And he could invent long ones, too; some of his tales were extremely long. He knew himself that they were not true and when he was finished telling one of these big stories, after he had let out a little laugh, he would say, "And that's no lie." (*Tales*, 95)

And indeed it was not.

NOTES

1. I also did not know that Joe Neil's story, "The King of Egypt's Daughter," was the same narrative John Shaw first heard on tape and recognized as the work of a master storyteller.

2. MacNeil, Joe Neil, *Tales Until Dawn: The World of a Cape Breton Gaelic Story-Teller*, trans. and ed. John Shaw (Kingston, Ontario and Montreal, Quebec: McGill-Queens University Press, 1987).

3. John commented on this story in an undated letter I received in February of 1993:

The Boban Saor story we told on the first night was one of two that did not appear in *Tales Until Dawn*. As far as I know it has been recorded only once in Scotland and nowhere else in Cape Breton. Summary: Boban Soar hears that people were coming to put him to the test and see whether he is equal to his reputation as a carpenter. He sees them approaching from afar, exchanges place and role with his apprentice, begins planing an adze handle. He uses his eye to measure the handle for the adze head lodged in a vice at the other end of the work table. When ready he throws it and the handle fits perfectly into the eye of the adze head. The strangers walk out, saying to each other: "Did you see what his apprentice just did? Well, if the apprentice can do that, imagine what the master can do." They never returned to test Boban Saor.

4. Master narrators, like the Yugoslav epic singers studied by Parry and Lord, do not build their stories word for word but rely on favored phrases and images around which their narrative is recreated anew at each performance. For a detailed and still classic study of the oral process, see: Alfred Bates Lord, *The Singer of Tales* (New York: Atheneum, 1970).

5. John elaborates on this:

Within the carefully transmitted framework of the tale, the story-teller was an active, frequently vigorous "shaper of tradition" whose personal, creative role in telling the story was known to Middle Cape story-tellers as *Eideadh na Sgeulachd* "The Raiment of the Tale." The devices used to achieve this differed from person to person, depending on a narrator's ingenuity and talents. (*Tales Until Dawn*, p. xxxii)

6. Mark Azadovskii, *A Siberian Tale Teller*, translated from Russian by James R. Dow; Monograph Series No. 2, Center for Intercultural Studies in Folklore and Ethnomusicology (Austin, Texas: University of Texas Press, 1974).

7. Linda Dégh, "Two Old World Narrators in an Urban Setting," *Kontakte und Grenzen: Probleme der Volkskultur-und Sozialforschung* (Göttingen: Otto Schwartz, 1969), 71-86.

8. Cheryl Oxford, "Jack in the Next Generation: The Intra-Family Transmission of a Jack Tale." Paper presented at the annual meeting of the Speech Communication Association in Atlanta, Georgia, October, 1991; 6.

9. This problem is disquietingly familiar to folklorists and ethnographers. Two particularly thoughtful and challenging books on the topic are: Dell Hymes, *"In vain I tried to tell you": Essays in Native American Ethnopoetics* (Philadelphia: University of Pennsylvania Press, 1981); and Dennis Tedlock, *The Spoken Word and the Work of Interpretation* (Philadelphia: University of Pennsylvania Press, 1983).

Old Stories/Life Stories
Memory and Dissolution in
Contemporary Bushman Folklore
Mathias Guenther

MATHIAS GUENTHER OFFERS what we considered one of the more unsettling essays in this collection. Its poignant documentation of the centrality of the storyteller for a people and the life of their culture moved us. Guenther, who lived and worked with the Bushmen of Botswana, witnessed continuing upheavals and powerful aftershocks of centuries of colonization in Bushman cultures. He details its direct impact on storytelling events, the stories, the tellers and their lives. As a whole, his work draws connections about the complex relationship between the health of a culture and the health of its oral traditions. We also saw an implicit connection between the health of a culture and the aesthetics of its oral traditions. When we communicated this to Guenther, he wrote to us:

> *Like you, I also think that [the essay] addresses itself to the theme of aesthetics as the constituent elements of beauty—[which] according to some [are] radiance, harmony and wholeness. A narrative, then, that addresses the supernatural and the numinous whole while, at the same time, informing, and being informed by, the personal and collective life*

*experience of the narrator and his generation does, by virtue of these lineal
and lateral, spiritual and social linkages, conform to some of these quali-
ties of the aesthetic.*

*His essay documents the tremendous loss to the world when indige-
nous cultures are fractured by the "natural" evolution of "progress" in
the modern age.*
[For pronunciation guide, please see Heckler, p. 16.]

*T*his essay[1] consists of a handful of texts[2] of complete or partial
versions of the Bushman (or San) myth of the origin of death.
They are told by 19th-century /Xam and contemporary Nharo sto-
rytellers, from the Cape and western Botswana respectively. While
constituting part of the same mythological tradition, the variants
provided of this key Bushman myth by the two sets of informants
differ substantially in style and content. I attempt to explain the
differences in terms of the life experiences of each of the
contemporary Bushmen. These affect each narrator's personality
and *Weltanschauung* and, in projecting these into his rendition of the
narrative, its moral and conceptual substance becomes altered
accordingly.

A century separates the two sets of accounts of a myth that is as
widespread within Bushman oral literature as it is old. The story of
Moon-Man and Hare-Child, and the origin of death among mankind
is, in fact, the most widely told of all Bushman myths.[3] It was
presumably the key item in the narrators' repertoire among the
beach-combing Cape San, the Kalahari hunters and herders, and the
fishing River Bushmen of the Kunene and Okavango Rivers in
northern Botswana and Angola. It is prominent also within the myth
corpus of the Khoikhoi, a herding people with close physical and
cultural links to the Bushmen. The myth has also found its way into
the oral traditions of some of the Bantu-speaking neighbours of the
indigenous Bushmen.

My exploration of the world of Bushman myths began with this story. It was the first Bushman myth I had ever read, prior to going to the Kalahari for my doctoral field work in the late 1960s. I had read versions and summaries of the myth, in what was published of the exquisite collection by Wilhelm Bleek and Lucy Lloyd (Bleek & Lloyd 1911:57-65, Bleek 1875:9-10; Lloyd 1889:7). This represents approximately half of the 12,000 or so notebook pages of texts collected by these two "faithful workers," the two pioneers of Khoisan linguistics and folklore who did their collecting among some of the last remaining /Xam Bushmen of the Cape.

Later on I had occasion to work with the Bleek-Lloyd collection and the following excerpt, recorded in 1873, is taken from the un-published materials. It was told to Wilhelm Bleek by /A!kunta, a young and exuberant, if inexperienced storyteller. In this lengthy account (consisting of seventy-nine notebook pages), the Moon is the person telling the story. In the excerpted passage, Moon contrasts his own celestial immortality with the mortality of "things that walk the earth": antelopes, birds, carnivores, humans. Like the roll-call of the animals entering Noah's Ark, the "flesh-things" are listed by species, twenty altogether. The selected passage leaves out those species for which Lloyd could not provide a translation—some with beguiling onomatopoeic names, such as the //'koä, the !kon!kouru, the !koen/ku and the kwakwara.

> I die, I live; living, I come again;
> I become a new moon.
>
> Man dies; man, indeed, dies; dying he leaves his wife.
> When I die, I return, living.
>
> The gemsbok. The gemsbok dies, the gemsbok dies, altogether.
> The hartebeest. The hartebeest dies, the hartebeest dies, altogether.
> The she-ostrich. It dies, it indeed dies.
> The kudu. The kudu indeed dies, and dying, it goes away.
> The springbok. The springbok dies and, dying, it goes away forever.
>
> Myself, I die; living again, I come back.

The korhaan [bustard]. The korhaan dies; the korhaan, dying, goes
away.
The cat does [die]; it dies. The cat goes away, dying.
The jackal. The jackal dies; dying, the jackal goes away.
The lynx goes away, dying.
The hyena. The hyena dies, it goes away, dying, dying.
The eland. The eland dies and, dying, it leaves.

Myself, I die. Living again, I come back. People see me; people say:
"Look, the Moon does indeed lie here; it is grown, it is a Full Moon."

Things which are flesh must indeed die and, dying, go away. For they
are the ones that walk on the earth; so it is with them. I am one who
must do otherwise, one who sails in the sky.

Things which walk the earth, they are the ones who, dying, must go
away.
Myself, I walk in the dark.
In the darkness I sail
I sail, gazing from the sky above.

 The second selection is by Dia!kwain, who provided Lucy Lloyd
with a large body of texts which tended to be unfanciful, reflective,
and didactic in their emotional tenor.[4] The full story has been pub-
lished (Bleek & Lloyd 1911:57-65). In its hectoring and exclamatory
tone, it is consistent with this storyteller's general narrative and
moral bent.

 It was because of the hare's doings that the Moon cursed us, that
 we should die, altogether. When we died, then, we could have re-
 turned again, living. The hare was the one who would not believe the
 Moon when he was willing to talk to him about it. He contradicted
 the Moon.
 For this reason the Moon spoke, saying this: "You, who are people,
 when you die, you shall die altogether and vanish. For, once I said
 that you should rise again, when you died; that you should not die
 altogether. For I, when I am dead, I again return. I live again. What I
 had intended was that you, who are humans, should be like me in
 that matter. Like me, you, too, should not die and go away forever.

That's what you, who are mankind, will do when you die and for this reason I thought I would give you joy."

"When I told the hare about it—knowing that his mother was not really dead but only asleep—the hare said, no, his mother did not sleep, but his mother had really died. It was this that I became angry about, thinking that the hare might say: 'Yes, my mother is asleep … She lies sleeping; she will arise presently.'"

If the hare had believed the Moon we, who are people, would have come to be like the Moon: we should not die, altogether. The Moon cursed us on account of the hare's doings, and we die, altogether.

When I asked my own two teachers, Tsao and N/umiko, for some *hua* ("old stories," of the old people) one of the first tales I was given was the story of Moon, Hare-Maiden, and Death. Having recorded a couple of summary accounts of the myth from other narrators, I received a version each from Tsao and N/umiko. These two Nharo elders were my language teachers at the beginning of field work and my chief informants and friends for the rest of the time. The occasion and storytelling context was an outing that I went on with the two men, as well as my interpreter and field assistant Tsaxa, about four months into field work. We left /Oaxa, a small village attached to one of the large, European-owned and mission-run farms of the Ghanzi district, to stay overnight, camping in the veld, away from the pressures and tensions of life and work at the overcrowded mission farm. It was the first of a number of such outings which the four of us enjoyed and found relaxing and well suited for storytelling. The basic—and, to Bushmen, golden—rule was one of reciprocity: I would provide transportation and food—a pick-up and a side of goat, mealie meal, tea, sugar, biscuits and tobacco. They were the ingredients for a rare and cherished food-feast. In return, they would provide *hua*. These came up, over tea and a shared pipe, around the fire. Our unspoken agreement was that *hua* would be provided by my guests as long as tea and tobacco were, in turn, forthcoming from their host.

Tsao, the older of the two men, began:

There is an old apron and an old blanket on the face of the moon. These are from the hare. She was making them hot on the fire and she put them on the moon's face. And the moon tried to scratch the blanket and the apron off his face.

You see that the moon is black on the other side while it sometimes shines on this side: this is because he is trying to scratch off the blanket. This is why the moon has many colours.

And the hare said: "You will be dead and being dead, never come back. You and all of your people!" After the hare had said that the moon went back and he said: "This woman is saying bad words."

And taking an axe he split the hare's lip.

Those are the lies we heard. Those are the lies we were told by the old people.

No sooner had he finished when N/umiko launched into his own, very different version of the story:

The hare was going at night to gather *xum /uri/uri* berries, after the women had all returned home from gathering them. On her way back, and carrying a supply of berries, the hare maiden passed the moon who was busy chopping the tortoise with an axe. It was a big one, the tortoise.

The tortoise called out to the hare, saying: "Hieeh!" The moon called out to the hare maiden, who was carrying the *xum /*uri/uri berries on her head: "Give me one of those *xum /uri/uris!*"

The hare was going to pass it to him on a stick but he said to her: "No, no! Come into my house and give me a bunch of those */uri.*"

When she gave the *xum /uri/uri* to the moon he caught her and he "put her down" ["had sex with her"].[5]

When he was done he said to Hare Maiden: "Go now to your home and tell all the people at home that, upon their death, they will do exactly as I do, upon my death. Tell them that when they die they must, indeed, die. But they *will* rise again! Because when I die I come back again, again, again, and again. Go and tell them that and come back to me again in the morning and report to me."

When the hare girl got to the people she said to them: "You must all die because the pus of a person smells disgustingly. You must die and die and die. You *must* die!" And when, in the morning, she came to the moon's place, the moon asked her: "What did you say?" And

she said: "I told them a person's pus stinks and that therefore people must be dead and dead forever."

After she had said that the moon took the axe—the axe he had been using to chop up the tortoise—and split her lip. Then the hare took her [steenbuck] blanket and pubic apron and made them hot over the fire. She threw them over the moon's face.

That is why the moon's face is black and white.

That is why the hare's upper lip is split.

And that is why, when you hear a hare at night, you will hear it saying "tsotsouri," as though it were laughing at the moon.

It is only in their basic plot line that these two versions bear any resemblance to the dozen or so published versions one finds in the annals of the anthropological study of the San people. The sparseness of Tsao's account contrasts with the richly embellished texture of other versions; the violence and lasciviousness of N/umiko's tale stands in opposition to the mystical portent that hangs over most of the variants collected among other groups, at earlier times. A vile, old man, violating an innocent maiden here; a world-weary (and slightly irascible) sage, consoling a bereft, orphaned child there; lecherous arousal, seduction and revenge, numinous inspiration, hope and, almost, resurrection. How was I to explain this perplexing disjuncture: my two oldest informants, both senior members of their culture, each the elder of his respective extended family, both articulate and garrulous, offering up such truncated or profaned accounts of a myth that holds centre-stage position within the cosmology and supernatural world of their people? And why would one of them, the elder of the two, be so curtly dismissive and self-conscious about the story?

It took many more *hua*-sessions, many more conversations, with the two storytellers and dozens of other Bushmen—and women, young and old ones, and a couple of years living among the people before the answers to these disquieting questions began to suggest themselves. Some have to do with the nature of oral tradition and transmission among nomadic, fragmented, isolated and individualistic societies such as the Bushmen. Such circumstances encourage the development of individual and regional cultural variation.[6]

Others have to do with the cultural and performance context of the narratives.

One of the contextual elements is the temperaments and life experience of the narrators. It is this biographical-contextual element—the linkage between story and life story—that I will explore here, with reference to the two contemporary[7] Bushman storytellers. I visited with Tsao and N/umiko—the latter was my next-door neighbour at /Oaxa village—virtually every day throughout my twenty-month stay in Ghanzi. I think I gained sufficient understanding of the lives and personalities of these two storytellers to interpret their respective stories along such lines. In looking at the life situation of Tsao and N/umiko and their accounts of this and other stories, I am struck by how much a storyteller's life is itself a narrative, with its own drama and turmoil, its text and texture. The characters and plot of his own life story become interwoven with those featured in stories of his people. Storyteller after storyteller and generation upon generation will put their own life-stamp on this store of tales, changing details, nuances and emphases, and, over time, substance, form and meaning. The creative spark of stories and storytelling and much of its aesthetic lustre and moral tensions are engendered largely by the elements of idiosyncrasy and contingency entailed in the merger of life story with story.

In some ways the life stories of my two storytellers were as disturbing as their versions of the story of the Moon, the Hare, and Death. As Hare-Maiden, at Moon's bidding, was to be a harbinger of eternal life, yet brought death, so the two old farm Bushmen, at the anthropologist's bidding, came forth with *hua* attesting not to the vitality of their people and their beliefs, but to a process of cultural dearth and disintegration. It accompanies the loss of economic self-sufficiency and political independence farm Bushmen like Tsao and N/umiko had to endure when the white and black settlers took over their hunting and gathering grounds as pasture for their cattle.[8] Paralleling the processes of the Kalahari's desertification and water table depletion, one senses a like process of spiritual depletion within the mythological landscape of this desert land. One feels it settling, fog-like, over the veld myth-landscape. This, until recently,

was the stomping ground as much of robust hunters and trance-dancers as of mythological were-creatures, flying antelopes, and trickster heroes of many guises. They were the "old people," the spirits and beings of the "First Order" of the mythological past which remained alive and current through the much-told *hua*, the "old stories." This dreamtime-world has now entered its twilight phase, and just as the "people of the Early race" fade off the mythological horizon of many farm Bushmen, so do the old stories about them.[9] Sadly, some of them—such as the story featured here—elicit derision and embarrassment in the storytellers. One of them, Tsao, presents the myth as a "lie of the old people," the other, N/umiko, as a tabloid melodrama.

Tsao held the respect and trust of his extended family who lived, three generations deep, in a homestead of some half-dozen huts scattered around his own dwelling. His extended household was the largest at /Oaxa and he presided over it in the fashion of a traditional band //*exa* (headman). He settled domestic disputes and lent his good counsel whenever decisions were being weighed by any of his three sons, sons- or daughters-in-law, neighbours or visiting friends, or by the whole band collectively.

I saw him at a trance curing dance once. It was held at /Oaxa village in early winter not long after my arrival there, when the village was in the grips of an outbreak of chicken pox. Everyone was deeply concerned as the sickness reminded them of smallpox which, until as recently as a decade ago, had ravaged the countryside and killed hundreds of Bushmen (especially the children). It had left its marks on the faces of the survivors, some of them the trance-dancers of the day whose survival of the dread disease had been seen as a man's (or woman's) calling into the shaman's vocation. In Bushman ritual practice, shamanism revolves around the trance dance, the society's major and only group ritual performed for the purpose of curing. Tsao was himself one of the dancers; he was dancing for two of his grandchildren at the time, who were among those down with the disease. Loin-clothed and bare-chested, calves wrapped with dance rattles, he looked very much the part of the *n/a ''kxau*, the "dance man," as the Nharo call their trance dancers. I tried to observe

him closely, if discreetly. It was evident from his every move that he knew what he was doing: pre-dance warm-up routine, followed by the trance-free, vigorous dancing and singing that a dancer needs to go through to make his "stomach boil"[10] and, with it, the therapeutic sweat that is a dancer's medicine. All this Tsao did, along with three or four other dancers who shared the dance circle with him. Like his colleagues, he was in the process of being transported to the sought-after pre-trance state, when a dancer's body is rigid, his steps stiff and choppy, his eyes stare blank and unfocused, and his singing ceases. I saw, just at that moment, how Tsao checked himself; how, forcefully shaking his head and body, he walked briskly away from the circle of the dance fire, the chanting women and dancing men, into the darkness surrounding the fire.

Striding through the moon-lit night, the old man headed straight towards his hut some two-hundred yards away from the dance circle and trance fire. There he wrapped himself in his bedroll and lay, sleepless and alone. Ninn/ai, his wife of some thirty years, had stayed behind in the circle of women, where, as one of the principal singers, she remained throughout the night-long dance. Her strident chant accompanied his fretful thoughts as he lay in his hut.

A few days later, when he shared his thoughts and feelings of that night with me, I learned that the question weighing more heavily on his mind than all others was this: Would *moruti* come to hear about what had just happened? The evangelist's prayers and admonitions rang in his head, more urgently this night than at other times. For, it was he, Tsao, the most respected Bushman household head at /Oaxa, who had been appointed by the African evangelist from South Africa as his church translator, warden, and assistant at services and catechism class. At such occasions *moruti* directed his most vehement exhortations at the *n=a kx'au* and at //Gauwa: the trance dancer and the Trickster God, the two key figures in the religious domain of Tsao's people. Both of them are healers, the one dispenser, the other creator and custodian of the curing arrows and medicines, and both are either controllers or protectors of game animals. Both are damned equally by the evangelist, in his eyes they are a most sinful and benighted pair, one a witch doctor, and the

other, none other than Satan himself. And here, this very evening, was Tsao, on the verge of trance himself, a witchdoctor himself, about to issue the death-shriek and to collapse in trance. And in trance, about to have his soul leave his body, to seek out //Gauwa, to plead with him and cajole him to release the curing medicine that would make his grandchildren better. Would he not be pleading with Satan himself? Was not //Gauwa, the trickster God, the Evil One *moruti* spoke of? Was he, the *moruti*'s right-hand man who, every Sunday, translates the word of God and the message of Jessu Kriste—a message of hope which Tsao had just learned and which was dear to his heart—about to become a vile witch doctor, to consort with Satan? Was it lies, all of it? Lies of the old people?

At the time I knew Tsao, the brooding thoughts of that night were representative of his attitude to life generally. Even though he had led a rich and full life, as well as a conversion experience a few years back that transformed his spiritual and moral outlook on life, he was now, in the winter of his life, troubled by an abiding sense of uncertainty, insecurity, and self-deprecation. While such feelings were, to varying degrees, held by all of the farm Bushmen as a result of their general destitution and oppression, in his case they were exacerbated by the conversion experience. In embracing what the new faith offered, he perforce rejected what he had held to before, throughout many decades of living. Added to his ambivalence and doubts were guilt and anxiety over sin. This brand of *Angst*, which is not part of the moral disposition of Bushmen generally, came to weigh on him heavily. It bore a distinctively Calvinist stamp, appropriate to the denomination of the Christian mission church that had taken him into its fold. Its doctrine, of ever-present and inescapable sin within mankind, at and of all ages, was something of an obsession to the evangelist. It was conveyed forcefully to Tsao, one of his most ardent converts as human sinfulness was a frequent theme in the homilies Tsao translated for him at church services or catechism classes. As a result the notion of sin had become enrooted in Tsao's mind, and appeared to weigh heavily on his heart.

N/umiko struck me as emotionally less complex a man than Tsao. Fatalistic brooding was basically foreign to his nature. For

instance, like Tsao, and many other farm Bushmen, N/umiko had converted—or, rather, been converted by the energetic evangelist; moreover, he was also one of the congregation's elders. I had the impression, however, that the experience had not moved him nearly as much as it had his fellow-elder Tsao. It seemed to me that N/umiko, like many another farm Bushman (and, perhaps, church member anywhere), was motivated with regard to this decision, not so much by spiritual but pragmatic considerations. Being a convert and elder at the mission settlement held a variety of fringe benefits: it provided a place to stay, with water and grazing for one's goats; the mission school took in one's children or grandchildren; the mission clinic offered treatment. Another consideration in N/umiko's mind was that the place held the prospect of offering retirement from full-time farm work as it was run not by a imperious, hard-driving *"buru baas"* (Boer boss), as were Ghanzi farms gener-ally, but by a somewhat more lenient farm supervisor and the evangelist. Having worked hard all his life, as well as limping with severe arthritis, N/umiko was anxious to turn his back to farm labour.

There were times, however, when N/umiko, too, would fall into sloughs of despondency and despair, preceded or followed with flashes of anger. I witnessed such moods on several occasions, over the twenty months I lived at /Oaxa, in the hut neighbouring N/umiko's. Unlike Tsao's bouts of depression, which seemed due to diffuse existential qualms and a personal sense of moral inade-quacy, in N/umiko they seemed triggered by specific and current instances of injustice that he himself, or a member of his family or his network of kin or friends, were being made to suffer. Unfortu-nately, iniquities of this kind were not infrequent in N/umiko's life, as in that of most of the rest of his people, given the wider social and economic setting of the contemporary Bushmen. As a tribal minor-ity, of landless and herdless people, in a society of colonizing farmers and ranchers, the Bushmen have suffered poverty, hunger, and oppression for some six or seven generations.

In N/umiko's view, the cardinal injustice of all was the dominant and domineering presence of settlers on land that belonged not to

them but to his own people.[11] He was keenly aware of what he deemed an egregious state of affairs and his outrage sometimes flared up in the context of one or another incident of conflict that erupted around him. "Here they are, on Bushman land," he exclaimed on one such occasion, "the *Buru* and the //gauko, blacks and white, all of them are here. Many, many of them, to stay, sitting on their ill-gotten lands, gathering power and wealth—cattle, trucks, houses, planes, schools, hospitals. The Bushmen," he continued his railing, "in the meantime, have sunk ever more deeply into destitution. And they have to suffer getting bullied and beaten." He could start lengthy diatribes of this sort, standing in the centre of /Oaxa village near the residential cluster of either the black or white members of the settlement, alone, a Lear-figure howling into the Kalahari wind. I once saw him work himself into such rage and frustration when in this state that he went to seek out a black Tswana or Kgalagari to pick a fight. As on previous occasions, he was drunk at the time, on *!khadi* (home-brewed beer). Given his intoxicated state, his diminutive size, his age and arthritis, such fights inevitably ended in his being beaten up and bruised. N/umiko was a strong advocate of the notion, popular amongst some of the more "political" farm Bushmen, that the Bushmen should have their "own place," assigned to them by the government, with their own headman, where "Bushmen only" would grow crops and herd cattle and goats.

Most of the stories he told me—in a narrative style that was dramatic and colourful—were tales that featured the trickster /xriri (jackal), situated within a pioneer farm setting in which /xiri's opponent was the *Buru baas*. Through his many ploys—stealing the *baas*'s food, beating him, stringing him up by his testicles, seducing his wife or nubile daughter, eating his children, and shirking work—Jackal got the better of his boss (who, duped and stupid, continued to pay his wily farm hand his rations and wages). Spinning out these trickster stories might have afforded N/umiko a measure of vicarious release from his sense of impotence. In a way, these Jackal-tales are narratives of resistance, perpetrated through acts of violence and sabotage towards the landowners. What Jackal-Trickster did to the

encroaching settler and oppressor was what the storyteller N/umiko had all his life been unable to do to any of them. The one exception, perhaps, was that he had become good at shirking work, as he pointed out to me with a conspiratorial grin, tapping his arthritic leg with his cane.

Unlike Tsao, who was unrelentingly earnest (and who bore a permanently furrowed brow), N/umiko also had a light side. It manifested itself in extroversion and buffoonery and, most readily and frequently, in flirtatious banter with women, especially with his numerous female joking partners and ex-mistresses. He enjoyed long story sessions, over tea and, whenever available, *!khadi*, as well as idle conversation and gossip. His talent for mimicking other people and animals was well received, as was his routine of "speaking English." He reeled off a lengthy discourse consisting solely of nonsense diction in which he imitated the phonetic sounds and tone of English, enigmatically interspersing his monologue with such recognizable snippets as "number one," "spitfire," "wireless," "nonsense," "shifting spanner," and "one Zambia—one nation." (The last was the signal tone of Radio Zambia which a farm Bushman might sometimes pick up on the "wireless" he had received from one of his Bushman trading partners or bought himself at the European trading store.)

Whenever Tsao and N/umiko tell one of the *hua*—such as the one of the Moon, the Hare, and Death—the text seems to have become for them a screen upon which to project their individual personalities and life experiences. These provide the narrative and moral key and frame to the version each of them gives of the ancient text: ambivalence, self-consciousness, shame and guilt pervade Tsao and his narratives. This tone applies especially to those stories that deal with portentous matters, such as divinity and creation: such as the myth of the origin of death. Troubled by religious doubts that accompany his conversion, this storyteller introduces or concludes such narratives with the disclaimer that what he is telling is one of the lies of the old people.[12] His sense of propriety is reinforced by his august role as church translator and his status as elder and churchwarden, so that whatever sexual or other obscene elements

appear in a tale, he swiftly edits out. In contrast, such elements, which are abundant in bawdy trickster tales of Bushman folklore, N/umiko fastened on and spun out—he was, himself, of trickster-esque disposition. Even so portentous a story as the Moon, the Maiden, and Death received such treatment from this storyteller. Apart from seduction and lechery—both cardinal trickster traits—he also injected into the story elements of violence and vindictiveness, dominance and control, defiance and anger. These moral and emotional elements were consistent with N/umiko's own sense of being a victim of injustice, expropriation and exploitation, by a dominant settler group. Despite all of the sound and fury of the story, it is not without whimsicality. For instance, both narrators and listeners considered the plot element of the hapless tortoise funny, and laughed when it appeared in the story.

What I took down on my tape recorder that evening of our first storytelling outing was no myth, aquiver with deep meaning. The versions of the story collected by Bleek and Lloyd a century ago suggest that this was once a myth of great portent.[13] Today, the tale is to the one storyteller a shameful abomination, to the other a droll oddity; a lie or trifle from the past, to be made light of, bowdlerized or repudiated. The *hua* of the old people are receding into their ancient past. The new generation of Bushmen from Botswana, at whose apex stand these two old men, have new concerns, that gravitate around new gods and a new social reality. While the quixotic, protean Trickster can find his way around today's farms and *baas*'es, the misdeeds and misadventures of Moon-Man and Hare-Maiden do not readily fit into the new reality.

Yet, while different in text and tenor, this old story has not been deleted as yet from a storyteller's repertoire. The reason it still gets told—as do others of like vintage—may be that such *hua* do continue to hold some relevance for the storytellers. As we saw, the way Tsao and N/umiko tell the tale, how they set its key and develop its "emotional core," reflects the tensions of their lives. These—the clash of the new church religion with the old, integral curing religion and the erosion of the integrity of one's culture and people and their organic ties to the land—recast the old tale and add to it new

elements of meaning. So altered, old stories have the capacity also, in turn, to give meaning to the new social reality, enabling the storytellers (and listeners) to cope more effectively with the many troubles that new reality holds in store. Because of an implicit congruence between life story and told story, the *hua* of old are thus no mere cultural floss or flotsam, "survivals" from a long-gone cultural horizon. They are, instead, instances of contemporaneity of tradition, that merge old with new story elements.

I can imagine moments also when this contemporaneity is even more direct, when the *hua* itself may suddenly become palpably real, in terms of its own inherent old plot and meaning. One can expect such moments to come up in a culture in which storytelling is an on-going, ever-practised cultural process, and in a cosmology wherein the mythological and historical past are not clearly delineated. For instance, we saw the trickster shuttling back and forth between the "First Order" and the new reality. Another example is hare, the principal of the tale before us: the Hare-Child of old has kept a portion of its one-time "human flesh" within the body of today's animal into which it was transformed. That part the /Xam Bushmen were prohibited from eating whenever they snared a hare, as "it was flesh (belonging to) the time when he formerly was a man" (Bleek & Lloyd 1911:61).

With respect to the Moon and the Hare Maiden, such a spontaneous moment of merger of myth with reality, among today's Bushmen, might happen on a moonlit night, when one is out hunting; or as one quietly walks back home at early dawn from a trance dance at a neighbouring village; or sits around a fire late at night, drinks tea and smokes tobacco and tells or listens to *hua*. At such occasions farm Bushmen today may hold thoughts similar to those of //Kabbo, over a century ago:

> You seem to think that the moon has forgotten. Yet the old man [the moon] knows; he understands when people are talking at their house. Even though far off, he will become angry and will enter the sky, because he wishes darkness to lie upon the people, so that people would not be able to see the ground, as the ground would be dark ...

The people say to each other: "You are the ones that laughed at the old man, and when you do, [this] is what the old man will do: he becomes angry when hearing people laughing at him. For people will laugh, they look at him and they say that his stomach has turned black. This is why he goes into the sky angrily, for he wants us to live in darkness."

"For darkness resembles fear, when trees do not stand in brightness so that people become afraid of the trees, the trees with darkness in them."

Angered he went up into the sky. He would make us lie in darkness. What I should do is lie down and look away from it, as it rose.

For there was no peace. The lion's spoor [footprint] was there. We were always afraid in darkness and we would lie quietly in any place that was light.

Bbu! The great moon, which comes out (or has come out)! It is a great red thing; it is not small!

When it hears its name the moon becomes angry. Sulkingly and offended, it goes into the sky.

NOTES

1. I thank Melissa Heckler, Carol Birch, and Megan Biesele for the insightful comments they have made on my paper.

2. The texts are all transcriptions of oral narratives which were collected amongst either the /Xam Bushmen of the Cape during colonial times or the contemporary Nharo Bushmen of western Botswana (the Ghanzi District). They are fairly literal transcriptions that attempt to minimize any alterations to the narrative style of the native storyteller. The one narrative feature that I have altered, for the benefit of the western reader, is repetition. It is the hallmark feature of /Xam narrative and a sentence or passage may be repeated dozens of times. This paradoxical effect—variation through repetition—is accomplished by slight alterations in the phrasing of each repeated sentence, as well as changing the subject in each instance. A /Xam storyteller (such as /A!kunta in the first narrative) may use repetition as a narrative device for variation, enhancing the textual expansiveness and textural richness of his story. Tense shifts have been kept in the transcriptions; they are another typical feature of Bushman narratives that is consistent with the absence, in Bushman mythology, of such linear-time coordinates as past and present. In order to convey these stylistic features and their poetic impact the reader should read the narratives aloud.

Two of the four /Xam narratives have been published; the one is Dia!kwain's text which appeared in Wilhelm Bleek's and Lucy Lloyd's *Specimens of Bushman Folklore* (London: George Allen & Co., 1911, 63-65) and the other//Kabbo's, appearing in M. Guenther's *Bushman Folktales* (1989:82). The other two are unpublished and were taken from the Bleek and Lloyd collection of /Xam folklore at the Archives of the Jagger Library at the University of Cape Town and are published with the library's permission. /A!kunta's and //Kabbo's narratives are, respectively, from Bleek's notebook #5 (1403-82) and Lloyd's notebook no. LII-35 (3154 rev.-5156 rev.). About half of the /Xam collection was published by Wilhelm Bleek and Lucy Lloyd in their *Specimens of Bushman Folklore* (1911) and by Dorothea Bleek (Bleek's daughter) in *The Mantis and his Friends* (1923). In my own recent collection of Bushman folktales (Guenther 1989) I include over a dozen unpublished /Xam narratives, as well as my own collection of Nharo folklore I gathered during my doctoral field work in social anthropology from 1968 to 1970 in Botswana.

3. In her exhaustive "catalogue" of Khoisan folktales, Sigrid Schmidt (1989:63-70) lists the many versions (approximately 70) of the tale that have been collected over the past century-and-a-half. See also Guenther 1993:4-15.

4. See Bleek & Lloyd (1911:x-xi) and Hewitt (1986:233-46) for more information on Bleek and Lloyd's various informants, as well as their narrative styles and competence. Also see Guenther (1989:27-29, 1991a).

5. In English we would say "raped her"; however, no such word appears to exist in the Nharo language. The Ju/'hoansi use a similar circumlocution; "gu ha ko g/aoh" ("took her by force"). (M. Biesele, pers. comm. 18 Dec. 1993).

6. I have expanded on this explanation for variation within Bushman oral tradition and belief elsewhere (Guenther 1979, 1986a:216-17).

7. There is not enough biographical information on the /Xam storytellers to attempt such an analysis of the cross-narrator variations of texts. I have elsewhere (Guenther 1991a) attempted to explore the contextual dimensions of the /Xam collection, including the biographical one.

8. The bleak life situation experienced by the farm Bushmen of Ghanzi here described applies to the late 1960s, the period during which I worked amongst them (Guenther 1976, 1979, 1986a). The socio-economic and political conditions of the Bushmen were not the same all over the country and neighbouring Namibia (Biesele, Guenther, Hitchcock, Lee and Macgregor 1989, Guenther 1986b); moreover, today the conditions of the Ghanzi farm Bushmen have improved (Guenther 1986a, chapter 9).

9. It should be noted, however, that at the same time that old tales are fading new ones are appearing, with new plots and protagonists (or new

versions of the old). My collection of Nharo tales (Guenther 1989) contains a number of new narratives that deal with a number of the new social and cultural issues (such as Christianity and biblical texts, farm life, ethnic tensions with colonizing white and black settlers).

10. Within the shamanic system of curing of the Nharo (and other) Bushmen, healing power is derived from a mystical, as well as physiological, substance and force called *tsso* by the Nharo (and *n/um* by the neighbouring !Kung. It is, perhaps, best translated as "potency." Residing in the stomach and inert at normal times, *tsso* is activated through trance dancing. This action changes *tsso* from its cool, inert state to a condition of intense heat and volatility, causing potency to move up the dancer's body and to pour forth in the form of sweat (or, among the /Xam, nasal hemorrhage). Trance-induced perspiration is held to contain therapeutic powers and is applied by the medicine man to the patient. For more information on Nharo healing see Barnard (1979) and Guenther (1986a, chapter 6). Information on !Kung healing can be found in Richard Katz' fascinating monograph *Boiling Energy* (1981); also see Marshall (1969).

11. N/umiko's assessment of the settlers' land rights is supported by history. In the 1890s the treaties for the Ghanzi farm lands were negotiated by the British colonial officers not with the indigenous Bushmen but the Bantu-speaking Tawana in Ngamiland to the east, whose chief laid claim to Ghanzi as the Tawanas' hunting territory. This claim the British accepted even though the Tawana, a relatively small and militarily weak Tswana state, had only tenuous hold over the area (which, until the 1870s, was firmly under Bushman control). See Guenther (1991b).

12. Melissa Heckler has pointed out to me that the Ju/'hoansi in Namibia, whom she visited in the early 1990s, also employ this disclaimer when they tell stories. Perhaps it has now become a stock rhetorical element of contemporary Bushman storytellers generally, that is attached to a traditional tale, especially when its telling is elicited by a European. My impression when I collected stories, a generation ago, was that the disclaimer was not merely a standard rhetorical convention but a reflection of doubts and ambivalence about the content and value of the story on the part of the storyteller. It was used only by a few narrators, with attitudes of self-consciousness and social and cultural marginality (such as Tsao).

Megan Biesele has quite another reading of this stock phrase, which she was frequently given by storytellers in Botswana, when she collected in the '70s. She "connects it with the cosmological split between the 'people of the Early Race', also called 'hua' by Ju/'hoansi in Botswana and even Namibia sometimes, and the creator God no longer on earth or directly involved in human affairs." Moreover, she "connects it to the idea that dreams 'are how

the gods deceive us'—a deception process, like stories, still going on" (personal comment, 18 Dec. 1993).

13. However, given the high degree of individuation of Bushman storytellers (Biesele 1993:26, also see Hewitt 1986:233-46 and Guenther 1989:22-29), there might also have been storytellers then who added their own light touch to the myth, tempering numinous portent with whimsicality.

REFERENCES CITED

Barnard, A. 1979. "Nharo Bushman Medicine and Medicine Men." *Africa*, 49:68-79.

Biesele, M. 1993. *Women Like Meat: The Folklore and Foraging Ideology of the Kalahari Ju/'hoan*. Johannesburg: Witwatersrand University Press/ Bloomington & Indianapolis: Indiana University Press.

Biesele, M., Guenther, M., Hitchcock, R., Lee, R. & MacGregor, J. 1989. "Hunters, Clients and Squatters: The Contemporary Socio-Economic Status of the Botswana Basarwa." *African Studies Monographs*, 9:109-51.

Bleek, D. 1923. *The Mantis and his Friends*. Cape Town: T. Maskew Miller.

Bleek, W. 1875. *Brief Account of Bushman Folklore and Other Texts*. London: Trübener and Brockhaus.

Bleek, W. & L. Lloyd 1911. *Specimens of Bushman Folklore*. London: George Allen.

Guenther, M. 1976. "From Hunters to Squatters: Social and Cultural Changes among the Ghanzi Farm Bushmen." In R. B. Lee & I. DeVore (eds.) *Kalahari Hunter-Gatherers*. Cambridge, Mass.: Harvard University Press, 120-33.

———. 1979. "Bushman Religion and the (Non)sense of Anthropological Theory of Religion." *Sociologus*, 29:102-32.

———. 1986a. *The Nharo Bushmen of Botswana Tradition and Change*. Hamburg: Helmut Buske Verlag.

———. 1986b. "Acculturation and Assimilation of the Bushmen of Botswana and Namibia." In R. Vossen & K. Keuthmann (eds.) *Contemporary Studies on Khoisan*. Hamburg: Helmut Buske Verlag, 7-51.

———. 1989. *Bushman Folktales*. Oral Traditions of the Nharo of Botswana and the /Xam of the Cape. Stuttgart: Franz Steiner Verlag Wiesbaden. Studien zur Kulturkunde, 93)

———. 1991a. "Attempting to Contextualize /Xam Oral Tradition." Paper presented at the "Bleek and Lloyd 1870-1991" Conference, Cape Town, September 1991.

————. 1991b. "'Independent, Fearless and Rather Bold': A Historical Narrative on the Ghanzi Bushmen." Paper presented at the 18th annual conference of the Canadian Anthropology Society, University of Western Ontario, May, 1991.

————. 1993. "Story Telling and the Foraging Context: The Case of the Moon and the Hare." Paper presented at the 7th International Conference on Hunting and Gathering Societies, Moscow Academy of Sciences, 17-23 August, 1993.

Hewitt, R. 1986. *Structure, Meaning and Ritual in the Narratives of the Southern San.* Hamburg: Helmut Buske Verlag.

Katz, R. 1981. *Boiling Energy Community Healing among the Kalahari !Kung.* Cambridge University Press.

Lloyd, L. 1889. *A Short Account of Further Bushman Material Collected.* London: David Nutt.

Marshall, L. 1969. "The Medicine Dance of the !Kung Bushmen." *Africa,* 39:347-81.

Schmidt, S. 1989. *Catalogue of the Khoisan Folktales of Southern Africa.* vol. 2. Hamburg: Helmut Buske Verlag.

Innervision and Innertext
Oral and Interpretive Modes of Storytelling Performance

Joseph Sobol

THIS ESSAY HAS COME AT THE END because it signals both an ending and a beginning. Its form and content suggest how the many divisions in and between traditions may come together—not to form "a more perfect union" nor as an unholy alliance, but as a new and distinct form. Like a sapling, the profession of storytelling has roots in fertile soil with numerous, and as yet unseen, branches that may reach up and out. These essays, like growth rings, literally mark the passing of a year. Only the future will tell us what kind of year it has been.

Joseph Sobol minutely examines lines spoken by Jim May and Syd Lieberman in storytelling performances. He grounds his thoughts in the observations he has made over years of close attention and consideration. Sobol approaches storytelling and folklore with brio and a playfulness of spirit and intellect. It was this very spirit that provided the image which we felt should culminate the book.

Nearly every essay has addressed the relationship of tale, audience, and teller. Authors struggled with and sought out apt analogies, images and words to discuss and enrich our shared vocabulary of this many layered reality. Our stress on the complexity of ideas, values, and

traditions that give us models to think with rather than rigid rules, was itself given a buoyancy by Sobol's concluding image. And so we say in closing, to you, our readers, if we sound tantalizing in our words here, we mean to be. This is an essay to savor and one that brings us full circle.

I first heard Jim May and Syd Lieberman tell stories, one right after the other, during an open swap at the 1984 National Conference on Storytelling, at Washington College outside of Jonesborough, Tennessee. In the memories of many storytellers who came into the field in the late '70s and early '80s, those story-swaps on the porch at Washington College are touched by a roseate glow. This night in 1984 was particularly significant for Jim and Syd. They were friends, both schoolteachers from upstate Illinois working their way into the burgeoning profession of storytelling. Their performances on the porch marked a crystallization for each of them of a new dimension of personal voice, as well as of a new level of recognition in the storytelling community.

Working my way into the artform myself, I was struck that night by what seemed a polarity between their styles. Whatever Jim said, even when he was actually reciting, seemed conversational, emergent, spontaneous to the point of a certain appealing hesitancy. Whatever Syd said seemed by contrast recited, shaped, strongly sensible of the literary arc of his words, phrases, sentences, and paragraphs. The occasion crystallized an awareness that had been growing in me of divergent modes within what presented itself, under the crusading banner of NAPPS, as a united movement. What follows is an exploration of these divergent modes, and of the ground of their apparent common cause.

Within the past twenty years there has evolved a national—even, to a limited extent, an international—community of performers who position themselves under the sign of a self-conscious revival of traditional storytelling. Although their actual practices cover a range of performance conventions—from a variety of ethnic traditional

storytelling styles, to stand-up comedy, to theatrical impersonation, to autobiographical performance art, to oral interpretation—these contemporary performers share in the invocation of ancient traditions and roles as a common signifying framework.

There are many useful angles from which we could examine this storytelling movement. I will focus here on constructing a polarity of communicative models within the practice of professional storytelling, and using this polarity, then, to reflect on the movement's sources, its place, and its prospects: I will call these models the conversational and the literary, or the oral traditional and oral interpretive modes.

Jim May and Syd Lieberman have helped me, since that night in 1984, with my own developing understanding of the complex interrelationship of these performance modes. The brief comparative study of their performing styles essayed below is based on personal acquaintance, on encounters with their live and taped performances over a six year period, and on recent telephone interviews with each (unfortunately not recorded, but paraphrased here to the best of my oral traditional abilities).

I. ISSUES

First, let me review the scholarly debate that has grown up over recent decades about the nature and implications of orality and literacy in culture.

The awakening of the debate is generally traced to Milman Parry's work with oral epic singers in the Balkans in the 1920s and '30s. Parry's work was cut short by his early death, but it was extended in the 1950s by his student Albert Lord and published in the seminal book *The Singer of Tales*. Here it was revealed that epic singers in primary oral cultures—cultures which rely mainly on oral memory and performance to store and maintain their cultural possessions—do so not by strict, word-for-word, rote memorization, but by mastering the sequences of the tales, along with a repertoire of rhythmic verbal formulas and proverbial metaphors, epithets, images, and patternings. This allows them to improvise, or to rhapsodize their epic songs (the word *rhapsode* coming from the Greek

root meaning "to stitch songs together": Ong 1982:13), chanting sagas which might last for many evenings at a stretch, in a manner at once formal and repetitive, yet equally spontaneous and emergent.

What sent shock waves through the academic literary-critical establishment were the connections that Parry and Lord were able to draw between this oral formulaic style of the Yugoslavian *guslars* and the style of the Homeric epics. Parry and Lord demonstrated convincingly that the *Iliad* and *Odyssey*, too, were constructed out of these same repeating metrical formulas—not different in kind from a Chicago blues singer's "Woke up this mornin' with the blues all round my bed." Thus they concluded that the works we cherish as the foundation of our written literature were actually early crystallizations of a much more basic, and still extant, mode of poetic performance—in effect, a massive, magnificent folksong.

This theory is now widely accepted in all its main points, though still debated on matters of emphasis and implication. It has led scholars to a deeper investigation of the nature of primary oral culture and of the contrasting values fostered by other cultural media.

Eric Havelock built upon the oral formulaic theory in his *Preface to Plato*, a radical reinterpretation of Plato's *Republic*. What had not before been understood, he claimed, was that the dramaturgy of that work expressed the cultural collision between the analytical, scribally trained philosophers of Plato's Academy and the older, orally ingrained wisdom of the poets, the Homeridae. Havelock argues that before Plato's time, Greek education was essentially oral, and consisted of learning, by imitation and osmosis, the cultural formulae embedded in the epic poems. There was no room in this system for analysis, dialectic, critique, indeed for the development of the individualistic mental processes that are founded on the tool of writing. Thus there was no room for the kind of intellectually driven individualism that Plato was trying to foster in the elite of his new educational order.

Yet Walter Ong points out that in the *Phaedrus* and other works, Plato's Socrates argues directly the opposite way, condemning writ-

ing for the harm it does to memory, and for rendering external what properly belongs to the inner life. Ong would have it that Plato lived on the cusp of a technological reordering of thought—much as we do today—and that the carping of Socrates bears a sobering resemblance to the TV-bred media critics of the contemporary storytelling revival. Ong writes that "the new technology is not merely used to convey the critique: in fact, it brought the critique into existence. Plato's philosophically analytical thought ... including his critique of writing, was possible only because of the effects that writing was beginning to have on thought" (Ong 80).

By prescribing and proscribing the media of culture, Plato was struggling to create a new kind of human being. But evolution mounts by devious, spiral paths, and in the transformation-theorists' enumeration of the qualities of this new, writing-born being, it begins to appear that his advent was by no means an unmixed blessing. Rather, through their eyes, the transition from oral to literate cultural dominance looks more like a drama with similar tragic overtones to the fall from Eden, or the bargain of Faust.

This line of argument was originally put forward, and extended to the edge of obsession, in the works of Marshall McLuhan. McLuhan's intellectual cattle-raids have been tamed a bit in the writings of Ong, but the thrust of his dialectic is preserved: that oral culture depends on the ear, and fosters warmth, feeling, immediacy, interiority, tribal identity, synthetic and paratactic thinking and expression, submergence in the body of nature. Writing, beginning with chirographic (manuscript) culture and exponentially accelerating with the advent of typographic (print) culture, depends on the eye, and fosters individualism, detachment, cold logic, analytical thinking, the breakup of tribes, the evolution of national identities, and emergence from the body of nature into an uncertain and hubristic separateness.

Scholars from a wide range of disciplinary perspectives have seized on this oral/literate polarity as a field for the modeling of culture and communication. Literary and theological historians, folklorists, cultural anthropologists, socio-linguists, and cognitive and educational psychologists have all weighed into the debate.

What I get from their various, often highly technical agitations is not easy to summarize. For present purposes I will draw a series of four important propositions, that can help us understand key aspects of contemporary storytelling performance.

II. PROPOSITIONS

First, there is the proposition advanced by socio-linguist Wallace Chafe (1982:35-53) concerning the very different *tempos* natural to the different uses of language—face-to-face conversation, writing, and reading. Speaking, he notes, is far faster than writing, if only because of the physical mechanisms involved; but speaking and listening are both slower than reading. In spontaneous conversational speech, we become accustomed to a certain rhythmic fit between the pace of our thoughts and that of the language in which we express it. Chafe writes:

> Observation of spontaneous spoken language has led various investigators independantly to the finding that it is produced in spurts, sometimes called idea units, with a mean length (including hesitations) of approximately two seconds or approximately six words each. Idea units typically have a coherent intonation contour, they are typically bounded by pauses, and they usually exhibit one of a small set of syntactic structures. They are a striking, probably universal component of spoken language ... If that is true, then when we speak we are in the habit of moving from one idea to the next at the rate of about one every two seconds. Perhaps that is even our normal "thinking rate," if language reflects the pace of thought ... If that is our temporal baseline, the activity of writing presents a problem. If we write more than ten times more slowly than we speak, what is happening in our thoughts during that extra time? ... In writing, it would seem, our thoughts must constantly get ahead of our expression of them in a way to which we are totally unaccustomed when we speak. As we write down one idea, our thoughts have plenty of time to move ahead to others. The result is, we have time to integrate a succession of ideas into a single linguistic whole in a way that is not available in speaking. (1982: 37)

Chafe takes this to account for the far greater density and com-
plexity commonly found in the actual language of written, as com-
pared to spoken, discourse. The writer, poking over his typewriter
or pacing, like Flaubert, around his garden pulling out his hair over
one choice word, "loads" his syntax with surplus information, so
that the reader, skimming along in his armchair free of the human
complexities of face-to-face interaction, can have plenty with which
to take up the communicative slack. These same syntactical riches in
the context of an interpretive performance can simply overload the
listeners' ability to process spoken languange. Chafe's discourse
analysis demonstrates in linguistic terms what I had long experi-
enced in listening to contrasting storytelling styles: performances
based on textual or conversational approaches are substantially
different in communicative content, due to differences in the genera-
tive context of the language itself.

Second, there is the proposition, advanced by both Chafe and
Deborah Tannen in *Spoken and Written Language* and elaborated by
Tannen in *Talking Voices*, that conversational discourse is
characterized by linguistic, paralinguistic, and kinesic "involvement
strategies," designed to evoke a sense of unity between speaker and
listener.

Linguistic involvement strategies, such as repetition,constructed
dialogue, metaphor, simile, and word painting, are common to oral
and literary storytelling, though originating in speech. Nonverbal
involvement strategies can include variation in pitch and tempo,
gesture, physical and emotional mirroring, as well as the vast regis-
ter of unspoken information which comprises the *relationship* of
conversational partners. None of these are available to the writer,
except in a refracted and distanced form. He has to rely instead on a
range of "contextualizing" conventions—from literary mockups of
conversational voice, to conventional literary forms of addressing
imaginary readers, to the studied impersonality of academic dis-
course—to fill in what is sacrificed to print. Thus it has become a
byword among linguists and literary scholars to say that writing
aims at the status of "autonomous discourse," or "context-free com-

munication" (as discussed in works of Kay, Rader, Hirsch, and Olson). Ong writes:

> Oral cultures know a kind of autonomous discourse in fixed ritual formulas ... as well as in vatic sayings or prophecies, for which the utterer himself or herself is considered only the channel, not the source. The Delphic oracle was not responsible for her oracular utterances, for they were held to be the voice of the god. Writing, and even more print, has some of this vatic quality. Like the oracle or the prophet, the book relays an utterance from a source, the one who really "said" or wrote the book. (78-79)

Oral interpretive storytelling, too, can have some of this "vatic quality," as if a text were speaking through the performer's mouth. This has a cultural validity all its own, but should not be confused with "oral tradition." Pleasant DeSpain, whose original training was in oral interpretation, discovered the difference early in his storytelling career. He told me in an interview:

> I came from my own background at the beginning. It was somewhat of a disaster; where, for the first six months, I kept reverting back to the kinds of stories and poems that I had learned in Oral Interpretation experiences. And one night in a coffee house that I had been invited to ... I had all of my material ready, and I got into the middle of the program and I just decided to—I had memorized alot of things in the beginning—I just told a story that I knew very well, but I told it spontaneously. And got such a response, I realized, this is how you communicate effectively through story.

Third, there is the proposition that takes up much of McLuhan's later work, and is developed in various ways by Heim and Lakoff (Tannen 1982), among others: the accelerating transformation in the dominant media of culture toward electronic information-processing is tilting society dizzyingly quickly away from literacy and towards a very different mode of experiencing cultural information. McLuhan calls this new mode "secondary orality." Secondarily oral media are based, in a sense, upon the analytic capacities born of print. But by the nature of radio, television, tape recorders, and film,

our sensory load is returned to an aural, or a mixed aural and concrete visual dimension (as opposed to the abstract visual processing required by alphabetic writing). Robin Lakoff projects an extreme view of this change, in her contribution to *Spoken and Written Language* (Tannen 1982):

> Now access to all the information one previously gained through literacy can be gained by other means, via newer media, and we see that it is the younger people who are the first to recognize this and become able to take advantage of it. Literacy will shortly not be essential for simple survival anymore, nor will there be any need to preserve it except as a curiosity or an atavistic skill, like quiltmaking, learned and proudly practiced by a few. (259)

One can stop short of believing this entire *Brave New World* scenario, and still accept the important points: that Eurocentric cultural canons based on the divine status of literacy are bound to be relativized by omniverous new global technologies; and that, barring some final catastrophe, we can have no idea what new human sensory adaptations future media may bring into play. Meanwhile, passionate factions within each generation reorient themselves to a technologically swirling environment by cleaving back to traditional oral and tactile media. Hence the nearly continuous cycle of "folk revivals" that have proceeded in the West since at least the time of Perrault.

Fourth and finally, there is the proposition (argued by Ruth Finnegan in her opus-contra-Ong, *Literacy and Orality*, and implied in many of the essays in Tannen's edited volume *Spoken and Written Language*) that the very notion of an oral/literate continuum is an emprically problematic one. While oral and literate modes of language do unquestionably exist in functioning communities, including communities of professional performers, the ways in which these modes interact are multifarious and protean—certainly far, in practice, from the linear image of a continuum. Finnegan shows by examples from ancient Ireland and contemporary Africa and Polynesia that modes of composition and transmission of traditional

poetry and story can vary widely from culture to culture, though each may be broadly classed as non-literate. And in cultures where literacy is dominant, there remain realms in which orality continues to rule, from the domain of jokes and urban legends, to inspired preaching, to after-dinner speaking, to folk revivalism. Heath concludes her study of the uses of oral and literate modes (which she calls speech events and literacy events) in an African-American textile-mill community she calls Trackton with this cautionary note:

> Descriptions of ... literacy events and their patterns of uses in Trackton do not enable us to place the community somewhere on a continuum from full literacy to restricted literacy or non-literacy. Instead, it seems more appropriate to think of two continua, the oral and the written. Their points and extent of overlap, and similarities in structure and function, follow one pattern for Trackton, but follow others for communities with different cultural features. (Tannen 111)

Since these models are constructions in any case, referring to but in no way identical with the linguistic systems to which they refer, we might allow ourselves to reach for something more poetically ample to replace altogether the stick-figures of continuum or continua—something along the lines of Yeats's pair of intersecting gyres, one widening as the other narrows, revolving together in phases like the moon in relation to the earth and sun, and pouring their changing, refractive light over the living fields of human language.

III. EXAMPLES

The distinction between oral traditional and oral interpretive modes of storytelling is based on the way the teller learns and prepares to retell her stories. In the conversational or oral traditional mode, the teller hears the story from another teller, or, in the case of stories based on personal experience or invention, experiences the story in the flesh, in the ear, and in the imagination. She then proceeds to retell it *without the intervention of a written version*. She develops and polishes the performance orally and aurally, that is, in

the experience of retelling and rehearing the story with audiences. In the literary or oral interpretive mode, on the other hand, the teller begins with a written text, whether of her own or another's devising, and commits this text to memory. She then overlays performative elements of facial, vocal, and bodily expression and timing upon the preset verbal scaffolding, whether in the rehearsal process or in the heat of performance.

It is obvious that only in a Platonically ideal performance could either of these polar paradigms be realized. The purest "traditional" tellers today are likely to have had some contact with written versions of their own traditional yarns (Oxford 190-93). Tellers who develop their own original stories in conversational performance, can yet find themselves shaping phrases and passages with a lapidary precision that implies some "visual" relationship to the contours of the language on a page—as generated, that is, not for the ear but for the eye. And tellers with the strictest reliance on literary norms may be forced to adapt their words to the momentary inspiration of performance. Examples are given below. But there is an identifiable weaving, a gyring, between these polar fields of language-performance. Tellers on the revival circuit can generally be identified by a gravitational tilt towards one or the other. I will concentrate here on a pair of seasoned professional tellers, Jim May and Syd Lieberman, to show how their performances have evolved from their positions along the widening and narrowing gyres of orality and literacy.

Jim May and Syd Lieberman are both full-time professional story-tellers born, reared, and based in upstate Illinois. They are each in their forties; each a former teacher who used storytelling as a teaching tool. Each discovered from his own experience, as well as from observing other revival tellers, that it could also be a path of self-expression, and, not insignificantly, of self-employment.

Jim May is of German Catholic descent, raised in the tiny McHenry County village of Spring Grove, on a fourth-generation family farm. Personal and family memoirs of rural and small-town life form a large part of his repertoire. He often introduces a set of

stories by saying that he grew up on a dairy farm, population nine; then moved into Spring Grove, population two thousand; as soon as he could he went off to the University of Illinois, population thirty thousand, to major in Russian history and urban problems; and now, in his forties, he is back living in Spring Grove, collecting and telling stories about it. It is a modest, stand-up comic echo of Eliot's famous coda to the *Four Quartets:*

> *With the drawing of this Love and the voice of this Calling*
> *We shall not cease from exploration*
> *And the end of all our exploring*
> *Will be to arrive at where we started*
> *And know the place for the first time.*

In experiencing a particular storyteller's style, one can usually feel the echoes in this teller's bodily memory of the kinds of tellers and settings that have imprinted themselves upon him. It is the nature of oral transmission, when a performance is truly received, to be not simply oral, but a full-body imprinting, a human technology of which video-recording is a pale imitation.

The first professional tellers to make a strong impression on Jim were Ray Hicks and Jackie Torrence, both rural North Carolina tellers based in the oral conversational mode. After hearing these two during his first trip to the National Storytelling Festival in Tennessee, Jim came back Monday morning to his history class and decided to do something different: he threw away his lesson plan and told a folktale, "Soldier Jack," which he had heard both Ray and Jackie tell over the weekend.

It was certainly not a memorized telling, but an oral recreation. Elements of both versions mingled in his mind and fused with his own laconic, Midwestern vocal rhythms to produce a spontaneous piece of verbal art, based on the old motifs. "Those kids had never listened to me that way before," he says.

It was the beginning of a performing style. But behind that there is a deeper imprint of family and community oral tradition. The running joke in a bar Jim sometimes visits in Spring Grove goes,

"Who would believe that Jim May makes a living telling stories? Everybody knows that his brother is the real storyteller in the family." Jim's older brother runs a local construction company, for which Jim used to work during the summer. "I guess a lot of my real storytelling education came on coffee breaks with those guys," he told me. "It was like a constant audition. You couldn't *impress* those guys. You had to learn restraint."

Jim's brother was a trickster character, a self-employed liar who created his own exploits for the telling, sometimes after the fact, often without recourse to fact. "He would drive up in the truck and you'd ask him where he'd been, and he'd say Afghanistan. Things like that. He would talk in a made-up language. Long strings of nonsense words." Jim tells of a time his brother told the principal of their parochial school, Father John, that he'd seen a fox run under the chicken house. Father John ran to get his shotgun, and the whole school watched out the school windows while Jim's brother stamped on the floor of the chicken house, Father John circling outside, shotgun at the ready. Of course the only fox was inside the chicken house, dancing.

Events like these, enacted and retold, form the thread out of which Jim weaves his own stories. Jim's speaking style is low-key, almost flat, like the Midwestern landscape it represents. He stands with his head slightly bowed, eyebrows arched, like the former altar boy that is often his narrative persona, standing before the altar screen that divides innocence from irony. His personal stories are germinated from seed-memories that spring to life suddenly in a conversation or a workshop, and they are shaped in the retelling. He already knows them, as one knows one's own experience, but performance reveals their shape, their peak moments, and their natural pace.

Jim expects his stories to vary from telling to telling. Sometimes a performance will seem halting, as the conversational teller gropes for new images, and new words to convey them—these hesitations would be damaging to the trust engendered by the performer-audience relationship, were it not for the fact that *words*, in the textual sense, are not the primary standard by which the oral performer

builds that trust. He works instead by the standard of involvement and interaction, built by eye contact, solicitations of agreement, spontaneous remarks to and about the listeners, the feeling that each listener is being directly, conversationally addressed. There is little sense in Jim's performances of the teller's or the listeners' attention being diverted by the absent higher authority of a text.

On the other hand, an oral story may become so smoothed by frequent repetition that hesitations and interjections disappear, and its performance assumes the character of a recitation. It may gain then in verbal fluency, and yet lose in communicative force. Some of the tensiveness of Jim's storytelling comes from his navigation between these opposing shoals.

Syd Lieberman grew up on the northwest side of Chicago, in what at that time was a largely Jewish neighborhood. His grandparents were immigrants from Eastern Europe, merchants, traders, and peasants who scrambled for a niche in the new world, laying foundations for their children to build professional careers. Syd's Jewish heritage provides the subject for most of his repertoire: stories of immigrant experience, folktales from Yiddish and especially Hasidic sources, and personal stories that reflect in various ways on the Jewish-American journey from precarious urban refugee to bemused suburban professional.

When asked about the evolution of his storytelling style, he quickly said, "Well, aside from being an English teacher for twenty years, I used to write feature pieces for local newspapers." His writing was not fiction—he declares that he has never been capable of that—but what might be called in the trade "color pieces," character portraits, and reflections on events or themes from his own or his community's experience. The first stories he told were Jewish folktales, encountered in books or in other told versions. But Syd's learning process was, and still is, crucial to his performing style. He would write out his own adaptation of the story, shaping it through his literary sensibility to his own developing sense of performative speech. It was this version that he would subsequently learn, adapting it again from his own literary "voice" to his speaking voice.

A professional storyteller who had a major impact on his artistic direction, Syd says, is Jay O'Callahan, a masterful teller from New England who was also a writer before he began performing his own stories. It was hearing Jay O'Callahan that encouraged Syd to use his own original writing as performance material. Syd is most comfortable thinking of his pieces as writing, as performable literature. Writing them out beforehand gives him space to polish the language within a piece, and to shape the whole so that it feels "finished."

Ong points out that the notion of completion or closure is, excepting only certain ritual contexts, primarily fostered by cultures based on writing:

> By isolating thought on a written surface, detatched from any interlocutor, making utterance in this sense autonomous and indifferent to attack, writing presents utterance and thought as uninvolved with all else, somehow self-contained, complete. (1982: 132).

It is part of Syd's cultural set that he is most comfortable creating an autonomous, closed structure of this kind before bearing it forth into the open, contingent zone of performance. Jewish culture has traditionally, of course, for millenia been a culture of the Book. But it is a Book relentlessly re-oralized, by recitation, cantillation, disputation and exegesis. So that, in the Talmudic tradition, the biblical text retains its central place, but in tiny dollops of original wisdom, while on all sides sprout chirographic, residually oral thickets of marginalia: "Rashi said thus, but Simeon ben Yochai said thus," and so on off the four edges of the page. The process of re-oralizing a lovingly "finished" text opens the interpretive storyteller to a similar inrush of "marginal" responses, which gradually fight their way into a new equipoise with the original. Syd told me:

> For a long time after I start to perform a story, the piece keeps changing on me. I'm always shocked when I go back to the written piece a year or so later, and I see how different it's become with my telling it. Then after awhile it begins to settle down again as a told piece, and it stops changing. The words stop changing. It becomes

pretty much the same from one performance to another. And I'm comfortable with that.

When Syd begins a story he has a distinctive preparatory "set": he plants his feet, looks down at the ground and flexes his knees, like a football running back getting ready for the snap (it happens he was a star halfback in high school). Then he takes a deep breath in the same motion as he raises his head, squints at the audience—and speaks. It is a personal physical ritual, which he repeats, not only at the beginning of each program, but at the beginning of each piece within the program. His voice is a powerful tenor instrument, punching out with cantorial force his Yiddish-American colloquial rhythms, studded with Midwestern dipthongs that break so sharply they seem to crack.

I append, by way of illustration, a transciption of a short section of one of Jim May's personal stories, this version called "Most Valuable Altar Boy" (he usually tells it, coupled with another section, as "Horse-snot, or Everything You Always Wanted to Know About Sex Education at St. Peter's"), followed by a transcription of the opening section of Syd Lieberman's story, "The Italian T-Shirt." These were the same stories that I heard them tell back-to-back that night at the storytelling conference. The recordings from which the transcriptions have been done were made within a year of the conference, and both were released in 1985 on self-published cassettes. Jim's was recorded in front of a large group of Catholic church workers, at an early stage in the development of the piece when it still had much of its exploratory feel. Syd's was recorded in front of a neighborhood audience at his own Jewish Reconstructionist Congregation synagogue in Evanston.

Following Chafe's technique of reproducing spoken language for analysis, I have broken the texts into "idea units." Segments which are audibly bounded by pauses are numbered and separated by paragraph breaks; laughter is marked by parenthetical exclamation points, applause by asterisks, longer pauses by ellipses.

Four idea units in the Jim May excerpt are represented entirely by ellipses. These indicate pauses in which the idea content of the

previous unit was developed by the teller in concert with the audience, entirely by nonverbal means—a pause, a look, a gesture, or all these melded in a moment.

(From "Most Valuable Altar Boy," by Jim May):
1. At least in our parish, Heaven had sort of layers,
2. or ... or, it was sort of like theater tickets. (!!!)
3. And you had the people like, way in the back, kind of the second balcony, you know, they—
4. they just—just barely made it in, they—
5. they led *holy but boring lives.* (!!!!!)
6. But—but they got to be with God forever, and so that was good, but—
7. closer up front, you know, the mezzanine maybe, or, or about halfway up there were the—
8. the martyrs. (!!!)
9. Of course that meant you were killed for professing your faith, and that was no small thing, and they had more jewels in their crown and so forth—
10. But—
11. right up there in the first row, you know,
12. the best place in Heaven,
13. were the virgin martyrs. (!!!!!!!!!!)
14.
15. I don't know how many of you still have a shot at that, but—(!!!!!!!!!!!!!!!!!!!!!!!*****!!!!!!!!!!!!)
16.
17. I got away with that, you might not be able to stop me now. (!!!!!!!!!)
18. Um, but, but the, uh—and of course that meant that—that you were killed for professing your faith before you had sex.
19. (!!!!!!!!!)
20. It didn't give you much to look forward to ...
21. (!!!!!!!!!!!!)
22. But—we were told this life didn't matter anyhow, you know. (!!!!!!!!!!!!!!!!!!!!!!)

23. So that's what I was going for—I was—
24. I was nine years old, a certified virgin, I figured I was halfway there. (!!!!!!!!!!!!!!!!!!!!!!!!!!!!!!)

(From "The Italian T-Shirt," by Syd Lieberman):
1. I was babysitting for my two kids ... that day.
2. They were two and four at the time.
3. It was a normal day.
4. The usual things were happening: my two year old ... was beating his sister over the head with a toy hammer. (!!!)
5. Now he wasn't picking favorites, he had beaten himself over the head for a while too. (!!!!!!!)
6. My daughter, the more artistic type, was squeezing margarine into Henry Moore-type sculptures, (!!)
7. or sand painting with the sugar she had spilled all over the kitchen floor.
8. I tried to get some work done—
9. I kept getting calls:
10. An insurance company, they wanted to sign me up, a car agency had a good buy, they were gonna fix me up, a heavy breather wanted to pick me up—(!!!!!)
11. Huh! Huh! Huh! I thought he had emphysema when I got on the phone.
12. As I said, normal things were happening:
13. a five hundred-piece-puzzle fell off a shelf, got mixed up with another five-hundred-piece puzzle. (!!!)
14. A faucet sprung a leak,
15. and a quart of milk spilled—
16. in the refrigerator.
17. And then things got worse.
18. I took out the garbage, and the bag broke.
19. I stood there, like the man in the Glad Bag ad, watching dirty diapers blow all over the backyard.
20. How much would it take to set me off? Not much.
21. My wife came home, she began to yell at me, "Clean this,

and clean this, and how could this happen, and—and look
at this!"
22. I ran out of the house like a crazy man,
23. I knocked a bag of groceries down the steps,
24. a trail of eggs followed me down the street. (!!!)

IV. ANALYSIS

Even a cursory look at these two samples, in the light of the four
propositions given earlier, will reveal obvious and significant differ-
ences in the fabric of their discourse. Here I would like to borrow
some technical terms from Chafe's socio-linguistics in order to high-
light the concrete ways that oral traditional and oral interpretive
storytelling performance tend to differ.

Syntactic autonomy: Syntactic autonomy measures the extent to
which the teller's language conforms to the formal requirements of
written, as opposed to spoken discourse, by being arranged in
independent clauses and complete sentences. It is clear that idea
units in the Lieberman excerpt are far more likely to be framed
linguistically in complete sentences. Twenty-three of them possess
the formal arrangement of subject, verb and object—an unheard-of
level of syntactic autonomy for spoken oral discourse, but not at all
unusual for written language. The May piece, on the other hand, has
only eleven units containing all the elements of a sentence. This is
still a high proportion for spoken discourse, according to Chafe, but
not when you consider that the performance context demands some
elevation of autonomy. An audience is never a full verbal partner in
storytelling discourse, and any teller's language will reflect the fact
that she is to some extent on her own.

Intonational autonomy: Intonational autonomy shows how con-
sistently the tellers' grouping of spoken words matches their formal
grammar. The Lieberman excerpt contains fifteen units which end
in the intonational dip characteristic of a spoken period. May's
contains ten. This is still significantly higher, but not as high as the
difference in syntactic autonomy. The nature of performance has
apparently driven Syd to run several of his crafted sentences

together intonationally, a discourse strategy that Chafe calls integration.

Integration: Nearly all of the units of discourse in May are integrated—syntactically, intonationally, or both—with those before and after. Even units with all the syntactic elements of a sentence are preceded or followed by conjunctions: and, but, so, or. There are sixteen units linked before or behind by conjunctions in the May piece compared with seven in the Lieberman. Strikingly, four of the seven conjunctions in Lieberman appear in a single spurt of reported dialogue ("She began to yell at me, 'Clean this, and clean this, and how could this happen, and—and look at this!'"). Reported dialogue is the performed construction of oral discourse, clearly and precisely set off linguistically from the more literary language that surrounds it. Integration is a clear marker of the spontaneous, emergent flow of oral, as opposed to written speech. It is also a natural involvement strategy, born of holding onto a listener's attention in the time-flow of performance, as opposed to the frozen, autonomous present of print.

Imprecision and repetition: Jim makes much use of the kinds of linguistic markers (sort of, kind of, and so on, like, you know) that Chafe calls "fuzziness" (1982: 48). Although these may look weak on the page to an eye used to the precision of print, Chafe actually numbers them with other involvement strategies of conversational discourse. He suggests that they express "a desire for experiential involvement as opposed to the less human kind of precision which is fostered by writing." Jim's piece is also sprinkled with repetitions and hesitations that indicate the emergent language process in action. Syd's, on the other hand, contains none of these conversational markers.

Spontaneous side-comments and response units: My transcription of May, as noted above, contains four non-verbal idea units. This is my own way of notating those beats in the performance in which the storyteller pauses to let the audience catch up with the implications of what has gone before, and anticipate what may be coming. Jim was dealing with the most volatile possible combination of ingredients for his committed Catholic audience—sex and spirituality—so

there were major opportunities for this kind of telepathic conversation in his piece. Oral interpretive performers may be able to create these kinds of beats—but it takes a special effort to move away from the autonomous flow of language into the flow of non-verbal, imaginative conversation. Jim's spontaneous comment to the audience, "I got away with that, you may not be able to stop me now!" (#17) is no more than a verbal eruption out of this flow of pleasurably negotiated tensions.

Open and closed elements in conversational storytelling: This passage from Jim May's storytelling, though conversational in tone and in the strategies of style, is far from random in construction. The conversationally indeterminate segments generally lead up to a phrase, a passage or an image which is set, and varies little or not at all from performance to performance. Such set units in this excerpt would include nos. 5, 15, 20, 22, and 24. I have heard the story performed many times, and these are always present, in the same order. They seem to me to be in the same words as well—but they may be more in the nature of oral formulaic elements, which link and structure an improvisitory chain. They are like proverbs, or the punch-lines of jokes, fixed nodes within a freer discursive web.

Set moments within orally created stories tend to be peak moments, payoff points in the tales. They become fixed because they *work*—they solidify the meaning, the power, or the humor of the story for not just one audience, but many. They are fixed by the teller *in concert* with the audience, and become inscribed over the course of many performances with the accumulated responses of each group, as recorded by the teller in her performance-memory. The told story, then, lives inside the teller, not only as text, nor even as images and sequences, but as *experience*: experience of the story and of the telling, joined into a seamless whole by the medium of performance. This is an important area for further exploration, as we begin to develop a vital contemporary tradition of storytelling education. My own experience of creating, performing, and studying stories suggests to me that the zone of live storytelling performance must be looked upon as a contemporary medium in itself, related to but distinct from others, including oral interpretation and oral tra-

ditions of the past—a medium through which human beings, bodies and souls, struggle to preserve their place in the world.

V. CONCLUSIONS AND INCONCLUSIONS

The work of contemporary storytellers offers a rich field for discourse analysis of subtle variations in oral traditional and oral interpretive performance. For now, these small excerpts will have to stand as tokens of the cultural and stylistic multivocality that flourishes even in one small garden patch of the storytelling world.

It seems clear to me that this movement, with its interdisciplinary cross-currents and its complex artistic and cultural agenda, is not a revival of oral tradition in any simple sense; nor is it a renaissance of literature in performance. It is a significant amalgamation of these modes that comes at a crucial moment in the evolution of our cultural technologies. The storytelling movement represents to me a conscious and unconscious effort to heal the wounds that the orality/literacy split has left in the constitution of our multi-cultural society, even as the remaining oral cultures of the world are being absorbed at an unprecedented rate into the electronic global village.

Although orality tends to get first billing in the rhetorical framing of a contemporary storytelling event, the literary element is neither slighted nor divided against its elder. But they are often invoked (or at least they were, before professional storytellers were smitten en masse by the compulsion to make videos) in common cause against the electronic media, which are framed as the usurpers, the Darth Vaders, the dragon which the storytelling revivalist has been summoned to slay.

This reminds me of Ong's version of Plato, arguing against writing in a dialectical discourse born of his ability to write. Consider the generative matrix of the storytelling revival: outdoor festivals and indoor concerts in which microphones, P. A. systems, and sound engineers conspire to create electronic analogues for conversational intimacy; audio and video recorders and players that make it possible for us to study not just the texts of folktales but their performative dimensions as well; the novelties of isolation created by modern urban society, with its endless mobility and the tempta-

tions of rootlessness; atomized communities connected by cellular phones and the pulsating glow of the tube—this permanent floating existential crisis in which orality, literacy, even humanity itself as we have traditionally constituted it seem pale and uncertain and bled of meaning. From any angle except the most naive, however insistently the storytelling movement positions itself as an answer to its alienation, the electronically processed world is the performative context of this revival. How it will grow as we surrender the naivete of the first crusading decades, and find that storytelling is no answer—only a heartfelt and powerful means of asking questions—and what questions we will ask then about orality and literacy and performance and the world: this is a story that remains to be told.

WORKS CITED

Chafe, Wallace L., ed. *The Pear Stories: Cognitive, Cultural, and Liguistic Aspects of Narrative Production.* Norwood: Ablex, 1980.

———. "Integration and Involvement in Speaking, Writing, and Oral Literature." *Spoken and Written Language,* ed. Deborah Tannen. Norwood: Ablex, 1982. 35-53.

Eliot, T. S. "Little Gidding." *Norton Anthology of English Literature.* New York: Norton, 1979. 2:2286-92.

Finnegan, Ruth. *Literacy and Orality.* Oxford: Blackwell, 1988.

Havelock, Eric A. *Preface to Plato.* Cambridge: Harvard University Press, 1963.

Heath, Shirley Brice. "Protean Shapes in Literacy Events: Ever-shifting Oral and Literate Traditions." *Spoken and Written Language.* Op. cit. 91-117.

Lakoff, Robin Tolmach. "The Mingling of Oral and Literate Strategies in Written Communication." *Spoken and Written Language.* Op. cit. 239-60.

Lieberman, Syd. *The Old Man and Other Stories.* Audiotape. Evanston, Illinois: 1985.

Lord, Albert. *The Singer of Tales.* Cambridge, Mass.: Harvard University Press, 1964.

May, Jim. *Raised Catholic: Can You Tell?* Audiotape. Clifton Heights, Penn.: Myth America, 1988.

McLuhan, Marshall. *The Gutenberg Galaxy.* Toronto: University of Toronto Press, 1962.

———. *Understanding Media: The Extensions of Man.* New York: McGraw, 1964.

Olson, David. "From Utterance to Text: The Bias of Language In Speech and Writing." *Harvard Educational Review.* 47.3: 257-81.

Ong, Walter J. *Orality and Literacy.* London: Routledge, 1982.

Oxford, Cheryl. *"They Call Him Lucky Jack": Three Performance-Centered Case Studies of Storytelling in Watauga County, North Carolina.* Diss. Northwestern University, 1987. 190-93.

Polanyi, Livia. "Literary Complexity in Everyday Storytelling." *Spoken and Written Language.* Op. cit. 155-70.

Rader, Margaret. "Context in Written Language: The Case of Imaginative Fiction." *Spoken and Written Language.* Op. cit. 185-97.

Stein, N. and T. Trabasso. "What's in a Story? An Approach to Comprehension and Instruction." *Advances in the Psychology of Instruction,* ed. R. Glaser. Hillsdale: Erlbaum, 1982.

Tannen, Deborah, ed. *Spoken and Written Language: Exploring Orality and Literacy.* Norwood: Ablex, 1982.

———. *Talking Voices: Repetition, Dialogue, and Imagery in Conversational Discourse.* Cambridge: Cambridge University Press, 1989.

Yeats, William Butler. *A Vision.* New York: Macmillan Publishing Co., 1956.

About the Contributors

For more than twenty years, *Carol L. Birch* has been immersed in the storytelling revival. She is an award-winning recording artist and director, former chairperson of the Anne Izard Storyteller's Choice Award committee, a children's librarian with the Chappaqua (N.Y.) Library, and an instructor of Storytelling and Children's Literature at Wesleyan University and Southern Connecticut State University.

Joseph Bruchac is a storyteller whose work draws most strongly on his Abenaki Indian roots and the Adirondack Mountain region of upstate New York where he was raised by his maternal grandparents. The author of more than 40 books of poetry, storytelling, and fiction for both adults and children, he holds a Ph.D. in Comparative Literature from the Union Institute of Ohio.

Mathias Guenther began his anthropological research among the Nharo Bushmen of the Ghanzi farm district in western Botswana in 1968, with whom he has maintained his contacts over the subsequent years. He is currently doing field work on an art project recently started by a number of Bushman artists. He has always found himself collecting stories—in the latest project, narratives on pictures. He has published a number of articles on Bushman oral tradition, myth, ritual, and art, as well as a book-length collection of Nharo and /Xam stories *(Bushman Folktales: Oral Traditions of the Nharo of Botswana and the /Xam of the Cape)*. He is a professor of anthropology at Wilfrid Laurier University in Waterloo, Ontario.

Bill Harley is a singer, songwriter, and storyteller who works primarily with family audiences. He has won awards for his many recordings and is a regular contributing commentator to National Public Radio's "All Things Considered." The author of two children's picture books, *Nothing Happened* and *Sitting Down to Eat,* Harley lives in Seekonk, Massachusetts with his wife and two sons.

Melissa A. Heckler is an educator and education consultant who has worked in such diverse settings as the Homeless Student Program in

Southern Westchester, an in-village literacy program for the Bushmen of the Kalahari, and public schools in Westchester County. She holds an M.S. in early childhood education from Bank Street College of Education.

Rafe Martin trained as a literary critic with Northrop Frye and Marshall McLuhan nearly thirty years ago but found that bringing stories alive in the actual telling spoke to him more. Since then, he's gone on to become an internationally known, award-winning author and storyteller. His work has been featured in *Time, Newsweek,* and *USA Today.* His books and tapes have received Parents' Choice Gold Awards, ALA Notable Book Awards, and many other honors.

Peninnah Schram has been internationally recognized as an outstanding Jewish storyteller and compiler of Jewish folktales, including *Jewish Stories One Generation Tells Another, Tales of Elijah the Prophet,* and *Chosen Tales* (published by Jason Aronson Inc.) She is Associate Professor of Speech and Drama at Stern College of Yeshiva University and Founding Director of The Jewish Storytelling Center.

Joseph Sobol is a storyteller, musician, and folklorist who has been involved with the storytelling revival since 1981 and has written extensively on contemporary storytelling. He received a Masters in Folklore from the University of North Carolina and a Ph.D. in Performance Studies from Northwestern University, where his dissertation focused on the role of the National Storytelling Association and its annual festival in the nationwide revival of storytelling. He is currently touring the country with *In the Deep Heart's Core,* a musical theatre piece that he has created based on the works of the Irish poet and folklore revivalist William Butler Yeats.

Kay Stone teaches courses in folklore and storytelling at the University of Winnipeg. As a storyteller, she has appeared at numerous festivals throughout Canada and the U.S. She has published widely in both academic and storytelling publications. She is currently working on a book on professional storytelling.

Barre Toelken was drawn to folklore over forty years ago, when he lived for two years with a Navajo family who told coyote stories nightly during the winter months. Since then, over thirty years of teaching literature and folklore courses on the university level, he has tried to reconcile folklore theory with what everyday people actually do when they tell stories to each other. He has served both as president of the American Folklore Society and on the board of the National Association for the Preservation and Perpetuation of Storytelling (now National Storytelling Association). He is director of the interdisciplinary Folklore Program at Utah State University.